A Bright
Clean
Mind

ALSO BY CAMILLE DEANGELIS

Fiction

The Boy from Tomorrow

Immaculate Heart

Bones & All

Petty Magic

Mary Modern

Nonfiction

Life Without Envy: Ego Management for Creative People

Moon Ireland

A Bright Clean Mind

Veganism for Creative Transformation

by Camille DeAngelis

Coral Gables

Cover & Layout Design: Jermaine Lau
Published by Mango Publishing Group, a division of Mango
Media Inc.
For permission requests, please contact the publisher at:
Mango Publishing Group
2850 Douglas Road, 2nd Floor
Coral Gables, FL 33134 USA
info@mango.bz
A Bright Clean Mind: Veganism for Creative Transformation
ISBN: (p) 978-1-64250-074-5
LCCN: 2019941802
BISAC: SEL009000, SELF-HELP / Creativity

For Mumsy,
who made every word possible.

"Tell me what you eat and I will tell you who you are."[1]

—Thich Nhat Hanh

Table of Contents

INTRODUCTION

An Epiphany in Slow Motion

I grew up on a steady diet of Jim Henson, Judy Blume, and chicken cutlets, and I knew from the time I could grasp a crayon that I was going to be an artist. The more I used my imagination, though, the more uneasy I felt about eating and wearing animals who surely wanted to go on living as much as I did. When I was twenty, I went completely vegetarian, and creatively speaking the following decade felt like an alternating series of false starts and measured joys. I published three books, but I never felt as though these accomplishments served anyone but me.

When I became vegan seven years ago, I experienced an exhilarating surge of creativity that has continued to this day. As the knock against vegans goes, I wanted to tell *everyone I knew* that our bodies produce casomorphin in response to the casein in dairy cheese, meaning that we are literally addicted to our favorite chèvre; that we're the only species that drinks the breast milk of another; and did you ever wonder why, if cow's milk has so much calcium, everyone we know over the age of seventy is suffering from osteoporosis? I told anyone who would listen that I could feel new pathways lighting up in my brain, that something inside me had been liberated. I was excited to try new recipes and veganize the old ones, to share everything I was learning, and over the years that excitement has compounded itself.

But when I talk about going vegan with people who aren't, I usually sense an invisible wall going up between us. It's all very well and good for me, I can almost hear them thinking, but my way of life is not feasible for *them*.

Apart from the fact that I've written some pretty good novels, there's nothing remarkable about me. I wasn't raised in anything remotely resembling an alternative lifestyle. I have wistful memories of stopping for Egg McMuffins at dawn en route to my grandparents' vacation house in the Poconos. But I also remember calling the toll-free number on the back of a Noxzema jar to ask if Proctor & Gamble tested on animals. I can't recall what initial click of insight possessed me to do this; my parents weren't pet people, and as Carol Adams points out in *The Sexual Politics of Meat*, "meat eating is the most frequent way in which we interact with animals."[2] All I know

Dyeing Easter eggs with my sister Kate, 1992.

is that I wasn't ready to follow the thread of logic that connects testing on animals with *eating* animals. In my teens, I ate tuna sandwiches and a couple of steaks a year and called myself a part-time vegetarian.

This was still my dietary MO my freshman year at NYU, which is when I first began to think about writing a novel. I met this lovely, gentle girl named Chloe in one of my core classes, and I wanted to be friends with her even more when she confessed she was already working on one.

"This is what I have so far," she said shyly, handing me an old-school black-and-white composition notebook. It was two-thirds full, maybe more, and I could tell by the hurried quality of her handwriting that she'd spent many evenings flush with inspiration.

I knew enough to want to spend as much time as I could with people who weren't only *talking* about making art. So one night, Chloe and I went to this French restaurant in the West Village that is long since out of business. We ordered two deluxe steak dinners, and the waiter asked if we wanted wine. (Three months living in

Manhattan, and I still hadn't been carded.) Chloe and I traded devious looks.

Here we were, two eighteen-year-old aspiring novelists in a candlelit restaurant in New York City talking about books and ambition, drinking illegally, eyes alight with our newfound kinship. I felt terribly grown up, and *excited*, because in a sense we had settled in at this table for two to plot out at least the next ten years of our lives.

We were clichés, of course we were. But of all the elements in this scene, the one that makes me cringe is the meat on my plate.

The following summer, I found a copy of *Conversations with God* on the bargain cart at the Strand, an East Village institution advertising "eighteen miles of books." I'd dismissed the book as new-age baloney whenever I had to reshelve it at my bookstore job back in high school, but this time it practically leapt off the cart into my hands. I vividly remember reading the following lines on the A train one afternoon:

> A [highly evolved being], in fact, would never consume an animal, much less fill the ground, and the plants which the animal eats, with chemicals, then fill the animal itself with chemicals, and then consume it. A HEB would correctly assess such a practice to be suicidal.[3]

Whether or not I believed these words actually came from "God," they provoked a physical reaction in me. I did not want to be a flesh eater, not "part-time," not at all. But it took me another decade to un-believe the cultural narrative that cows willingly "give" us their milk, that chickens have no use for their eggs, that these animals aren't made to suffer for what we take from them.

None of that is true.

What I'm about to write is a difficult thing for artists to face, because *we're* the ones who are supposed to be seeing into the heart of the culture, testing out radical new ways of thinking and being and doing, and calling "bullshit!" whenever we see it. The truth is, though, that we are not nearly as open-minded as we like to think we are. How often do we say that something is "not for us" when we haven't given it a chance? How often do we *actually* challenge the prevailing cultural norms? And what about all the times we look

back over our thoughts and actions and feel a creeping shame at how little consideration we gave the needs and feelings of those around us?

If we truly want to grow as artists and as humans, we have to be willing time and again to look for the kinder, more responsible, more loving way, especially when that way is not the convenient one. As artists and innovators, it is our responsibility to offer a reasoned critical response to the dominant culture, and the most fundamental expression of culture is food.

Creativity is so much more than putting marks to paper, and to fulfill our artistic potential requires more than a good eye, a sharp intellect, and a belief in one's own capability. So, when I hear fellow artists talk of chronic anxiety, depression, and fear, that they need "comfort foods" like bacon and cheese to cope with these dark feelings, I want to tell them they're confusing comfort with anesthesia. I want to tell them they'll live longer, happier lives if they stop eating animal products, that world peace and environmental sustainability begin on their plates, that vibrant good health and rejuvenated creativity are the rewards for saying yes to the challenge of psychological growth. Here are just a few of the specific benefits I and other vegan artists have noticed:

- A growth mindset and innovative thinking *outside* the kitchen too.

- A greater sense of agency and resourcefulness. We feel emboldened to seek information even if what we learn suggests we revise our current modes of belief and action.

- We recognize the difference between empathy and lip service. As Ezra Klein points out in his podcast episode on veganism, "You don't need to accept any new ideas to be horrified [at how farmed animals are treated]. You just need to believe the ideas you already accept."[4] The more fully we explore our capacity for empathy, the better our art.

- We're more sensitive and perceptive. It becomes easier to hear what isn't being said out loud (e.g., "I agree that eating animals is cruel, but I can't change my diet because my partner won't like it and I'm afraid to put stress on the relationship").

- We're braver versions of ourselves because we're now willing to put words around what is inconvenient, contradictory, or patently untrue. Going vegan is a great way to begin overwriting the diffident people-pleasing demeanor that traditionally passes for "femininity" in our culture.

- Because we're actively challenging the dominant paradigm, you might say we're practicing true nonconformity—a quality artists are praised for yet seldom live up to.

- We have the mental and emotional wherewithal to work up to our potential. "So much energy goes into denial," as visual artist Jane O'Hara puts it—denial of animal suffering, corporate greed, the socioeconomic injustice of the current food system, and so on.

Can I "prove" that veganism is the diet for optimal creativity? The proof's in the pudding, for me.

Besides, what evidence does anybody have that an omnivorous diet is healthier, with all the scientific studies—those *not* funded by the dairy or livestock industries—that link the consumption of animal foods with heart disease, cancer, and other "diseases of affluence"? I've come to believe that self-deception is the most powerful impediment to creativity, and in the human experience there is nothing so delusional as the way we rationalize our treatment of animals. The moment one realizes one can opt out of this system may be the most transformative moment in the life of a human being, and that's why writing this book on the benefits of this exuberant new life feels like the very least I can do.

What's in This Book

In part I, we'll examine some psychological "sticking points" I've collected from real artists, using the vegan ethos to offer specific ways to "unstick." Some of these chapters get somewhat personal because I can't write about creative anxiety without sharing my own experience.

Part II features informal conversations with vegan artists working in a variety of disciplines. In between, I walk my talk when it comes to trying new things, so you'll read about my firsthand experiences (foraging and scuba diving and vegan hip-hop), novel ways of looking at old practices, and philosophical food for thought. I've also included a handful of recipes to fuel your creative work.

And in the back pages, you'll find practical tips for transitioning to a vegan lifestyle as well as a comprehensive list of blogs, books, podcasts, and films I've found helpful and inspiring.

What Is Veganism?

Veganism—a word coined by English animal-rights activist Donald Watson and his Vegan Society cofounders in 1944—is a lifestyle and philosophy dedicated to avoiding animal products as much as possible. As well as addressing very serious concerns regarding personal health and environmental sustainability, veganism promotes an awareness of the ways in which humans exploit our fellow sentient creatures for food, clothing, entertainment, and scientific research. Being vegan means removing yourself from this system of cruelty and domination.

I also want to share the most direct and heart-centered explanation of veganism I've ever seen (which I quote from one of @the_vegan_soldier's Instagram captions):

> Vegans measure the worth of life by the existence of life and the will to continue that life. Wanting to live makes a species worthy of living.[5]

We humans can't exist without inadvertently causing suffering and death in some form—the crow who flies into the windshield, the insects and other organisms we crush underfoot—but we don't have to do it on purpose.

How to Use Google to Learn about Veganism

Last summer I organized a picnic for a few friends at a park near my apartment, making a pot of vegan macaroni 'n cheese and folding in peas and tofu "bacon" bits. It was very tasty, if I do say so myself, and my omnivorous friends agreed.

"I'd have you over for dinner," one of them said casually, "but I wouldn't know what to feed you besides celery."

Isn't it funny how we pick up our phones to Google the most random things—"Where is the tallest building in the world?" "Are penguins monogamous?" and "Which film director has won the most Academy Awards?"—but we just shrug when it comes to "easy vegan recipes"?

Resourcefulness is an essential element of creativity, my friends. So, use Google for answers to the obvious questions:

Why do people choose not to eat or wear any animal products?
What are the health benefits of a plant-based diet?
How does a vegan get protein? Calcium? Iron?
Why is dairy bad for me?
How can I do a plant-based diet on a tight budget?
What vegan dishes can I cook so I still feel satisfied?
Why isn't honey vegan?

And when you're ready, try searching for the disturbing things like "undercover factory farm footage" or "animal agriculture environmental effects." There's a ton of information out there that's infinitely more important than where Taylor Swift went to high school, but it's up to you to type it in.

Common Stereotypes and Misconceptions about Vegans and Veganism

I'll be addressing each of these beliefs in depth over the course of this book, but they're so prevalent that it makes sense to look at them up front.

We're judgmental and intolerant.

When you rave about bacon and a vegan gives you a dirty look, they're thinking about everything a defenseless pig suffers in order to become the topping on your hipster doughnut. It's true that we occasionally lose our cool and say something hostile, but it's hard to be patient when we're so keenly aware of the suffering (*and* environmental devastation *and* the nasty effects of meat and dairy on human health) and it seems like no one wants to listen.

We're too idealistic.

You know how everyone's so fond of that Gandhi quote, "Be the change you wish to see in the world"? Funny how folks tend to give us a hard time for following that advice.

We live a joyless, ascetic existence.

The complete opposite: I eat anything I want, and I've never been happier in my life.

Diet is a personal choice.

Not when your choice promotes the suffering of sentient beings. (This is my response to a privileged non-vegan audience with easy access to fresh produce, nutritional information, and other resources. As food-justice activist Starr Carrington writes, "[I]t is inherently racist to impose blame upon the Black consumer for failing to consume healthier options without equitable education and awareness of one's transitioning food environment."[6])

Plant-based eating is expensive.

It can be if you buy a lot of faux meats, nut cheeses, and other fancy foods, but not if you get most of your groceries in the produce section and buy your grains, nuts, and legumes in bulk. (Also, keep in mind that government subsidies are behind the low prices for

meat and dairy in the US. Ultimately, you may spend much more on healthcare for diseases promoted by the standard American diet.)

Vegans don't care enough about human rights.

We believe all oppressions are interrelated. The system that tortures and kills innocent creatures for human consumption is ultimately the same system that starves human children all over the world, keeps the truth-seeking journalist in prison, and guns down unarmed Black Americans with zero consequences for the shooters. We need people working to dismantle this system from every angle.

Veganism is a lifestyle for well-off white people.

It's true that vegan activists of color don't receive the same level of recognition as white vegans, and privileged vegans *must* address the racism, classism, sexism, and ableism within our movement. Google "intersectional veganism" (or see suggested reading on page 259), and delve into the vital work of vegans from marginalized communities.

A compassionate lifestyle is an all-or-nothing proposition.

You're not vegan if you're occasionally eating dairy cheese or buying wool sweaters, but you're still living more ethically than you were before. When you know better, you do better, and it's like any other good new habit: if you slip up, just start again.

This Book Is for You

If you're tired of feeling chronically anxious and depressed and wish there were something besides medication that might help you, if you feel an affinity for animals and the natural world, if you've ever felt disgust at the sight of meat or remorse for having eaten it, if you've ever had the squirmy feeling that there are facts it is safer not to know, if you have ever felt unsettled after a meal that was meant to nourish you, if you've tried vegetarianism before but couldn't find the resources or support you needed, if you're scared as hell of cancer, heart disease, or diabetes: this book is for you.

STICKING POINTS

Halcyon On and On[I]

Sticking point #1: **"The creative process is often frustrating, but false starts and dead ends are inevitable."**

I used to believe anxiety and frustration were part and parcel of art making, too. But what if I told you it doesn't have to be that way?

In the spring of 2011, I signed up to volunteer at Sadhana Forest, a reforestation project and vegan community near Pondicherry in Tamil Nadu, India. Founded by Yorit and Aviram Rozin in 2003, Sadhana Forest draws environmentalists from all over the world, and the Ayurvedic vegan food is just as vibrant and varied as the volunteers who prepare and savor it: fruit salads with papaya, passionfruit, and bananas picked just down the road, breakfast porridge with jaggery, warm flavorful yellow dal and other stews and curries, lime-tossed salads of every color and texture. Mealtimes are social and sacred at the same time, with a moment of grateful silence before someone sounds a chime and everyone happily tucks in. *Sadhana* means "spiritual practice" in Sanskrit, and it's a fitting name for a place that will change your life, if you let it.

Before my arrival at Sadhana Forest, it hadn't occurred to me that I wasn't actually joking about being addicted to cheese. I'd reached a point where I felt a vague unease whenever I consumed an omelet or my favorite Cotswold cheddar, and I was excited to be joining a vegan community, but I didn't experience an epiphany until a long-term volunteer struck up a conversation at dinnertime. Jamey gently asked what was holding me back from going vegan, and I said I worried about what would happen when family or friends invited me over for dinner—that I might alienate or inconvenience them.

"I hear what you're saying," he replied, "but do you see how small a concern that is compared to the abuse animals suffer for our food, and what animal agriculture is doing to the planet?"

Sitting cross-legged on the reed-matted floor—having scraped the last delicious morsels off my stainless-steel plate, which I would later clean with ashes and vinegar in a basin behind the main hut—I felt a weird and exciting synergy between Jamey and me, as if I'd

I From the Orbital song.

asked him a very long time ago to meet me here and ask me these questions.

Every creative knows this feeling, even if they haven't yet experienced it in this context. It's *the click*, that achingly perfect moment when the story or image you've been fumbling toward for weeks, months, or even years resolves itself into the Legitimate Work you know in your heart it's meant to be. Artists live for these moments of revelation, or what psychologists call "peak experiences." Flashing lights, gears clicking into place.

"Yes," I said. "You're absolutely right."

"This thing is bigger than you," Jamey was telling me. The animals, the planet, our future: there could be no better motives.

In that moment, I made a commitment, but I didn't anticipate the magnitude of the change I'd experience over the next few weeks. Up to that point in my career as a novelist, I invariably "suffered" trough periods in between books, and these periods of frustration might last up to two years. I would start a new story and read over the pages with mounting despair. Maybe I had no more novels in me—not *good* ones, anyway. I was trying to clamber out of one of these troughs at the time of my trip to India, but it had never occurred to me that my diet might have an effect on my creative life.

A few days after I decided to go vegan, I came down with sunstroke. Tossing and turning under a mosquito net in the "healing hut," I felt depleted and full to bursting at the same time, and whenever I surfaced out of a fever dream I reached for my journal. I was getting ideas for everything: novels and short stories and blog posts and recipes I might invent or reinvent. Best of all, a novel idea I'd been struggling with for years finally resolved itself in two simple words: *gothic satire*. (I still haven't gotten around to that one. I'm keeping it in my pocket like a cashew-milk caramel, savoring the anticipation.)

I got well again, and the ideas kept coming; since then I've written six more books without so much as a daylong trough. One explanation is psychospiritual: there is no angst in my creative work because I'm no longer consuming the fear and grief of cows whose babies have been taken away from them to provide milk for human consumption. There may be a scientific basis for this

too: as pharmacology researchers Hassan Malekinejad and Aysa Rezabakhsh wrote in the *Iranian Journal of Public Health* in 2015, "The naturally occurring hormones in dairy foods have biological effects in humans and animals, which are ranging from growth-promoting effects that related to sex steroids, to carcinogenic properties that associate to some active metabolites of oestrogens and IGF-1."[7] (That's "insulin-like growth factor 1," a hormone produced in highest levels during puberty.) Scientists have also confirmed a link[8] between cancer and the artificial growth hormones commonly used by the livestock industry, and they can offer a biochemical explanation as to why meat from stressed animals is so often discarded as "PSE" (pale, soft, exudative) or "DFD" (dark, firm, dry). Unfortunately, there's shockingly little research on the connection between the adrenaline, cortisol, and other stress hormones coursing through a frightened animal's bloodstream and the chronic anxiety of the human who consumes that animal's flesh.[9]

Framed in these terms, the dark feelings we take for granted in the creative process seem rather karmic. Just now, I found one of my old blog posts from 2008 with notes on my creative cycle, and I had to laugh out loud when I read, "I have never finished revising one novel and started writing the new one the following week or month (and I've always wondered about those writers who say they do)." Talk about proving myself wrong—though, unfortunately, many health professionals aren't willing to do the same. If you Google information on vegan diets, you'll find a great many blog articles with an obvious anti-vegan bias written by medical doctors, psychologists, and nutritionists who warn against a plant-based diet because the evidence in favor contradicts years' worth of training. "Depression is related to inflammation in the body and low levels of serotonin," says Dr. Ulka Agarwal of the Physicians Committee for Responsible Medicine. "Plant-based foods naturally lower inflammation in the body because they are naturally low in fat and high in antioxidants. High vegetable intake increases the amount of B vitamins in the diet, which have been found to affect mood."[10] My own experience jives with scientific study results correlating a vegan diet with lighter mood[II] and higher energy levels.

II In cases of clinical depression, a plant-based diet may work in concert with medication and other therapies.

In that blog post from 2008, I write about the three Hindu gods sometimes employed to personify the creative cycle[III]: Brahma, "the creator," is the electric excitement you feel when you've found the perfect idea, Vishnu, "the maintainer," represents the actual work, and Shiva, "the destroyer," ushers in a period of chaos or inactivity in between projects (or having to scrap the work altogether, Heaven forbid). These three show up very differently for me nowadays: my experience of the Brahma phase isn't a phase at all; it's a constant. And as for Vishnu, I go back and forth between days and weekends at the library followed by late-night typing in bed (as I am doing now) and more "reasonable" hours. And Shiva doesn't destroy, he clarifies—though you might say clarity *is* a form of destruction. As Bernard Shaw writes in *Major Barbara*, "You have learnt something. That always feels at first as if you have lost something."[11]

Visual artist Jolynn Van Asten, who teaches transformational art workshops in Phoenix, Arizona, tells me going vegan has eliminated creative block for her too and that there's no need to "summon the Muse" anymore: "Now I can access 'flow' with just an intention to do so—instantly."[12] I can't guarantee that if you go vegan your creative growth will be as dramatic as ours has been—"your mileage may vary" and all—but it's certainly worth a thirty-day test run, don't you think? I've explored my creative potential as an omnivore, a vegetarian, and a vegan, and I feel too full of joy and purpose ever to go back on option three.

III I hope the point I'm making here is insightful enough to justify the cultural appropriation.

A knitting lesson at Sadhana Forest.

Better Than Celery for Dinner

Like we said, everything you could ever want to know about eating vegan is instantaneously accessible. So, start poking around! Search the #vegan or #plantbased hashtags on Instagram and drool over all the colorful and beautifully presented food photography, read nutrition primers (see resources on page 259) look up vegan versions of your favorite dishes, and search for any unfamiliar ingredients. You don't even need to make or change anything yet. Just see what's out there.

Secondly, after meals and snacks, jot down a few notes about how you feel. How's your energy? Your digestion? Your mood? Let yourself feel more curious about what's going on in your own body.

This Life of Verve & Loathing

Sticking point #2: "Sometimes I feel totally self-assured, and other times I dislike myself so intensely that I can't lift a finger to make anything."

When I was a child, I loved nothing better than to draw. You could give me a small stack of typing paper and a boxful of markers, and I'd be content for hours. My parents sent me to drawing and pottery classes at the local arts center, and my teachers were very encouraging. I had ability, and I took pride in that—maybe a little too much. Our elementary school art teacher used to hang our work in the hallway outside the cafeteria, and I remember waiting in the lunch line, looking up at a row of still lifes—apples, done in pastel—and playing a game of "which drawing is the best?" I'd choose one, and when I got close enough to see the signature, I'd remember with *such pleasure* that it was mine.

I played this game most lunchtimes until our teacher took down the apples.

I have another clear memory of the South Valley cafeteria. Picture me: seven years old, all knees and elbows, with awkwardly cropped hair thanks to a classroom lice epidemic. I am sitting in front of a Styrofoam tray with a cheesesteak ready to be washed down with a little carton of 2 percent milk. Only this isn't a proper Philly cheesesteak with shredded beef, onions, and peppers topped with melted American or provolone. This thing is a rectangular slab of reconstituted meat with a blister of lard studding the gray-brown surface. This is by far the most disgusting thing that has ever been presented to me as "food." I don't want to eat it, but I do—and then I feel disgusted with *myself*.

There are specific reasons why we remember what we do out of all the ever-vaster catalog of life experiences, even if these reasons never consciously occur to us. I believe that in these grade-school memories two irreconcilable attitudes about myself are encoded: the self-assurance I would need to pursue a career in the arts and the self-loathing that arises out of a sense of helplessness. Now and then I had my petty rebellions, but for the most part, I was a polite and obedient child; it wouldn't occur to me for many more years that I could choose not to eat that cheesesteak.

Over time this bifurcated sense of myself became more pronounced. I was assigned to "gifted" classes, and I always scored in the 99th percentile on standardized tests. Yet I was defective. My parents' acrimonious divorce and ongoing custody battles were a consequence of my inadequacy. My physical imperfections horrified me: mysterious knobs of flesh on my skull, the gap between my two front teeth, the dark leg hair that began to grow before I hit puberty. Physical symptoms led my parents to bring me to the doctor—stomach trouble, an ache in my lower back, shooting pains in my feet—and no doubt the doctor wrote them off as psychosomatic. I went to a series of therapists. I lay awake reading Nancy Drew mysteries well past midnight, the anxiety mounting that I might fall asleep during school the next day, which, of course, pushed sleep off even later.

I started high school, and the symptoms got weirder. The skin on my arms peeled off in swathes, and my fingernails fell out one by one. But I reacted to these developments with curiosity. I was *molting*, and I took that as a good thing, because by this point I'd become obsessed with the idea of metamorphosis. I watched the 1994 adaptation of *Little Women* over and over to hear Winona Ryder say of Jo's writing practice, "I gave myself up to it, longing for transformation." And I remember sitting in my mother's car in the library parking lot, feeling her dismay as she noticed the title of the book in my lap: *Seven Days to a Brand-New You*.

"What's wrong with you the way you are?"

"It's *fiction*," I huffed—as if I hadn't wished it weren't.

I was also fascinated with Sylvia Plath, as sensitive, self-absorbed white girls tend to be. For a senior year English project, I drew a sarcophagus lid with a female effigy in a blue-striped nemes headcloth inspired by "Last Words (Crossing the Water)." Phrases from various poems curved along a chest plate and covered the background: "Morals launder and present themselves," "Blameless as daylight," and "I shall hardly know myself," a reference to the poet's shining newborn self after death. In *Sylvia Plath: Poetry and Existence*, David Holbrook writes, "The psychotic delusion is that what is necessary is the destruction of an old self, and the rebirth of a new. In truth she won't be there to know herself."[13] As I read this

analysis, I wished someone could have coined "mansplaining" a few decades sooner. *Oh well, I guess that makes me cuckoo too!*

I grew out of that preoccupation with the morbid poets—though I never stopped identifying with them—and, by the end of my twenties, I'd summoned enough "necessary arrogance" (as the psychologist Eric Maisel calls it) to succeed at putting out my first two novels with a Big Five publisher. In the spring of 2010, I was granted a residency at Yaddo, the artists' retreat where Sylvia Plath and Ted Hughes stayed in the fall of 1959, and every day I climbed the winding stairs at West House to the same sunlit study where Plath worked at rounding out her first collection, *The Colossus and Other Poems.* Some evenings my new friends and I would curl up with a cocktail on the yellow velvet sofa in the drawing room and laugh to one another, "Oh yes, they definitely did the business on this very spot."

My time at Yaddo was exactly one year before my "vegan conversion" at Sadhana Forest, and in my journal, I mention eggs for breakfast and the Yaddo chef's infamous chocolate mayonnaise cake. These entries are also tinged with a cheerful sort of insecurity: *I think it's a good thing to surround yourself, on occasion, with people who make you feel slightly obtuse.* I told myself the writing was going well, but it wasn't really. Maybe I'd hoped my invitation to such a hallowed literary institution would change me somehow, give me the validation I needed to silence that desperate voice inside me chirping, "Let me show you how *interesting* I am!"

But I also recounted conversations in which I articulated (perhaps for the first time) the conviction that artistic development is linked to spiritual growth. Plath knew it too. During her time at Yaddo, she wrote, "[G]et rid of the accusing, never-satisfied gods who surround me like a crown of thorns. Forget myself, myself. Become a vehicle of the world, a tongue, a voice. Abandon my ego."[14] I wish I could ask her what she meant by becoming a "vehicle of the world"—*practically* speaking—and I wish I could tell her how I've chosen to interpret those words. In letters to friends and family, Plath expressed unease at the pleasure her new husband took in fishing and hunting.[15] One night Hughes took her out tracking in Yorkshire and shot a doe and her fawn, and though Sylvia had been

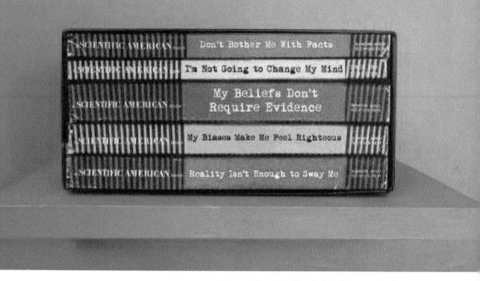

© Nava Atlas, *The Narcissist's Library*, detail, 2017.

cooking for him daily in his mother's kitchen, she wasn't willing to make a stew out of such beautiful, gentle creatures.

When I went vegan, I finally found the transformation I'd been yearning for since childhood, the natural result of a momentous shift in perspective: for what is my anxiety compared to the seventy billion land animals facing the dis-assembly line each year or the thousands of workers (many of whom are undocumented) who suffer serious injuries and appallingly low wages in order for our meat, dairy, and produce to reach the grocery store? This is not to invalidate what I or Sylvia Plath or anyone else with "first-world problems" have felt, but to suggest we turn our explorations outward and ask what logical steps we can take to alleviate the suffering of others.

I've come to believe that an obsession with metamorphosis indicates an impatience, an unwillingness to "do the work" on oneself—to focus on making one kinder, braver choice at a time until you evolve into the person you want to be. There can be no surefire fixes for self-loathing—particularly where mental illness is involved—but ethical veganism may very well provide a philosophical framework that prevents your emotional pain from eclipsing the world around you.

My friend Dixie once advised me to "be my own mama," which is an effective method for managing lingering feelings of self-loathing. The concept is simple: treat yourself as you would a small child in your care. Systematize your self-soothing practice into two types of actions: daily maintenance and strategies for "emergency" situations (e.g., a negative thought spiral). For me, simple maintenance includes making the bed, writing in my journal, going to yoga class, meditating for at least five minutes, and lighting a candle or incense to set a calm and cozy mood in the evenings. (A hand, foot, or face massage would be ideal, too, though truth be told, I almost never do it.) At the top of my emergency list is "headstand for at least ten to fifteen breaths," which is the only thing guaranteed to turn my mood around. (I would put my head on the floor of a filthy bathroom stall if I really needed to.) The idea here is to be more deliberate about caring for the softest parts of ourselves, so that we in turn can recognize the softest parts of others.

Imperfectionism

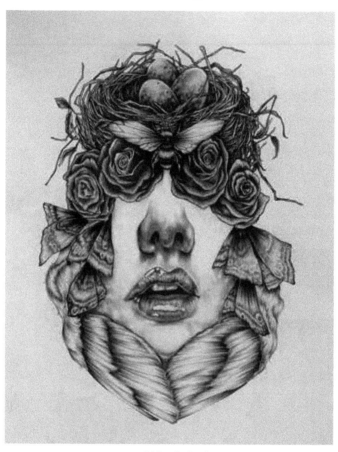

© Meneka Repka, *Nest Face*, colored pencil, 2016.
@noochdesignco

Sticking point #3: "The beautiful thing in my head withers as soon as I begin committing it to paper," or "I *know* perfection is unattainable. But if I can't do it as perfectly as humanly possible, why do it at all?"

In the 1940 film, *My Favorite Wife*, Cary Grant plays a presumed widower whose wife (played by Irene Dunne) was lost at sea seven years before. Naturally, Irene finds her way back from the desert isle just as Cary's about to marry again. As the long-separated couple

reacquaint themselves, Cary becomes suspicious of the man with whom Irene was shipwrecked (played by Randolph Scott). How could they be stuck on an island together for seven years without any messing around?

Cary's first glimpse of his competition happens as Randolph executes an impressive dive off the high board into a hotel swimming pool. When the three sit down for lunch, Cary seems desperate to pick any sort of hole in the man's genial and confident demeanor (especially when he finds out they've spent the past seven years jokingly calling each other "Adam" and "Eve.") His perfection is infuriating. When the waiter recommends the turkey à la king, Cary turns to Randolph with a steely glint in his eye. "Does turkey appeal to you, or do you confine yourself to *raw* meat?"

"Never touch it," the man replies blithely. "I am strictly a vegetarian." He proceeds to order "a glass of carrot juice, a milkshake, and some raw carrots" (your clue that the screenwriter would have ordered the turkey). Randolph tells Cary that while he and Irene never behaved dishonorably on that desert isle, now that Cary is about to be remarried, he'd like to marry Irene. "I've known your wife for seven years," he says, "and no man could ask for a better companion, a truer friend, or a more charming playmate."

"Isn't he impulsive?" Irene laughs, and Cary loses his temper. "Impulsive? *He's full of carrots!*"[16]

Randolph's character is strong, handsome, easygoing, respectful, and sincere, but the audience knows he doesn't stand a chance. Cary's jealousy is comfortingly realistic, whereas a man such as Randolph could not *possibly* exist in real life.

Popular culture loves to paint vegetarians—never mind vegans!—as humorless clods strapping themselves to an impossible ideal, and they've been doing it since Pythagoras[IV] (who isn't nearly as well known for his ethical vegetarianism as he is for $a^2 + b^2 = c^2$). One of the more notorious examples in the history of animal-rights activism is Henry Brougham's dressing-down of Joseph Ritson, author of *An Essay on Abstinence from Animal Food, as a Moral Duty*, in the *Edinburgh Review* in April 1803. Not only was

IV Since Pythagoras was the most renowned vegetarian of the ancient world, we were called "Pythagoreans" before the word "vegetarian" was coined in 1842.

Ritson writing his treatise using quill-feathers stolen from geese and oak-gall ink (inevitably containing crushed insects) by the light of oil from slaughtered whales, but as Tristram Stuart wryly recaps, the author (along with every other human who ever lived) was "murdering whole ecologies of microscopic organisms every time he washed his armpits."[17] Ritson wore wool and leather, drank milk stolen from calves, and ate eggs that should have grown into chickens.

Brougham was right. There are animal byproducts in all sorts of things I use, from the tires on my rental car to the glue that holds my secondhand furniture together. The lettuce I buy at the grocery store might be grown using fertilizer made from cow manure. If I were to adopt a cat, I'd have to feed her meat because cats are obligate carnivores. I'm killing ants and God only knows how many more creatures every time I go for a walk in the woods.

So why am I sticking with this lifestyle if I can't do it perfectly? Why even bother?

Because Donald Watson and his Vegan Society cofounders knew full well that none of us could possibly "do" veganism to perfection. That's why they defined it as "a philosophy and way of living which seeks to exclude—**as far as is possible and practicable**—all forms of exploitation of, and cruelty to, animals for food, clothing or any other purpose."

If I had said, "I must write the perfect novel; my prose must be as shiveringly gorgeous as Angela Carter's, my world-building as visionary as Octavia Butler's," then I'd turn into that character in *The Plague* by Albert Camus, who pens the opening paragraph of his magnum opus and spends the rest of his life fussing over it. People like Henry Brougham see the imperfect mess of real-world living as a convenient escape hatch: there's no dodging hypocrisy, so it doesn't matter if we engage in the avoidable forms. The person who lives his life by this line of thinking most likely won't ever recognize its destructiveness—not even on the day he finds he can't lift himself out of his favorite armchair, his feet swollen and purple with gout and his arteries hardened to caulk.

There's always been a great deal of avoidable harm in the arts too: the living animal body transformed into a glassy-eyed

unmoving copy of itself, a delicate design etched into the tooth enamel of the sperm whale, the ivory tusk fashioned into piano keys. Scrimshaw and taxidermy have long since fallen out of fashion for ethical reasons, but there's plenty more that's not so obvious: the mink and camel hair in our paintbrushes, the glue made from marrow, the ink from bone char, the ox gall in the box of watercolors. All the trees felled to bear our words or the tubes of dried-up acrylic paint destined for the landfill. We don't like to linger on how much destruction has to happen to make our creative pursuits possible, but why destroy more than we have to?

The justifications for continuing to eat and use animals seem to parallel the justifications I hear for why they're not following through on the art they once seemed so eager to make. "I'm not good enough." "This is just the way I'm built." "I could never do what you do." I feel saddened and frustrated by their defeatism—which is, in essence, not much more than egotistical problem seeking. They look at me and see the straight man who wouldn't lay a finger on somebody else's exceptionally pretty wife in seven whole years of solitude, a person who orders carrot juice for lunch. If the standard is impossible, it's much easier to let themselves off the hook.

As counterintuitive as it may seem at first, going vegan has made me *less* of a perfectionist. Much of this mellowing out has to do with what I call "ego management." No one ever enjoys realizing they're wrong, that they've been laboring under a misapprehension, and so, this lifestyle has helped to crystallize a fundamental truth for me: that I can't truly grow before owning up to my flaws.

I understand now that my skills are best put to use in advocating for those who cannot speak for themselves, at least not in any human language. Even when I'm writing fiction that seemingly has nothing to do with animal rights, I keep in mind something Plath once wrote, that "perfection is terrible, it cannot have children."[18] A fertile mind is an intricate tapestry of contradictions and desires that are, as Brougham put it, "lamentably incongruous and motley."[19] But perhaps our consistency lies in always aiming to do better.

Go On, Ask for the Carrot Juice

Think of a person for whom you feel an intense admiration, someone you've always wanted to be more like. Maybe they devote much of their free time to an important cause, or they're amazingly productive and fulfilled in their work, or they just seem so darn happy *all—the—time.*

If you actually know this person, take a deep breath and ask if you can speak to them candidly for a few minutes. Tell them how highly you regard them and ask if they have any advice to offer you. If this person is a celebrity or someone else you can only observe at a distance, spend some time searching online for any interviews they've done or pieces they've written about their background, beliefs, and motivations.

Either way, the chances are exceedingly high that this person you revere isn't some kind of superhero who lives up to impossible standards—that the qualities you most admire in them are qualities you can cultivate in yourself.

© Marinksy, *Tale*, watercolor and acrylic, 2016.
@marinksy.paintings

Lighting the Lamps in the Mind and Heart

Sticking point #4: "I hyper-caffeinate to fend off chronic lethargy. Even when there's time to create, I don't always feel mentally or emotionally up to it."

Google "creativity" and "diet" and you'll find a series of articles promising optimal brain performance if you eat from their recommended list of "superfoods." All kinds of berries. Nuts and seeds. Whole grains like oats, quinoa, barley, and amaranth. Avocados. "Sulforaphane for the brain," as raw-food coach Karen Ranzi says: cruciferous greens like broccoli, kale, brussels sprouts, and spinach.[20] Cauliflower and broccoli sprouts are especially rich in this cognition-boosting (and cancer-fighting) phytochemical.

The only animal foods nutritionists ever seem to recommend for brain health are eggs and salmon (or cold-water fish in general). When I was a kid, my father often quoted a doctor on the radio who asserted that eggs are "nature's perfect food," but clinical researcher and professor of medicine Dr. Neal Barnard has since dubbed them "the incredibly inedible egg," noting that one egg has as much cholesterol as a Big Mac.[21] Eggs make the list only because they're high in choline, a vitamin essential for brain and liver health, but you can get adequate doses of choline from collards, broccoli, cauliflower, brussels sprouts, asparagus, tofu, quinoa, and other plant sources instead.

As for salmon, the fish flesh you purchase at the supermarket most likely comes from intensive-confinement farming operations in which the poor creatures are forced to swim in their own feces. The types of omega-3s for which fish consumption is touted—DHA and EPA—actually come from the algae the fishes eat, and the human body converts a certain amount of ALA to DHA and EPA. So even if we're not sure we're getting all the omega-3 fatty acids we need from ALA-rich walnuts, flax, leafy greens, and other land sources, we can use algae supplements for DHA and EPA instead of fish oil, which tends to go rancid (and may be tainted with mercury).

Scientists have found that a traditional Mediterranean diet—high in vegetables, fruit, beans, and nuts—may lower your risk of Alzheimer's and cognitive decline in general. "When researchers tried to tease out the protective components, fish consumption showed no benefit, neither did moderate alcohol consumption," writes Dr. Michael Greger, a medical doctor who specializes in clinical nutrition. "The two critical pieces appeared to be vegetable consumption, and the ratio between unsaturated fats and saturated

fats, essentially plant fats to animal fats."[22] Greger recommends a vegan diet in bestselling books like *How Not to Die*.[V]

When you live by the standard Western diet—with super-high cholesterol and saturated fat from red meat, poultry, eggs, and dairy—all that gunk has to go *somewhere*, so over time it turns into plugs in your arteries and plaque in your brain. The effect is the same even if you consume these foods in moderation. So, if you want to keep coming up with brilliant ideas well into your golden years, quitting animal products is the best decision you can make. Mind you, I am not a nutritionist, but I have been vegan for seven years now and my thinking has never been clearer.

Kerry Lemon, a very talented and prolific illustrator from the UK, reports the same since going vegan four years ago, and she also experienced a more consistent energy level. "I no longer have the three o'clock slump, and heavy feeling after meals," she wrote me. "I used to have to plan creative activities for the mornings when I was at my best but am now able to work creatively at any time."[23] Artist and vegan lifestyle coach Vicki Brett-Gach concurs: "I have more creative energy (and feel it more consistently) than I had before I was vegan…now, I practically bounce out of bed in the morning and cannot wait to dive into my creative work. And I long for it like I never had before on the days when my schedule doesn't permit [it]."[24]

Physiological recalibrations occur whenever you make a long-term change in your diet, but when you go vegan, the cognitive shift is even more remarkable. "Not only did I lose weight, I also noticed better mental clarity," Adama Maweja writes in her essay "The Fulfillment of the Movement." "My mind opened up. It was as if I'd been in a dark room or tunnel, when suddenly a bright and brilliant light was turned on. I went to class, paid attention, and understood things at another level. I no longer had to labor over my books as before. I began to ask questions and make points that could not be countered. I could hear what wasn't being said and could read between the lines."[25]

V Incidentally, America's most famous pediatrician, Dr. Benjamin Spock, recommended a plant-based diet for children in his seventh and final edition of *Dr. Spock's Baby and Child Care*, published in 1998 (two months after Spock passed away at nearly ninety-five). Spock himself had begun eating vegan in 1991 after a series of illnesses, and in those last seven years he enjoyed a fifty-pound weight loss and increased mobility.

My experience was much like Maweja's, especially the light I saw above my head during that pivotal conversation with my friend Jamey; though in my case, it felt more like Dorothy stepping out of her black-and-white farmhouse into a world of technicolor. I felt like I'd been given a neurological upgrade: a brand-new mind, bright and clean. Ideas, *good* ideas, came rushing forth as they never had before—a leveling-up of what midcentury psychologist and creativity expert J.P. Guilford called the "fluency factor": "the person who is capable of producing a large number of ideas per unit of time, other things being equal, has a greater chance of having significant ideas."[26] Guilford also wrote that a creative act requires a change in thought or behavior and that creativity flourishes through mental flexibility, or a willingness to consider new ideas. In researching this book, I've shaken my head time and again at the wisdom we're encouraged to apply to every aspect of human life *except* the torture and consumption of animals.

But the clarity I experienced was primarily psychological. I began to notice all the myriad little lies we tell ourselves and each other. *I only eat animals that lived good lives. May all beings everywhere be happy and free, except those destined for my dinner. My diet is healthy because I want to believe it's healthy.* Feedback loops and confirmation bias became too obvious to ignore, like a spaceship landing in a public park in broad daylight. Over the past seven years, I've channeled these new insights into my writing, and while one could argue that my recent work is more fully realized simply because I am older and therefore more practiced, there is no other explanation for this sustained level of productivity when I once languished in those year-long troughs.

Put another way, the quality and quantity of my output increased with the quality of my input. When poet and musician Saul Williams taught a class at Stanford called "The Muse, Musings, & Music," he stipulated that each student had to go vegetarian for the semester in order to pass. Some were furious—they'd registered for the class expecting a famous slam poet to read their poems and pile on the praise. What the hell was *this* BS? Williams told the complainers,

Oh, you want me to monitor your creative output? Why would I want to dig through your shit if you're not paying attention to what's creating your shit? Why should I monitor what comes out of you if you're not monitoring what goes into you? You think there's no connection? What you read is your diet. What you watch is your diet. Channels? Dumb shit? That's your diet. What you listen to is your diet. What you talk about, what you *allow* to be talked about in circles around you? That's your diet. That's what you're ingesting…So you're digesting all this shit and trying to come up with something original? You're not surrounded by originality. How do you expect it to come out of you?[27]

I suppose someone who cares too much for propriety might be put off by the scatological nature of this argument, but Williams is spot on, in art and in general: owning our waste means taking responsibility for what we've chosen to put in our mouths (or let into our consciousness) to begin with. The old notion of passively waiting for the Muse to bless your efforts is now a matter of readying oneself by eating and otherwise living well.

In a piece called "Unleashing Creativity" in *Scientific American*, Ulrich Kraft offers "Steps to a Creative Mind-Set," chief among them being "Intellectual courage. Strive to think outside accepted principles and habitual perspectives such as 'We've always done it that way.'" [28] But I'm not too confident Kraft would apply his "intellectual courage" to the contents of his refrigerator. He continues: "To a degree, the brain is a creature of habit; using well-established neural pathways is more economical than elaborating new or unusual ones. Additionally, failure to train creative faculties allows those neural connections to wither. Over time it becomes harder for us to overcome thought barriers."[29] When people ask about my lifestyle and I reply with standard vegan logic, it's exceedingly rare that someone will respond to any of my points with "intellectual courage." More often than not, they ignore much of what I've said and walk away from the interaction thinking, "Camille loves animals. Isn't that nice." Those neural barriers are too reinforced.

On the other hand, we can use neural grooves to establish positive new eating habits. As vegan dietician Matt Ruscigno says, "It is really easy to stay in a rut and very difficult to get out of a rut.

We forget that it takes time, and that it's hard in the beginning… For those of us [vegans] who say it's easy, it's because we've developed *new* ruts." The one true challenge is in resolving to forge that new neural pathway to start with; we just have to persevere to the point where a new habit feels as natural and comfortable as a longstanding one.

We hear doctors' standard advice for slowing cognitive decline all the time: make a practice of doing things differently. Even good habits like cardiovascular exercise and oral hygiene should be practiced in new ways (like brushing your teeth in tree pose, for instance). Be deliberate about creating new neural pathways, they tell us—that's how we stay sharp. What we don't hear so often, though, is that changing your diet is the fastest, easiest way to a clear and fertile mind. It is a logical, specific change you can implement immediately.

Improving Your Input

Commit to a simple positive dietary change for at least one week: fresh juice or a smoothie in the morning *(see page 195 for a list of my favorite combinations)*, a big salad rich in plant protein for lunch, or fresh fruit instead of cookies or ice cream (if you like to work at night). Each day make a note of what you ate or drank and how you feel, both physically and about how your work went that day (being as specific as you can in your observations). If you didn't notice an appreciable difference, switch things up the following day: try a green smoothie instead of peanut-butter-and-banana, for example, or a three-bean salad with a tangy dressing instead of the vegan Caesar. Keep experimenting until you've found the foods that fuel you best.

Herbs and Spices to Light You Up

You probably already know that **ginseng** and **gingko biloba** are known to promote cognitive health, but the next time you're at your local health food shop, look for **gotu kola**, which is scientifically proven to oxygenate the brain and activate neural pathways. Adriana Ayales, owner of the Anima Mundi Apothecary in Greenpoint, Brooklyn, suggests shaking a daily "herbal cocktail" with raw coconut water, 1 teaspoon gotu kola extract, and ½ teaspoon flax or borage seed oil (for omega-3s). You can also drink gotu kola as a tea by decocting in simmering water for fifteen to twenty minutes.

In a *New York Times* interview, Serbian artist Ana Kras shares her recipe for a morning chai latte she says boosts her immune system and brings mental clarity.[30] Along with organic masala chai spice, ground vanilla powder, and homemade cashew cream, Kras recommends using Ayurvedic herbs like **ashwagandha** (dubbed the "Indian ginseng"), which several studies indicate may relieve stress and anxiety, and **mucuna pruriens**, a legume with anti-depressant effects; and powdered fungi like **reishi** and **cordyceps**. Kras, who is vegan, savors a cup of this "potion" along with toast and fig jam each morning before she gets to work. You'll spend a good bit of money at the health food store, she says, but the powders last a long time, and the mental boost is totally worth it.

Nothing gets me feeling full, cozy, and ready to write like a nice hearty vegetable curry with tofu or chickpeas, and it turns out that **turmeric**—"king of the spices" and an essential ingredient in curry powder—may fight brain plaque and keep nerve cells active as we age. Along with **cumin** and **coriander** (which also go into curry powder), turmeric boosts digestion. Adding freshly ground black pepper maximizes your turmeric absorption, and you can also juice fresh turmeric root for a "golden milkshake" or latte. Studies indicate **sage** and **lemon balm** can also stave off cognitive decline, so use these herbs in your cooking (or drink in tea form). **Ginger**, juiced or added to a curry or stir-fry, is another effective digestive aid; after all, the smoother things are moving down there, the more energy and attention you have for your work!

Whatever you're eating, make sure your meals are as colorful as possible—that's how you know your food is rich in phytochemicals, which are powerful antioxidants. In general, as vegan "artivist" Sara Sechi puts it, "A positive and colorful diet makes a positive and energetic individual."[31]

© Nicola McLean, *100% MY Wool*, acrylic, 2019.

Rendezvous with Fate

Sticking point #5: "I feel like I'm riding in the passenger seat of my own career (and life)."

Several years back I made a friend—a fellow writer, enormously talented—who quite enjoys her bacon and sausage, and over dinner one night, we got to talking about disease and genetics. "I already know how I'm going to go," she announced. (She was still in her twenties at the time.) "My family has a history of heart disease."

"People say that, but it's not your family medical history. It's the fact that you're all eating the same food," I argued. "You won't die of heart disease if you stop eating meat and dairy."

I'll never forget the look she gave me: the wide puppy-dog eyes, hands palm up, an exaggerated shrug. It was a gesture of utter helplessness. *No, really, it's out of my control.* Then she calmly took another bite of her shepherd's pie.

And I swallowed my frustration. My friend is every bit as intelligent as I am. I could have offered her plenty of scientific research to support my claim, had she asked for it: depending on which source you consult, only 5 to 10 percent of all cancers are genetic,[32] and even if you do have a genetic predisposition for cardiovascular illness, physicians like Dean Ornish and Neal Barnard have proven that eliminating animal protein will flip the figurative switch, even in cases where the disease has begun to manifest. Plant foods contain no cholesterol and tend to be low in fat. It doesn't matter if what you're eating is "lean," or "white meat," or "grass-fed free-range organic"—*all* animal protein promotes these diseases.

Why wouldn't my friend listen to reason?

Because as Jessa Crispin points out in *Why I Am Not a Feminist*, it's "[e]asier to think we are rendered absolutely powerless than to think we choose powerlessness because it is more convenient."[33] For many people, cutting out what have been comfort foods from childhood is too grave an inconvenience to contemplate. As my teacher Victoria Moran writes in *The Good Karma Diet*, "If you have the necessary information and you're still saying, 'I could never give up...,' listen to yourself. You're affirming weakness. There you are, created, the Bible says, in the image and likeness of God, and you're brought to your knees by a scoop of French vanilla."[34] The celebrated South African novelist J.M. Coetzee elaborates on this ubiquitous phenomenon of psychological enfeeblement in the foreword to Jonathan Balcombe's *Second Nature*:

> Ordinary people do not need to have something proved to them scientifically before they will believe it. They believe it because their parents believed it, or because it is accepted as so in the circles in which they move, or because figures of

authority say it is so. Mostly, however, people believe what they want to believe, what it suits them to believe. Thus: fish feel no pain.[35]

This voluntary disempowerment happens to a certain extent in our creative endeavors too. It's so easy to fixate on factors beyond our control—who is inclined to recognize and promote our work, how much compensation we're receiving compared to other artists—and in doing so, we fail to recognize the power we do have. If somebody whines because their novel or screenplay hasn't sold or if they plummet into existential crisis because nobody is buying their art, we tell them to pick themselves up and get back to it. We don't feel sympathetic toward those who don't do the work they need to do in order to succeed. Why do we expect people to take responsibility for their decisions in every aspect of life *except* their personal health?

Of all our cultural taboos, this I see as the most tragic. A heavy meat eater has a heart attack or is diagnosed with cancer, and we are expected to react with complete sympathy, as if the disease chose them at random. The patient's diet is "the elephant in the room," even as an orderly arrives with a lunch tray brimming with highly processed, chemical-laden animal products—right down to the cherry Jell-O jiggling in the little plastic cup.

Truth is—unless the options available to you are the result of systemic racism[VI]—your diet can never be a "personal choice," because what you choose to eat affects both the animals who die to become your dinner *and* every human in your life who will bear the burden of caring for you when you get sick. Blaming bad genes while continuing to eat food that research has proven time and again to be detrimental to our health would, in a saner world, be one definition of insanity. It makes me wish people would just come out and say "You know what? I love steak and hamburgers so much that I really don't care if I end up on an operating table twenty years from now." That, at least, would be honest.

VI It isn't a simple matter of "personal choice" even when fresh produce is available, as Starr Carrington writes in "Food Justice and Race in the US,". "Before imposing shame upon the consumer, one needs to truly analyze the difference between accessibility and affordability." (187) Check out Madrabbits.org for solid advice on eating well in a "food swamp" and/or on a fixed income.

And yes, there will always be anecdotes of spry centenarians who indulge in bacon and cigars on a daily basis, but as vegan dietitian Marty Davey quips, "Everybody has an Uncle Fred—the rest of us follow biochemistry."[36] It's not intelligent strategy to live as if you're destined to be one of the outliers.

This isn't a hypothetical, either. A colleague I met at a literary festival over a decade ago, a bestselling thriller writer, recently posted on Facebook that he is facing open-heart surgery. Needless to say, he is scared out of his mind, and hundreds of friends left comments with heartfelt wishes for his swift recovery. I wanted to be one of those friends. But if I were to message him and say, "Hey, once you get through this, look into switching to a plant-based diet, okay?", my concern might read too much like sanctimony. I can only hope this friend discovers the medical research on his own.

Kerry Lemon went vegan to help heal an illness, and looking back on that difficult period, she says, "I now feel oddly grateful that I became unwell and was forced to live a more ethical life."[37] So, you, the artist, have a critical decision to make—a choice you still make by changing nothing. You can take the risk of, twenty or thirty or forty years from now, logging weeks in a hospital bed awaiting triple-bypass surgery, enduring the indignities of Jell-O for lunch and your bottom hanging out of a skimpy blue hospital gown.

Or you could do what you need to do to ensure that at seventy, eighty, and ninety years of age, you'll be at your desk or easel or microphone where you belong.

Stepping into your creative destiny requires accepting responsibility for your actions (and inactions). Open your notebook and spend some time considering how you might be giving your power away.

Part two: are you able to see your creative practice in a more holistic manner—to recognize that sound physical health results in greater productivity and artistic satisfaction?

If you don't feel ready to eschew all animal products just yet, make a note of everything you eat for the next three days, including portion estimates. Then visit the USDA National Nutrient Database (https://ndb.nal.usda.gov) and make a note of the saturated fat and cholesterol content of each item. Tally it up. You may be shocked at what you find, especially if you like to think of yourself as a relatively healthy eater. Once you've switched to a vegan or mostly-vegan diet, you can use this site to tally up the protein content of everything you eat—and as long as you're eating balanced and colorful meals, that number will be a *pleasant* surprise.

New Channels of Thought

"Too many of my ideas don't seem worth executing. Maybe I have nothing new to offer."

For two decades now, a group of ten Viennese musicians have visited the local produce market in search of new instruments. One chooses a pumpkin to serve for her drum, another a large head of celery for a guitar, another a calabash for a horn. Back at the workshop, a flutist drills a hole through the core of a carrot of improbable size, which begins to resemble a woodwind instrument the more he labors on it. The members of the orchestra spend hours fashioning these vegetables into leek violins and cucumber-o-phones, and then they go on stage to perform original compositions inspired by Kraftwerk, John Cage, and Frank Zappa. After the concert, the audience is invited to partake of a stew made from every last scrap of produce that wasn't used in the performance.

When I hear someone lamenting their inability to come up with ideas that please them, it seems to me the artist in question needs to approach their work from a radically different angle. The underlying trouble isn't a lack of fresh or viable ideas (or talent), it's a deficiency of curiosity resulting from fatigue and/or discouragement, which can usually be remedied with a good night's sleep, a wholesome breakfast, and a block of time set aside for deliberate, yet spontaneous, exploration. You don't have to leave your house, or your kitchen. Food is the obvious place to begin reviving yourself. You are literally refilling your well, yes, but when you go out of your way to try something new, or when you prepare familiar foods in unfamiliar ways, you are forming new pathways in your brain that will eventually lead you out of your rut. After declaring that there is no such thing as originality, the adman John Hegarty writes in his book *Hegarty on Creativity: There Are No Rules*, "The value of an idea is in how it draws its inspiration from the world around us and then reinterprets it in a way we haven't seen before."[38]

I'm not an entrepreneur, but I find vegan food research and development incredibly inspiring. Tell these geniuses it can't be done—marinated soy protein you could mistake for real pork, or a cultured "cheese" that's as rich and tangy as a dairy product—and they will make it happen, even if it takes years and years of

trial and error. And if it hasn't been done yet, I promise you they're working on it.

What do innovative thinkers from Leonardo da Vinci to the Vegetable Orchestra have in common? A healthy disrespect for tradition. A tradition is self-justifying—*we should do it this way because we always have*—and while culture and tradition give us a vital sense of continuity and belonging, they also discourage innovative thinking. Over time any given culture must evolve into a wiser version of itself, and it's up to individual members to make that evolution happen. "I assure you, even though I avoid hides and furs and choose a vegan diet, my Indianness is critical to who I am," writes Linda Fisher, an artist with both Ojibway and Cherokee ancestry. Fisher points out that "[m]ost tribal people survived comfortably eating meat sparingly, while thriving on the cornucopia of the land… European influence introduced Native people to commercial trade, and fire power, and buffalo began to be killed in great numbers. Only recently has meat become an important staple."[39] Fisher proves that Native Americans can actively participate in their culture while opting out of those practices they find morally objectionable.

Many chefs are making it their life's work to create a more compassionate cuisine within their culture. Vegan soul food chef and author Jenné Claiborne emphasizes the surprising compatibility of the two traditions:

> Soul food cooking is all about optimizing flavor and texture. What we love and crave are the spices, the sauces, and the preparation style. Soul food is about seasonings (smoked paprika, Old Bay, celery, hot sauce) and preparations (smoking, frying, grilling, baking). You don't need meat and cheese for amazing soul food, and you don't even need mock meat and fake cheese—you can get outstanding results by applying classic soul food seasonings and cooking methods to vegan ingredients like fruits, vegetables, grains, beans, and mushrooms.[40]

Chef, author, and food-justice activist Bryant Terry is doing the same: focusing on classic soul food produce like yams, plantains, okra, and mustard and collard greens, and using traditional spice

mixes and marinades with tofu, tempeh, and jackfruit instead of pork and other animal flesh. Kiki Vagianos is working comparable magic with traditional Greek cuisine; Chloe Coscarelli and Pietro Gallo with Italian; Jean-Christian Jury, Alexis Gauthier, and Willy Berton with French, and so on. I have a vegan friend from Brazil, Vini, who still actively participates in those aspects of his native culture that do not conflict with his ethical beliefs. He's currently working at a vegan restaurant in Curitiba, so yes, Brazilian vegan food is very much a thing! The more you learn about the possibilities for gourmet vegan cuisine, the more you've got to wonder about the chefs who scorn it. What do they have to lose by trying something different?

When J.P. Guilford was evaluating a subject's creative capability, he'd ask, "Does the examinee tend to stay in a rut, or does he branch out readily into new channels of thought?"[41] By making your food choices outside the dominant paradigm, you're exercising flexible thinking without even trying. It's only by imposing so-called "restrictions" that we allow for the most ingenious workarounds.

Someone could write a whole book about vegan food research and development in the first two decades of the twenty-first century. The most surprising discovery of the past few years has got to be aquafaba (from the Latin for "water" and "beans"), the liquid from a tin of chickpeas (or other beans) that can be whipped into a downright miraculous egg substitute, ideal for meringues and other desserts vegans once thought they'd never be able to eat again. Aquafaba was "invented" in 2015 by Goose Wohlt, a vegan software engineer who's been conducting and taking detailed notes on his culinary experiments for many years now. Appreciating the efficiency of crowdsourcing, Wohlt started a Facebook group called "Aquafaba (Vegan Meringue—Hits and Misses!)," which is eighty-three thousand members strong at the time of writing. The more we share our results, the more delicious our lives will be.

Other vegan innovators are bringing their discoveries to market. There's Miyoko Schinner's exquisite farmhouse cashew cheeses, Violife's "parmesan" and "gorgonzola," and plenty more vegan cheese brands I enjoy almost as much; the Field Roast hazelnut cranberry roast en croute that makes for a very satisfying "Thanksliving"; various brands of soy or almond nog, which are light and delicious and won't make you feel queasy for drinking raw

eggs; classic ice cream flavors from Nada Moo, or fancier nut- and coconut-based ice creams from Coconut Bliss (cherry amaretto, ginger cookie caramel). Stanley Chase, founder of the Louisville Vegan Jerky Company, stumbled upon the perfect recipe when he accidentally over-baked the tofu he'd marinated in a spicy sauce from a traditional Hawaiian pork dish. Having the delightful suspicion he was onto something, Chase brought the jerky down to his neighborhood bar. "They devoured the fortuitous first batch and asked for more," he writes on the company website. "Where could they buy it? What was it called? And the best part…none of them even knew it was vegan."[42] Louisville Vegan Jerky is a pricey snack—a three-ounce bag retails for upwards of six dollars—but gosh, is it ever delicious, and best of all, no pigs were harmed in the making of it.

The growing market for compassionate foods is driving the slow-but-steady evolution in American culture. The *Wall Street Journal* and other papers reported in 2013 that many Southern farmers who've grown tobacco for generations are now shifting to chickpeas to meet the insatiable demand for hummus.[43] Queens-based Elmhurst Dairy, founded in the 1920s, moved to plant milk production exclusively in early 2017; I tried a "flight" of their new "milked nuts" at the Boston Veg Fest, and their hazelnut milk is pretty darn sublime. And along with surprisingly quick advances in "clean meat" (i.e., grown in a Petri dish using biopsied muscle cells), Big Ag is investing in plant-based substitutes because it's what people are buying (and many of these consumers aren't vegetarian, they're just moving in that direction). Beyond Meat makes burgers, sausages, and chicken strips that taste disconcertingly like the real thing, and their biggest competition is another California startup calling itself—with amusing irony—"Impossible Foods."

Impossible is a foolish word indeed, so you may as well quit using it in relation to veganism. Here's my theory: begin to experiment in the kitchen—as methodically or meanderingly as you please—and you will notice new tendrils of possibility unfurling in your primary creative practice. A year or two after going vegan, I found myself combing Google Books for vintage British cookbooks to see what kinds of dishes people were eating in Scotland in the late eighteenth century. When I discovered Susanna MacIver's

Jerry Drave, *How Vegans are Born*, digital comic, 2018.
@vegancomics

Cookery & Pastry—first published in 1773 after years of teaching cooking classes to young housewives in her Edinburgh flat—it occurred to me that, blood pudding and potted cow's head aside, I could veganize many of these recipes: potato fritters and almond custard, "green meagre" soup, and mock venison pasties filled with minced seitan marinated in red wine. And when I finally get back to the book that I needed this research for in the first place—the "gothic satire" I mentioned earlier—this culinary experimentation will hopefully render my Pythagorean characters all the more vivid.

Of course, there's no need to fall (however happily) down a research rabbit hole. "For a while I've followed the tenet that if I don't recognize a fruit or vegetable, I buy it and Google it when I get home to find some recipes," vegan web designer and podcaster Paul Jarvis writes in *Eat Awesome*. "This approach keeps things fresh and interesting in the kitchen."[44] Better yet, Google while you're still at the store so you can pick up anything else you might need for that recipe. Do you want to be the kind of person who bypasses the kohlrabi because it looks *weird*, or would you rather charm your friends with kohlrabi schnitzel? (That is a real recipe, by the way.

© Philip McCulloch-Downs,
Nurture/Nature, acrylic, 2019.
@vegan_artivist and @mr.cronch

You'll find it on the blog *Elephantastic Vegan*.) Look for liquid smoke, too, which is just the condensation from a hickory-wood fire. When I made a pot of split pea soup and added half a teaspoon, one of my meat-loving relatives went on and on about how delicious it was. It had never occurred to her that split pea soup could be just as satisfying without ham.

Leonardo da Vinci—a vegetarian, and surely one of the most innovative thinkers who ever lived—conducted his artistic and scientific experiments with what he called *ostinato rigore*, "obstinate rigor"—a daily practice of following his curiosity wherever it might lead him.[45] And should we do the same, that obstinacy *will* carry us to inconvenient places from time to time; but when it does, we're bound to come up with an idea worth getting excited over.

Divergent Thinking in the Kitchen

J.P. Guilford is best known for the concept of "divergent thinking," in which you generate as many solutions to a given problem as you possibly can. So, play this game with yourself (and maybe with your partner), especially when you're running out of groceries: how many delectable meal options can you find for what's already in the fridge and pantry? With its inherent values of curiosity and open-mindedness, veganism fosters divergent thinking—as opposed to the "one right answer" of the standard Western diet. After all, there's so much more to the culinary world than three sections on a plate marked "protein, vegetable, and starch"!

Ordinary Cruelty

Sticking point #7: "Before I can begin my work, I have to be thoroughly prepared against any pratfalls by which I might humiliate myself."

I've never met an artist who didn't have an anecdote to share about childhood bullies, though some stories are more infuriating (and heartbreaking) than others. In her book, *Beasts of Burden*, vegan artist and activist Sunaura Taylor, who was born with a condition called arthrogryposis, recalls how her classmates taunted her for "walking like a monkey" and excluded her from playground games in which she could have easily participated.[46] My experiences were mild in comparison: a drawing of a dog on the sewing-room chalkboard labeled "Camille"; acrylic paint chips thrown at my head in art class whenever our teacher turned his back; an enormous dead insect left stinger-side up on my chair in Latin class with a note that read *SUCK MY GLADIUS*. Even now, at the age of thirty-seven, my stomach drops whenever I hear teenagers laughing in the street. It depresses me to think of all I haven't said or done for fear of ridicule, then *and* now.

Last fall, I went for a three-hour drive with a friend who was starting the audiobook of Brené Brown's *Daring Greatly*, and as we listened to Brown's explanation of what she calls the "Viking or Victim" mentality, I remembered not just those bullies from my middle and high school years, but the teens since then who have committed suicide after one too many run-ins with Internet trolls, the students and teachers gunned down in their classrooms, the unarmed Black men and women murdered by the police. Brown writes, "Either you're a Victim in life—a sucker or loser who's always being taken advantage of or who can't hold your own—or you're a Viking—someone who sees the threat of being victimized as a constant, so you stay in control, you dominate, you exert power over things, and you never show vulnerability."[47] Time and again, my parents would say the kids who mocked me were only diverting attention from their own insecurities, but, even as a child, that explanation struck me as inadequate. The "Viking or Victim" mindset is encoded in our most fundamental patriarchal notions of what it means to be human; it is a very old (and thus taken-for-granted)

paradigm dictating that you cannot empower yourself without disempowering someone else. In *Daring Greatly,* Brené Brown also writes that "cruelty is cheap, easy, and chickenshit,"[48] but I can only agree with her to a point. Eating and wearing animals are the easiest cruelties of all.

© Jerry Drave, *Song for a Lost Home*, digital illustration, 2018.
@illusdrave

It is no great stretch to suppose that we learned how to dominate and brutalize our fellow humans by practicing first on domesticated animals, controlling every aspect of their reproduction before violently ending their lives. The connections are blatant: Southern plantation owners treating humans like livestock; Black Americans "animalized" in various ways by white supremacists to this day; Jewish people transported to the Nazi death camps in cattle cars; the US Department of Homeland Security literally caging children they've separated from their parents; Donald Trump saying

of "undesirable" immigrants, "These aren't people, these are animals."[49] A figure like Trump draws power from victimizing others, in this case by denying these "aspiring Americans" their fundamental needs.

To come to terms with the various ways in which the "Viking or Victim" psychology has affected our emotional and creative lives, we must acknowledge that we ourselves have practiced cruelty by proxy. Behind the bacon is a creature who has suffered tail and ear clipping and castration, all without anesthesia. Behind the breakfast omelet is a system in which the boy chicks, "useless" to the industry, are thrown into a trash can or ground up in an industrial macerator, and in which chickens' beaks are cut or burned off (again, without painkillers) to prevent them from pecking each other out of sheer frustration inside their tiny battery cages. Behind the milk is a mother whose children have been taken from her again and again until she is too worn out to continue—so that she may very well be inside your hamburger as well. All of these animals endure excruciatingly painful lives in cramped and filthy conditions (lying or standing in their own and others' feces) before they are slaughtered on dis-assembly lines. If you are brave enough to search for it, you may find footage of slaughterhouse workers kicking the animals who struggle, screaming and cursing at them, stabbing at their soft bellies with pitchforks. These men, in turn, have been bullied by their corporate overlords.

Here is the truth of it then: I would be teased and mocked at school, and then I would come home and consume fried eggs and meatballs, chocolate chip cookies, and tall glasses of milk. I was complicit in a system of cruelty I thought I would have done anything to overturn if only I were older and stronger and smarter. Now I have grown into that person, and I want to know why we who are brave enough to be vulnerable don't recognize the feelings of the most vulnerable creatures of all. We artists are supposed to understand better than anyone how cruel it is to mock or bully people who don't think or act or look like we do. It is our empathy that allows us to render our characters alive enough to cheer for, real enough to cry over, but something's not connecting. In 2010 a scientific study (organized by the neuroscientist Massimo Filippi) indicated that the brain activity of those who accept the moral argument in defense of animals is more responsive to images of both human and animal suffering than that of meat eaters. In reaction to the torment of

another, the vegetarian brain lights up where the omnivore's brain does not.[50]

In his book *Flow*, Mihaly Csikszentmihalyi doesn't put too fine a point on it: citing bull and dogfighting, gladiatorial combat, boxing, and other displays of culture, he writes that "cruelty is a universal source of enjoyment for people who have not developed more sophisticated skills."[51] This is true not just of the pint-sized brutes who terrorize the schoolyard—already living a stereotype at the age of seven or ten—but of those who have not refined their critical thinking to the point that they are able to discuss our treatment of animals without resorting to hostility or contortioned logic. Ashley Capps wrote a poem about a cow she saw in a pasture every day for months until one day she wasn't there and never would be again—"A hip pulls / loose, shoulders dismantle in the hands / of some masked worker. There is nothing / in this world that loves you back"—and to dismiss these lines as sentimental would not be a "sophisticated" response.[52]

Most humans are able to look back with a sense of perspective on the insults and bruises they've received. I was lucky to have parents, stepparents, and other family members who consistently nurtured my self-esteem, and I never had cause to feel unsafe or unloved. They told me life would get easier, and it did: as I grew up, I cared less and less what anyone might think of me, my writing, or any of my other creative efforts. It's never going to get easier for the animals, though. They can't ever transcend their tormentors so long as people like us are still eating and wearing the products of their bodies. As German activist Malte Hartwieg says, "You like farm animal rescue stories, but you're not vegan? Do you realize that those farm animals are being rescued from *you*?"[53]

The artist who offered this "sticking point"—a photographer, scriptwriter, and blogger, a very nice man who was likely bullied in school far worse than I was—is the kind of omnivore who agrees with every vegan-themed post I put up on social media. Habit is the only thing holding him back from going veg, and I suppose he manages to put those thoughts out of his head when he sits down to dinner. But to me, this doesn't seem so different from standing by silently while the class jerk beats up your best friend. "Teach us to care and not to care," T.S. Eliot wrote in "Ash Wednesday,"[54] and this is the paradoxical path of us sensitive souls: to care less about what the trolls and bullies

say and think, and care *more* for those on the receiving end of the torment, even when they don't look like us.

Recalibrating Your Language

Begin training yourself to notice the cruelty encoded in many of the words and figures of speech we take for granted. "Killing it" and "crushing it" have entered the popular vernacular as a way of saying someone is doing really well—but killing or crushing *whom*? (It turned my stomach to see the photo a high-school classmate posted of his two-year-old daughter holding a small fish at the end of a line. "She's killing it!" he enthused. *Indeed, she has.*) Notice when you or the people around you inadvertently use language that demeans animals or other humans, and consider how you might express the same idea more compassionately: "kill two birds with one stone" can become "feed two birds with one hand," "killing it" can become "acing it," and so on. Colleen Patrick-Goudreau dives deep into animal-related language and etymologies in her *Animalogy* podcast, which I highly recommend.

Here's another example, a line I love from Henry Lien's novel *Peasprout Chen, Future Legend of Skate and Sword*: "How tenderhearted he is to love even things that are so different from us."[55] Peasprout is only just waking up to the truth of animal suffering; in the future she will not refer to animals as "things," and she may say "who" instead of "that." It may seem like a small matter, but referring to an animal as *she* or *he* instead of *it* de-objectifies and dignifies that animal (even if you're not sure of the sex; I don't know about you, but I'd rather be called a *he* than an *it*!)

Wallpaper Girl

"This market is so saturated that it's more important than ever for me to position myself to STAND OUT."

In early 2015, I met a friend of a friend with a presence that was warm and familiar, and when I found out what he does for a living, I felt a cosmic tap on the shoulder: *you need to work with him.* Tim is more than a coach or a therapist; his approach is a combination of talk therapy, life coaching, and energy healing, which sounds like baloney until you experience it for yourself. I wanted to tell more meaningful stories, to write books that would truly help and inspire people (in addition to entertaining them), and I wanted to feel that I deserve to make an adequate living from my writing.

In our epic monthly sessions, we worked on all that and more, and I felt more clear-headed and empowered than ever. But when Tim would say things like "I see you becoming a voice for the women's movement," a small but undeniable part of me wanted to

Alfredo Meschi, Project X. Photo by Sara Morena Zanella.
@alfredomeschix

shrivel up and hide under the futon, so we had to examine that too. Tim occasionally hosts personal-growth workshops at his home—a cozy nineteenth-century farmhouse north of Boston—and during the one I attended, we paired up and sat facing one another making steady eye contact, taking turns "witnessing" and "being witnessed." When it was my turn to be witnessed, I gave in to the urge to take off my glasses so that my partner's face was fuzzy. This way I wouldn't have to look at her looking at me. "This is stupid," I whined to myself. "What the hell is the point of this?"

By the end of the exercise, I was longing to remove myself from the room. I said "excuse me," as if I were only going to the toilet, and instead I hurried down the long corridor to Tim's dining room and ducked under his massive antique table, where I cried as quietly as possible. In my world, it doesn't qualify as a revelation unless accompanied by copious amounts of tears and snot.

A little while later, Tim—that blessed man!—came into the dining room and sat down on the carpet beside me. "I thought it was odd that you seemed so resistant to that exercise," he said gently. "Well, now we know you're afraid to be seen."

Even if you're not a visual artist, I bet you have recurring images in your head just like I do—pictures I may someday get around to drawing or painting if I don't outgrow them first. The most resonant of these is from my teenhood, a self-portrait in which my skin matches the pattern of the intricate William Morris paper on the wall behind me. A paradox still asking to be painted in oils.

It defies logic, I know. I wanted so badly for my novels to be "taken seriously," yet I felt nervous and embarrassed whenever I received a glowing review or an invitation to appear at a bookstore or festival. I'd like to have a larger following on social media so that more people have the chance to read my helpful books—this one and *Life Without Envy*—but the prospect of having to manage the inevitable snark and trolling, perhaps multiple times a day, totally turns my stomach. I want to "stand out," but it's more important never to feel exposed or unsafe—or at least this has been my subconscious reasoning. When writer and cultural critic Jill Louise Busby posted a video in which she says, "We are obsessed with comfort and security, and that is not revolutionary," I felt a sharp tingle of recognition.[56]

There are several reasons why I haven't been comfortable making myself "too visible," too many to delve into here. The point is that we can't fulfill all the good we're capable of if we're too afraid of being insulted or laughed at or willfully misunderstood. It's one thing to "play small" to avoid making your partner, parents, or friends feel insecure (to the point of resentment, perhaps) that you've become more successful than they are; it's an understandable impulse though it serves no one. But when you can't find it in you to clear your throat and say what needs to be said, to stand up for those who aren't able to stand up for themselves, you fall into line with all that is conveniently unjust in this society. Same goes if you are seeking recognition in order to feel wanted and adored—if your art ultimately benefits no one but yourself.

When we feel the drive to announce ourselves, to take up space and snatch a few precious seconds of attention for our work, it is a useful exercise in ego management to consider the forced invisibility of others. Hip-Hop Is Green founder Keith Tucker introduced me to the concept of symbolic annihilation, developed by George Gerbner in 1976 to describe how members of underprivileged groups are underrepresented and misrepresented in the media—if they're represented at all—using stereotypes and denying individual identities in order to maintain our current system of social inequality. In 1978 sociologist Gaye Tuchman expanded on the concept, writing that symbolic annihilation manifests in three ways: by omission, trivialization, and condemnation. "That's why you don't see me on TV," Tucker says. "You don't see [hip-hop artist] KRS-One's music playing anywhere. You don't see other artists who are talking about meaningful things...it's been omitted."[57]

But Tucker would agree that no one is less seen than animals in factory farms; as the adage (usually attributed to Paul McCartney) goes, if slaughterhouses had glass walls, most people would choose vegetarianism. When you look down at your breakfast plate, you don't see the filthy crowded cages in the eggs or the dis-assembly line in the bacon. In your cheese or yogurt or veal, you don't see the calf torn from his mother's side, crying out for her milk and her warmth and comfort. It is a bizarre thing that an artist like me should want so ardently to be seen and appreciated while supporting these invisible cruelties.

Some artists look for ways to draw attention to themselves for the animals' benefit. PETA's been doing this for years with commercials featuring celebrities like Mya, Mayim Bialik, RZA, and Pamela Anderson, and these ads have been much more effective than their ill-conceived (and indeed racist) campaigns comparing factory farming to human slavery and genocide. You watch a talented singer like Mya twirling in a dress stitched entirely out of vegetable fronds, and when she tells the camera, "I no longer see product—I see process," you feel inclined to consider her point.[58] Another PETA activist, vegan chef Nikki Ford, uses her body to protest the use and abuse of circus animals. "She was a traffic stopper, for sure," wrote one journalist in Greensboro, North Carolina. "Nearly naked with her body painted like a zebra, Nikki Ford had men craning their necks for a look as she stood at the intersection of South Elm Street and East Friendly Avenue early Tuesday afternoon. But it wasn't her body that Ford or the two women with her wanted passersby to notice. It was the sign she held that read: 'Get Animals Out of UniverSoul Circus.' "[59] One might argue Ford is objectifying herself, but her message is far more memorable than if she were carrying it on a sign. Same goes for ANIIML, a musician, performance artist, and animal-rights activist who says, "I see the body as the most beautiful, most controversial, and yet most basic piece of art we are given to create with and from."[60] In her headshot, her left eye has been Photoshopped to look like a cat's.

Even more astonishing is Italian artivist Alfredo Meschi, who had forty thousand Xs tattooed all over his body (with vegan ink, of course) to symbolize the estimated number of animals killed for their flesh each second. He regularly posts photographs of his neck, arms, and torso on social media. "Yesterday was the first sunny and really warm day of spring in Tuscany," he wrote in one Instagram caption. "For me, it starts the period of the year when I can openly mourn the loss of our animal companions. Through public performances, peaceful vigils, bearing witness, I will offer my body to people's attention."[61] Meschi was inspired by Mexican artivists who paint their bodies to protest government collusion with drug cartels, but he felt compelled to create a more permanent statement. The choice to tattoo one's skin is an act of creative agency, and Alfredo's

decision underscores the fact that factory-farmed animals don't have *any* control over their own bodies.

Instagram is the ideal resource for discovering vegan artists from all over the world, and the #veganillustration hashtag is how I found Samantha Fung (@oneheartillustration) and Kate Louise Powell (@katelouisepowell)—young animal-rights artivists who present themselves with hair and makeup and clothing that is even more vibrant and colorful than their artwork. Posts of new work are interspersed with snapshots from animal-rights marches and community outreach projects. In making their physical appearance so remarkable, artists like Samantha and Kate ensure that you will also remember what they stand for.

Artists like these are often dismissed as attention seekers, but critics of animal-rights activists tend to search for any reason, logical or not, to invalidate the message in their own minds. On the contrary, writer and Our Hen House cofounder Jasmin Singer says that when we change our lives to include *all* animals within our circle of compassion, we naturally become less self-absorbed. For Singer, showing up for the animals means speaking candidly of the shame and self-loathing that come saddled with an eating disorder,

© Marinksy, *Better Half*, altered photograph, 2017.
@marinksy.paintings

and sharing how she's grown into a woman who can present herself to the world as "thick and grabbable and real."[62] When you watch her TEDx speech, you have the impression of someone who has distilled the best of herself into her feminist animal-rights advocacy. Singer knows that we each need to grow into who we need to be in order to do as we are destined.

Each of the artists I interview in part two put themselves and their work out into the world in a deliberate way in order to create this book. I wouldn't have found most of them without social media. As for me, my first big step away from the antique wallpaper is in writing these words—as Jill Louise Busby writes, "Truth fights for itself. If you're open to it, it will use you as a weapon"—though I know I'll need to show up online and in real life to promote this book in a bigger way than ever before.[63]

But I'm up for it. The animals need all the help they can get.

Sure, it would do you good to make a list of the scary putting-yourself-out-there kind of things you've been dragging your feet on, and it might just blow your mind to consider who else might benefit once you've stopped procrastinating.

But let's also take some time to deal with the "I'm too this" or "not enough that." Instead of focusing on what you perceive to be your faults or inadequacies, look at your great project of self-improvement this way: How can you become more of what you already are? In other words, focus instead on enhancing your strengths. Here's an example. A few people have told me over the years that my enthusiasm is overwhelming—that they can't be friends with me because they find me "too much." On the other hand, dozens more have said how much my energy inspires them and that they want as many books and blog posts and videos as I can put out. In front of the right audience my eagerness isn't a fault, which means my work here is in channeling that enthusiasm into ever more practical resources for those who will appreciate them.

The Well at World's End

: "There's never enough _____": time, energy, money, attention, praise, or love.

Maybe you've heard that Scottish folktale about a girl whose jealous stepmother sends her to gather water from the well at world's end with a sieve for a ladle; most versions are a mash-up of "Cinderella" and "The Frog Prince." The girl manages to find the well, but she has no clue how to fill the sieve until an enchanted frog instructs her to plug the holes with moss. I think of that story sometimes when mundane conditions seem to be conspiring against me: day jobs that gobble up precious writing time but don't provide enough

Alec Thibodeau, *Competition is Overrated*, screen print, 2018.

to live on, bank fees for not maintaining a minimum balance, an eight-year-old laptop that hopefully won't die before my deadline. Even when you manage to fill the sieve, your drinking water tastes faintly of mud.

In *Life Without Envy*, I wrote at length about the "scarcity mindset" that traps artists in a never-ending struggle for professional recognition, since there will never be enough accolades to satisfy everyone who strives for them. Lately, I have been reframing this outlook in terms of "real-world problems": not to say that a middle-class writer's want of money in the bank is insignificant compared to a scarcity of food or potable water (though it must certainly look so to one who is hungry and thirsty), but to empower the artist to respond to problems beyond her immediate sphere.

Now the artist replies, "I can make a small donation to an international relief organization, but apart from that token gesture, I can't really *do* anything to help." But that's not true. She can look at how corporations misuse our resources and how her own diet is supporting that system. For starters, it takes roughly 2,500 gallons of water to grow the feed crops to produce one pound of cow flesh for human consumption,[64] and as one *Newsweek* reporter articulated this ludicrously inefficient use of resources all the way back in 1981, "The amount of water used in the production of one pound of beef would be enough to float a destroyer."[65] While beef is the worst, all meat production is wasteful: one pound of chicken uses 815 gallons of water, and one pound of pork uses 1,630.[66] Compare these numbers to 25 gallons of water per pound for wheat[67] or 244 gallons a pound (or less) for tofu.[68] Dairy is extremely water-intensive too, with 683 gallons of water needed to produce a single gallon of milk[69] and 896 gallons to make one pound of cheese.[70] Eating vegan does make a difference, since it takes roughly 4,000 gallons of water to produce one day's food for a meat eater versus 1,200 gallons for a vegetarian and only 300 gallons for a vegan.[71] The US livestock industry uses two billion gallons of freshwater per day,[72] an appalling statistic given that at time of writing, the residents of Flint, Michigan, *still* have to use bottled water for all their basic needs. Not only is factory farm runoff the leading cause of water pollution (culminating in the dead zone in the Gulf of Mexico),[73] the

filth sickens low-income Americans (who tend to be people of color) because no one *wants* to live that close to a hog or cattle farm.[74]

Those gallons-per-pound figures seem abstract so long as water still runs freely from your faucets, but it is becoming increasingly difficult to ignore ongoing crises in the Middle East, North Africa, Cape Town, California, and elsewhere, and water-wealthy regions won't be very far behind. In a report on the environmental effects of industrial agriculture, researchers at the Center for a Livable Future at Johns Hopkins University explain, "In many parts of the world, irrigation is depleting underground aquifers faster than they can be recharged. In other cases, agriculture depends upon 'fossil aquifers' that mostly contain water from the last ice age. These ancient aquifers receive little or no recharge, so any agriculture that depends upon them is inherently unsustainable."[75] The Ogallala Aquifer—one of the largest in the world, stretching across eight states in the American Midwest—is being depleted at a rate ten thousand times faster than it can replenish itself.[76] Compared to crops raised directly for human consumption, animal agriculture squanders so much water that the World Resources Institute is predicting water shortages for at least 3.5 billion people—half the current world population—by the year 2025.[77] Analysts at the Food Empowerment Project note that "as scarcity increases, water's value as an economic commodity rises—and multinational conglomerates are only too eager to profit from this deteriorating situation by buying up water rights on every continent."[78] So, it's likely we'll see ongoing armed conflict over control of water sources, and as Dr. Breeze Harper points out in *Sistah Vegan*, these shortages and any resulting violence will disproportionately affect people of color.[79]

There is already enough food and water to sustain every human life, and in a fair and just world every human would have access to them. Because we wouldn't be forcibly reproducing livestock, land once reserved for feed crops could yield produce for human mouths. And if this line of thought sounds foolish and unrealistic, it's because our corporate overlords have trained you well. People who live and breathe for the pursuit of money will likely never understand how much we have to gain by taking less. "People feel empowered, it doesn't feel like a sacrifice. That's a huge shift,"

says *Cowspiracy* filmmaker Kip Andersen of the rising popularity of ethical veganism. "Whereas before, veganism may have been viewed like you were giving up something, now it's been reframed as what you gain: you gain health, you gain a greater sense of living in bounds with your values, you gain all the environmental benefits."[80] The scarcity mindset manifests in a variety of ways, but I believe the most tragic is the way we see ourselves in relation to animals. *We* are worthy of nourishment and kindness and moral consideration— not them. *Our* desires are valid—not theirs. *We* deserve comfort and safety—not them.

But what if we could find nourishment and kindness without denying safety and comfort to anyone else? Who would we be then? "Benevolence is not a commodity that needs to be distributed sparingly like cake or chocolate," writes Matthieu Ricard, a Buddhist monk who's been dubbed "the happiest man alive." "[B]y also loving animals, we love people better, because our benevolence is then vaster and of better quality. Someone who loves only a selection of sentient beings, even of humanity, is the possessor of only fragmentary and impoverished benevolence."[81] In this wealth-obsessed Western culture of ours, all that we set our eyes on is something to be possessed, consumed, and forgotten—and we *still* believe we don't have enough.

Here is the same voracious egotism that leads us to feel threatened or diminished by someone else's success, or to feel panic in the face of competition for an award we believe we deserve more than anyone else who is trying for it. The miserliness implicit in "what I eat is a personal choice" and "let me have my vices" is the miserliness encoded in our belief that our hard work should be rewarded in precisely the grandiose way we have envisioned it. It is an outlook of predation and entitlement and taking advantage instead of cooperation and caring and service. To heal this, we need only shift our attention from what we believe we are owed—more money, more time, more recognition—to what practical actions we can take to overthrow the *real* inequities. "This journey we're on is an exercise in expansion, not contraction," says Honey LaBronx, the vegan drag queen. "Only when we can open our hearts and minds and borders and beliefs, only when we're all playing the game called EVERYONE WINS, will we ever get anywhere."[82]

If I were to rewrite "The Well at World's End," here is how I would do it. The girl, realizing at once the futility of her task, absconds with a ladle from her stepmother's kitchen, going in search of the well at world's end because she has an inkling of just how much there is to see and learn along the way. She fills her bucket, makes friends with the enchanted frog, and all the way home she offers a generous sip of water to anyone who is thirsty.

Fun Ways to Puncture Your Scarcity Mindset

- Write and/or illustrate your own fairy tale in which the protagonist goes in search of something only to find they've had a wealth of it all along.
- Design a board game called "Everybody Wins!" in which there is still a motivation to play.
- The next time you pour yourself a glass of water, say a few words of gratitude before you drink it.

A Small and Certain Thing^{VII}

Sticking point #10: "Is my work important? Does it bring value or benefit to the one receiving the work?" or "My art feels irrelevant in the face of everything that's wrong with the world."

Of all the paradoxes in the creative life, this one might be the twistiest: continually questioning the value in what you do is the way to create meaningful work. I've talked this over with lots of creative folks over the years. One friend, a visual artist, points out that every new painting is an object taking up space, and she worries about creating something she'll eventually judge to be clutter. Another friend, a writer, questions the worthiness of her fiction—*Will it enlighten my reader in some sense? Does the work have to do that at all?*—to the point that she feels she's making very little progress. Another writer friend, a poet and playwright, sees an irresolvable tension between expressing your creativity to feel closer to God and the apparent narcissism of believing you have anything to contribute that hasn't already been said or done by superior artists.

In her essay "The Art of Truth-Telling: Theater as Compassionate Action and Social Change," vegan playwright Tara Sophia Bahna-James writes, "Theologian Hans Urs Von Balthasar suggested that in order for art to reflect truth (and not simply propaganda or pornography), it must not glorify itself but rather point toward God. I understand this to mean that all true art points to the Oneness of Beings."[83] I do believe a creative practice allows us to commune with some sort of divine intelligence—it seems like an obvious reason for just how delicious it feels to be in the "flow state"—but I also like to think that what you're doing can still be art even if you're making it out of mischief or general self-gratification. Bathroom graffiti of the "I was here" variety may or may not qualify, but in its simplest form, art is an affirmation of one's own existence.

There's nothing "less than" about making marks or sounds or stringing words together purely for the pleasure it brings us. Browsing one afternoon in the Fleet Library at the Rhode Island School of Design, I happened upon a book, *The Biology of Art*

VII After Leonardo: "Man has great power of speech, but the greater part thereof is empty and deceitful. The animals have little, but that little is useful and true; and better is a small and certain thing than a great falsehood." *The Notebooks of Leonardo da Vinci*, trans. and ed. Edward MacCurdy, vol. 1 (New York: Reynal and Hitchcock, 1938), 76.

by British ethologist Desmond Morris, about the drawing and painting of non-human primates. The scientists studying these gorillas, chimpanzees, and capuchin monkeys continually belabor the contrast between this art and that of human children; in toddlerhood the two are evenly matched, but as the human child grows, the sophistication of her images rapidly outpaces that of the chimpanzee. Yet the non-human artists are capable of great concentration and display obvious enjoyment in their mark-making. Is it *art*? I would like to bypass the human evaluator and ask the chimpanzee directly.

© Josephine Skapare, *Gamergate*, digital illustration, 2018.

On the other hand, it is not the chimpanzee's responsibility to play a part in fixing what is broken and corrupted in this world. Most of us humans aren't content to amuse ourselves; we want to create something *of consequence*, a story or a song so supernaturally exquisite that it whooshes the Great Pacific Garbage Patch clean out of existence while simultaneously restoring every species we ever drove to extinction— and if it can't do all that, then at least it can temporarily alter the reality of someone you will never meet.

This is going to sound sanctimonious—forgive

me!—but I like to think that the value of what you do is directly proportional to the virtue in who you are. Take Ben Franklin, for example. We remember him as an ardent abolitionist, but did you know that, as a young newspaperman in Philadelphia, he routinely printed ads for slave sales and descriptions of runaways? In *Benjamin Franklin: In Search of a Better World*, Haverford history professor Emma J. Lapsansky-Werner connects Franklin's decision to quit meat at the age of sixteen to his eventual willingness to recognize the evil of slavery:

> The experiment [of vegetarianism] had brought the advantage not only of allowing him to feel healthy and moral, but also left him more money to buy books. This anecdote…highlights his capacity to continually learn and grow through observation and experimentation, his ability to allow new insights to change his behavior, his penchant for disregarding or challenging his detractors once he became wedded to an idea, and his appreciation for serendipitous offshoots from principled behavior… His abolitionist posture, which he came to in the final decades of his life, reflects these same qualities.[84]

It is for all these reasons that Ben Franklin was the most creative and prolific of the Founding Fathers—because out of all of them, he was the one most willing to prove himself wrong. In his autobiography, he laid out a "plan for moral perfection" that centered around the cultivation of thirteen virtues, my favorite of these being Resolution: "Resolve to perform what you ought; perform without fail what you resolve." His method of record-keeping sounds like an eighteenth-century bullet journal. "[I]n its proper column, I might mark, by a little black spot, every fault I found upon examination to have been committed respecting that virtue upon that day. I was surpris'd to find myself so much fuller of faults than I had imagined; but I had the satisfaction of seeing them diminish." Choosing veganism has had the same effect on me: I have begun to see where I had been false without realizing it, and the various ways I could do better. I cannot create sympathetic characters with realistic flaws if I'm not continually seeking to understand my own. "I am not suggesting that within every artist beats the heart of a committed animal advocate," Bahna-James

writes, "but I do believe that the arts provide a safe space for accessing the compassionate muscle."[85]

Consistency wasn't among the thirteen noble attributes on Franklin's list, but I believe it's the most underrated virtue of all: when you say one thing and do another, you are acting against the significance of your contributions. Also essential is Franklin's thirteenth virtue, humility. So often, when people rationalize animal suffering, it's their egos doing the talking; they cannot bear to admit that our corporate overlords have duped them even though almost everyone else believed in Old MacDonald too.

I admit it often seems as if we vegans are trying to dictate to the rest of the world precisely how to eat and act and think, but I hope you'll permit me this distinction: I don't need to be right, but I do need to be *useful*. None of us were put here for Netflix and Doritos.

It seems terribly nebulous and cliched, this notion of "making a difference" with one's art, and it's true some folks use the platitude to position themselves as change-makers when they're mostly interested in securing a nice cushy piece of the status quo. Back in the day, a whole lot of people regarded George Bernard Shaw as an insufferable snob—his outspoken vegetarianism being just one symptom—but Don Juan's monologue in *Man and Superman* indicates, to my mind, that Shaw wasn't one of *those* so-called artists: "I tell you, as long as I can conceive something better than myself, I cannot be easy unless I am striving to bring it into existence or clearing the way for it."[86] *Something better than myself*: because a persona is but one facet of the person who dwells behind it, and I suspect that in private, Shaw was humbler than any of his contemporaries could have imagined. *Clearing the way*: for as they say, if the work can be completed in a lifetime, then it is not ambitious enough.

And here we sample another flavor of the same paradox: the belief in oneself necessary to conceive of a project that will outshine one's ability to see it through. If we are sincere in our intentions, we have to revisit the possibility—again and again—that what we have conceived of is not the vessel of beauty and renewal we would like for it to be; but if that's the case, it doesn't necessarily mean we have failed. Perhaps the most important project is in the asking.

A Plan for Moral Improvement

If you were to choose three or four virtues to cultivate in yourself, which ones would they be and why? It might help to start by reflecting on past behavior you remember with regret; consistency is at the top of my list because of the times I've made an expedient choice at the expense of my ideals (like when I've purchased a pain reliever without thinking about animal testing). When you've got your list, spend some time thinking and writing about how you might exercise these attributes, and by what specific metrics you can gauge your improvement. (For instance, when I go shopping, I can make a point of pausing to check the label before dropping any item into my basket, Googling for answers if need be. I can also investigate alternative remedies and stock my medicine cabinet with those instead. Another example is checking my balance each morning in my banking app to answer my desire to be more financially prudent.) You'll enjoy this if you're a nerd for bullet journaling!

FOMO or Faux Moo?

Sticking point #11: "I cringe every time I hear the phrase 'living your best life,' because I always have this twitchy suspicion that I'm not."

Raise your hand if you've ever been there: you watch an enviably clever creative collaboration birthed out of a networking event you decided not to attend; you look at someone else's incredible productivity and curse your own plodding work habits; another artist posts photos from a month-long residency in some exotic locale, and, as you troll their social media feed, you are kicking yourself for not applying. Why does everybody else seem so much more fulfilled in their creative work? Why is everyone else so much *savvier* than you are? In her book *Aphro-Ism,* Aph Ko writes that social media provides a false sense of control over one's own destiny, but this truth may not apply if you're too preoccupied watching what everyone else is doing (or *appears* to be doing) to post any carefully curated photos of your own.[87]

According to the Apple Dictionary, FOMO—an acronym for "fear of missing out"—is the "anxiety that an exciting or interesting event may currently be happening elsewhere, often aroused by posts seen on a social media website." We artists may be loath to admit this, but FOMO affects us almost as keenly as it does teenagers, concertgoers, and unrepentant capitalists. If we're not hopping on a plane every month or two to lead a workshop or give a keynote at some prestigious conference, if we're not the ones stumbling upon a bookshop-speakeasy inside a bombed-out department store somewhere in Eastern Europe and posting pics that immediately go viral, then we're tamping down the panic that we aren't "sucking the marrow out" of the creative life—that perhaps, someday, someone who hasn't been born yet will regard our careers as ineffectual or mediocre, if they consider our work at all.

If this fear motivates us to apply for grants and fellowships and implement more efficient work habits, it also results in the urge to join a queue before we even know what everybody's waiting for. The more you use your devices, the worse you feel it, since marketing and advertising execs—being human themselves—know precisely how to exploit our insecurities. "The one and only way to

protect yourself from ad manipulation is to work on your emotional intelligence," writes content strategist Oksana Tunikova. "Once your EQ is high enough, you will be able to recognize manipulation in a few seconds and decide, consciously, whether the proposition is right for you."[88] You might think it's easy to tell when someone is trying to manipulate you into buying a festival VIP pass or a three thousand dollar e-course, but things get murkier when said products appeal to your most cherished creative aspirations.

You may be surprised to find out who coined "sucking the marrow" as a life strategy: it was Henry David Thoreau, the world's most notorious wannabe hermit. He wrote in *Walden*, "I did not wish to live what was not life, living is so dear; nor did I wish to practice resignation, unless it was quite necessary. I wanted to live deep and suck out all the marrow of life, to live so sturdily and Spartan-like as to put to rout all that was not life."[89] The bonus irony is that Thoreau identified as a vegetarian—"I am by nature a Pythagorean"[90]—and while he did admit to occasionally catching and eating a fish, "A little bread or a few potatoes would have done as well, with less trouble and filth."[91]

What does it mean "to live what is not life"? Thoreau defines such an existence as "frittered away by detail":[92] allowing oneself to engage in frequent distractions from the central question of what it means to be alive in human form upon this earth at this particular moment, and to pretend those distractions are the answer. So, it seems as if most of us are misusing the phrase "sucking the marrow"; Thoreau knew he was only "missing out" on things that weren't worth experiencing anyhow.

Which is exactly how vegans feel about animal foods. My friend Meta Wagner, an arts professor at Emerson College, drove me a tiny bit bonkers when I read the following in her book, *What's Your Creative Type?*: "A-Listers take to competition the way a lapsed vegan takes to a hunk of sirloin—that is to say, with great gusto."[93] Meta has subscribed to the notion that artists are more sensual and appreciative of luxury than "ordinary" folks are, that not to partake of oysters and caviar and foie gras is to deprive oneself. But where you see a long list of things we vegans can't eat, we see a list of things that aren't food: I "miss out" on a steak or a bowl of ceviche in a

restaurant in the same way I don't get to eat a bowling ball or an electric pencil sharpener.

All the same, I need to remember what it felt like to be a vegetarian skeptical of veganism if I hope to convince anyone. Food-related FOMO may be the most powerful variety—owing in part to bearded-hipster culture with its bacon-infused everything and backyard DIY butchery—but for me it was always ice cream. My grandfather worked for Sealtest for decades, and sometimes he'd answer the home phone with "Breyers, what's your flavor?" Mine was mint chocolate chip. Much later on, while volunteering on a homestead farm in Vermont, I spent a blissful afternoon in a cabin in the woods—which my friend had built himself, plank by plank—and when he proffered a pint of artisanal mint chip ice cream from a local creamery, I decided that I could live quite happily without indoor plumbing.

Kerry Lemon, temporary tattoo design.
@kerryannelemon

But I didn't marry that guy, and I don't regret it. Several months later, I went to India, where it occurred to me that "not living what is not life" would mean eating ice cream made from soy and nuts and coconut instead, and, for the first couple years, I satisfied myself with what I could find in the freezer case in the natural foods aisle. And then I moved to Boston and discovered FoMu, as in "faux moo": a gourmand's paradise of dairy-free desserts. Cardamom pistachio, ginger dark-chocolate dukkah, golden milk, avocado, blueberry shortbread cheesecake. I have never brought an omnivore to FoMu who has not been willing to admit that this ice cream is as good or better than "the real thing." It is every bit as rich. There is another vegan ice cream parlor with a punny name, Like No Udder, right down the street from where I live on the East Side of Providence, and their owners are friendlier and more hardcore-for-the-animals. While they do have more elaborate flavors like Thai iced tea and "unicorn poop" (made with Skittles)—they were also one of the first companies to sell vegan soft serve—Like No Udder is the place to go for an old-fashioned neighborhood ice cream parlor kind of

experience (plus '80s power ballads and cat videos on endless loop). You go to FoMu when you're ready to swoon.

Recently I took the train to Boston with my friend Dan (whom you'll meet properly in part two), who'd been wanting to try FoMu ice cream for as long as he's been vegan. For lunch beforehand, we went to Whole Heart Provisions, a deluxe salad joint where you can have coconut curry and falafel and roasted Japanese eggplant topped with crispy-fried lentils and chickpeas on a bed of arugula and jasmine rice, with a choice of creamy, spicy dressings. A nine- or ten-dollar (compostable) bowl will more than fill you up.

As we feasted, I told my friend about this chapter I wanted to write—why Faux Moo is the antidote to "FOMO," all of it, not just the ice cream—and in talking around it I came up with a two-step cure. Firstly: when you feel FOMO, what is it about that particular experience that you desire for yourself? If somebody's doing something enviable, then apply for that residency or arrange the conditions for an adventure of your own, be it in Bali or Berkeley or the park down the street from your house. Explore, investigate, or do something bizarrely out of character and make art out of whatever results. Remember that you can't see and do and be everything there is to see and do and be, even in the span of a thousand lifetimes. So pick one thing at a time and *revel* in it.

The second step is going to sound corny, but I don't care: you have to commit to living the life that's in front of you instead of obsessing over experiences you are never going to have (like, say, being Beyoncé). I observed a good example of this as Dan and I hopped on the number 1 bus to FoMu's new location on Tremont Street in the South End. An elderly man in a wheelchair boarded the bus at Symphony Hall, and when the driver and another passenger helped him, he heartily thanked them both for their patience and respect. I spent the rest of the ride down Mass Ave watching the man in the wheelchair as he chatted brightly with the middle-aged couple sitting beside him. He told them he's a Vietnam veteran, although he didn't say if that's why he's in a wheelchair. "I wanted to grow old with my wife, too," he chuckled, "but I'm seventy and she's forty-three!"

Is this man "missing out" on plenty of amazing experiences in life? Absolutely. But it looks like he's not wasting much time crying over it.

We arrived at the new FoMu—which has dispensed with the charming hand-lettered menu board, alas—but they still had my two favorite flavors, mint chip and lavender, and both were divine as ever. Dan ordered two scoops of peanut butter chocolate cookie and we sat in upholstered armchairs by the front window, silent and rapturous. There was nowhere we would rather be and no finer food we could ever dream of eating.

No Animals Were Harmed in the Sucking of This Marrow

I find it kind of squicky that digital marketers are now using "JOMO" ("joy of missing out") to sell retreat packages and social media monitoring apps, but it's still a concept Thoreau would have approved of. Hide your smartphone and spend an evening making the art you're always saying you wish you had the time for.

To Learn Something Is to Lose Something^{VIII}

`© Immy Keys, tarot cards designed for the stop-motion animation film *Should I Be Eating Animals?*, hand drawn and digitally colored, 2018.
@immy.keys

Sticking point #12: "I feel vaguely uneasy, like I'm missing something important—some fundamental truth about myself that's hiding in plain sight."

Any student who hasn't dozed (or Facebooked) through Psych 101 can tell you what cognitive dissonance is—"the state of having inconsistent thoughts, beliefs, or attitudes, especially as relating to behavioral decisions and attitude change,"[94] a concept first defined by Leon Festinger in the 1950s—but they may not be so eager to look for an example from their own lives. Some dissonance is obvious, or at least it ought to be—the person who owns a dog or cat, claims to be an "animal lover," and thinks nothing of eating cows, pigs, and chickens even though *all* of these creatures think and show affection, seek comfort, and avoid pain. The discrepancy is not apparent to the vast majority of us because we have chosen not to see it, which makes sense given the heft of cultural and familial tradition and the coercive hypnotic effects of industrial capitalism.

Recently I was debating with a vegetarian friend on Facebook, and I suspected that some of his resistance to veganism originates in his long-term relationship with a meat eater who works in

VIII After George Bernard Shaw.

animal agriculture, at one point slaughtering pigs as part of her job; yet, she's always considered herself an animal lover ("She cried whenever she had to kill them," he wrote; but as one popular meme goes, "animal lovers who eat meat—that's like a cannibal calling themselves a people person.") "I don't feel I have cognitive dissonance," my friend told me, and I had to laugh out loud. "That's the point!" I wrote back. You don't know you're experiencing it until you notice something, or someone says something, that unlocks your perception. It's like looking at a chaotic mess of colors and shapes not knowing it's a Magic Eye until the hidden image presents itself.

If you Google examples of cognitive dissonance, you'll see mainstream psychology websites offering examples—a pack-a-day smoker calling himself healthy because he goes to the gym, losing even more money because you refuse to acknowledge you've made a bad investment—they generally ignore the love-animals-eat-animals paradox. Keep scrolling, though, and you'll eventually find some clear-eyed analysis. "When we compartmentalize conflicting beliefs, our brains are attempting to construct a rational framework under which our irrational and incongruent beliefs can exist harmoniously," the blogger Vegan Rabbit explains. "Humans have a deep desire to believe the best about themselves. We like to think of ourselves as good, smart, kind people. We like to be right. However, whether we are actually right is inconsequential, because believing we are right is more important to us than actually being right."[95]

Since we've been so committed to not connecting these dots—even one of my smartest friends is still fuzzy on the concept—we need to examine as many concrete examples of cognitive dissonance as we can, since we have to truly understand it before we can train ourselves to see it. Let's start with an example that has nothing to do with food.

Even if you haven't read or watched the *Harry Potter* series, you know the gist of the story, right? With the help of his teachers and classmates at a boarding school for magical study, underdog orphan battles the diabolical wizard who murdered his parents, along with said wizard's cult following of "Death Eaters." The novels go deeper than the standard epic battle of good versus evil, though.

As David Neiwert notes in his interview with *Harry Potter* actor Daniel Radcliffe, who also starred in *Imperium*, a 2016 film about white supremacists: "One of the most interesting things about the Harry Potter books and films is that J.K. Rowling really wove in a deeper anti-fascist message—the villain, Voldemort, was clearly a fascist prototype, and the whole cultural conflict was over 'blood purity' and dehumanization."[96]

Suffice to say, J.K. Rowling's political stance is left of center. Like the rest of us bleeding-heart liberals, she expressed her shock and anger in the aftermath of the Brexit vote and, a few months later, the 2016 US presidential election. One of her readers fervently believed that Donald Trump was the best thing to ever happen to America, and told her so in no uncertain terms:

> Just burned all my Harry Potter books after being a fan for 17 years. The Philosopher's Stone was one of the first books I EVER read.

> I'm upset it has to be that way. You embarrassed me, disgusted me, and I will never read your work again.

Rowling tweeted a screenshot of the girl's irate messages (having taken the high road by concealing the username and avatar) with the following remark: "Guess it's true what they say: you can lead a girl to books about the rise and fall of an autocrat, but you still can't make her think."[97]

In this and every other example of cognitive dissonance, the subject has invested an immense amount of intellectual and emotional energy in a particular belief system and, being so attached, will not consider any evidence of the flaws in that system. The ego is often employed to bolster this dissonance with even the flimsiest rationales, and the "sunk cost" of believing the lie goes deeper and deeper. You are cheating yourself, your art, and everyone who experiences it when you dodge this confrontation. How can you tell the truth when you're actively avoiding it?

I've been collecting examples of food-related cognitive dissonance for a good while now, but there's one anecdote that elucidates this concept in a way that is appallingly straightforward: in the summer of 2016, a woman in Wisconsin opened a package of bacon and found a nipple still attached. She was horrified. An ethical

vegetarian looks at that image pinging all over the Internet and thinks, "Well, *duh*. How could it never occur to her that bacon is part of the body of a pig, and pigs are mammals too?"[98]

© Immy Keys, *Put Your Ethics Before Your Ego*, hand drawn and digitally colored, 2019.
@immy.keys

We come into this inheritance the moment our parents give us a bottle of warm cow's milk to drink, and, as adults, we perpetuate the dissonance. The first and second time I read *Bird by Bird*, Anne Lamott's frank advice for aspiring writers was a balm and a comfort to me. The third time—after I went vegan—I couldn't get through the introduction. Lamott tells us that she and her writer friends feel more alive when they're writing than at any other time in their lives. "And sometimes when they are writing well, they feel that they are living up to something. It is as if the right words, the true words, are already inside them, and they just want to help them get out. Writing this way is a little like milking a cow: the milk is so rich and delicious, and the cow is so glad you did it."[99]

From earliest childhood we are made to believe in the wholesomeness of cow's milk, the innate goodness and simplicity of the family farm, but the plain truth is that like humans (and every other mammal on the planet), cows don't produce milk unless they've given birth. So, the cow is artificially inseminated, her baby stolen from her soon after birth, her mammaries tugged until her milk comes tainted with blood and pus. Perhaps we could plead ignorance in pre-Internet days, but today this information is widely and freely available to anyone with the courage to spend just ten seconds searching for it.

But the vast majority of us don't. So, it's not at all surprising that in a 2009 study, psychology student Alina Pavlakos found most five-year-olds do not understand where the meat they eat comes from. Pavlakos's professor, William Crain, drew upon her research in a paper aptly titled "Animal Suffering: Learning Not to Care and Not to Know." "They all knew they ate meat," Dr. Crain wrote, "but when asked, 'Do you eat animals?' most said, 'Nooo!' as if the idea were outrageous."[100] Children's author Jennifer Armstrong frames this problem-no-one-recognizes-as-such with singular poignancy:

> How does a child's developing moral/ethical self resolve the jarring disconnect between the animal books she is given to read in the library and the animal meat she is given for lunch in the cafeteria? What is she to make of the trusted adult who holds in one hand a living baby chick to caress with tender care and a chicken nugget in the other hand to eat with special sauce?[101]

If we come to our parents with questions they aren't willing to ask for themselves, their discouragement leads most of us to give up our nurturing instincts and accept the dissonant value system of the dominant culture.

In the seventeen-plus years since I quit meat, I have only heard one intellectually honest rationale for eating animals. A friend of a friend once said, "I admire you for being vegetarian. *I* couldn't do it. Steak tastes too good." Then came the moment of perfect candor: "I'm too selfish to give it up."

This girl was a rare bird in my experience: she'd developed a taste for what we call "the finer things in life"—several meals a week at gourmet restaurants, a wine refrigerator for her growing collection of fine French and Italian reds, eventually a Midtown penthouse—and she savored her economic privilege without ever rationalizing or excusing it. Most of us are good-hearted but essentially selfish humans, and when someone actually owns up to it, I have to give them props.

That friend of a friend proved to me that it is possible to eat animals without cognitive dissonance, but to do so requires a hardening of the heart the artist simply cannot afford—not if they are to practice their art with any real sensitivity or compassion.

As Saryta Rodríguez writes in *Veganism in an Oppressive World*, to untangle what the dominant paradigm has done to your brain, you have "to slacken your attachment to your own beliefs and preferred strategies (which are, to an extent, informed by socially unjust institutions in which reason really means what-white-cis-men-said-a-hundred-years-ago)."[102] Intersectional vegan activists like Rodríguez point out that this work is particularly critical for white people who are only just beginning to see the extent of their own privilege; the antidote, she writes, is to "allow yourself to actually be influenced by the ideas of marginalized folk." Perhaps the average white person experiences more cognitive dissonance than those who are clued into disparities of power from the get-go.

Cognitive dissonance is the method by which we enable ourselves to overlook not just that others are suffering, but the specific ways we have contributed to that suffering. Undoing such societal conditioning—critically examining one judgment or assumption at a time, over a sustained period of time—can only have a liberating effect on one's creative work too, because you're finally noticing all that this culture has trained you not to see.

Connecting the Dots

Take inventory of your bookshelves, your Netflix queue, even your kitchen catch-all drawer. Think back over the things you've scoffed at or regarded with wary unease. Seek out what you've been putting off reading or watching or otherwise paying serious attention to—and it may be that the longer you've been putting it off, the more urgently (in terms of personal growth) you need to read or watch it. For me, *Conversations with God* was a prime example, as was Peter Singer's *Animal Liberation*, which I found on the free bookcase when I was working as an editorial assistant right after college. That book gathered dust on my shelf for more than a decade, because subconsciously I knew that reading and understanding it would require lifestyle changes I didn't feel prepared to make. The purpose of this exercise is to locate and resolve those points of avoidance as a more deliberate route to personal growth. (And it doesn't have to be only books or films about animal rights, environmentalism, and human health, either; you can seek out intimidating new ideas in any subject at all. Racial justice is another great place to start.)

EXPERIMENTS AND EXPLORATIONS + CONVERSATIONS WITH VEGAN ARTISTS

A Conversation with Yitzy Holton-Hinshaw and Colin Weeks

Colin Weeks and Yitzy Holton-Hinshaw are best-friend singer-songwriters based in Montreal. We connected online after they both read my book *Life Without Envy*, and we've been following each other's work ever since. You can stream Yitzy's *Island Time* and *No Bad Days* and Colin's *Magic* on Apple Music or Spotify.

How did you guys meet?

COLIN: We went to music school at Selkirk College in Nelson, British Columbia, and became instant friends on orientation day.

YITZY: I knew I'd need friends in that little mountain town, so I turned on my social switch (not something I'm always able to do!) When orientation finished up, I dragged the four nearest people to a coffee shop.

COLIN: He was so weirdly confident, I had mixed feelings about him at first! After we dropped out, all of our friends moved to Montreal. We all live within a five-block radius. Yitzy and I are the only two in our friend group without significant others, so we've sort of buddied up. We're affectionate with each other, and people often mistake us for being a couple.

This is one of my favorite soapbox topics: that there are so many varieties of real, intense, and nourishing love besides the romantic kind, which in our culture gets prioritized and obsessed over.

COLIN: But I think that's very slowly changing.

I love how your friendship inspires you. You guys must collaborate all the time!

COLIN: We're totally hitched up, musically speaking: we share everything we write as soon as we've written it. We've both started learning bass, so we could play in each other's bands.

YITZY: It's so seamless—musically—that there's no point looking for another bass player.

Did either of you have any formative moments in your childhood in terms of your relationships with animals? And when the time came, was there any sort of dramatic "vegan epiphany"?

COLIN: Rather than one specific moment jumping out to me, I think, in hindsight, my whole childhood makes a lot more sense now. We're born incredibly compassionate, but slowly trained out of it without realizing.

YITZY: I'd always considered myself a big animal lover, but I hadn't noticed the huge disconnect. I saw how much Colin was enjoying being vegan. He'd be experimenting in the kitchen, making avocado toast and these crazy smoothies, and I'd try some.

COLIN: I just want to feel good about my choices, and give people a chance to look at them and say, "What is that light and where is it coming from?" I prefer to wait and let people come to me in their own time. I don't tell them what to do.

YITZY: Nobody can get angry with you for that. They can't go, "No, you *don't* feel great." I've found it so advantageous to quietly lead by example rather than explain why someone should change their lifestyle. That's how Colin converted me (and his mom, and his dad, and multiple friends).

Have you noticed any changes in your physical and emotional health? Has veganism affected your creative output in any noticeable way?

YITZY: I went vegan primarily for physical health. Though I can't say I noticed a huge change in that regard, I feel a hundred times better about my relationship with animals and my reduced environmental impact. I don't know if I can attribute my creative output *directly* to veganism, but I'm certainly happier and more self-confident, and I've had the most fruitful two years of my li'l career.

COLIN: Most notably, clarity—both physically and emotionally. Veganism cued a chain reaction of major life events for me (that is still unfolding), and as I continue to explore myself and come closer

to aligning all of my values with my lifestyle, I become a much more honest artist in the process.

So, what's in a "crazy smoothie"?

ITZY: Avocado pits!

COLIN: I'd read somewhere that avocado pits have tons of nutrients in them. Obviously, you need a high-speed blender (like a Vitamix), and you should use a smaller pit.

YITZY: It won't taste too bitter if you use the right ingredients. Fruit. The one time kale isn't the answer!

I picture you guys having these amazing musical dinner parties.

COLIN: Yup! I'll come over and Yitzy's in an apron, we'll put on old jazz records—Louis Armstrong, Benny Goodman—or Hawaiian music. I'm the assistant, chopping veggies and pouring wine while Yitzy takes the lead on elaborate meals like stuffed peppers and enchiladas. We love making this special peanut sauce to put in our dragon bowls. And we've started praying before meals, it just tastes better.

YITZY: I'm atheist, but it's pretty cool to thank the universe a bit—remembering to practice gratitude for what we have. I can say that's one thing I learned from my Jewish upbringing.

Would you say veganism has affected your spiritual beliefs?

COLIN: The concept that we are one with the universe, or rather that we *are* the universe, used to confuse me. But I've become so much more open to new ideas and schools of thought, and I absolutely see the world in a different light than I used to. Veganism was a major wake-up call to me and forced me to really look at the world and do my own research into what is actually going on.

Album design by Maria Serna.

YITZY: I've definitely become more open to ideas that I had previously filed under "hotchy-chotchy." Since I went vegan, I've started doing yoga daily, leading a more minimalist lifestyle, and doing my best to practice mindfulness meditation. It's helped me zoom out and consider the larger picture with some issues; I feel more equipped to question things that I know *must* be the case because they've always been that way and accept different perspectives.

Do you feel a responsibility to live more ethically for the sake of posterity?

YITZY: Yes! I look up to my heroes and want to be like them. I certainly don't expect to be anyone's hero, but if I have the opportunity to appear on stage in front of crowds, I sure as heck want my influence to be positive. (Also, I try not to sell throwaway merch items like pins and am working on a project to sell entirely upcycled band shirts!)

COLIN: Absolutely. My goal with music is to inspire people to live more sensitively in such a desensitized world. I want to remind people that it's cool to care. Veganism hasn't changed the way I work or play, but it has changed my approach to the musician's lifestyle. In our culture there's this super-romanticized notion of the "starving musician," living in the gutter and treating yourself like shit. There's a lot of that in the Montreal music scene. When we play a gig, we're usually offered a couple beers on the house, but why not a glass of water with a salad instead? If you're going to be doing it night after night you need to take care of yourself. Sometimes I think we stick out like sore thumbs.

YITZY: ...We do *occasionally* get drunk.

COLIN: Yes, but compared to most people our age, we're not living that lifestyle. There's a contrast between how we're trying to live and what most musicians are doing. We go to bed early, and we eat well. We're *thriving*, not "starving."

YITZY: I do love being the guy biking home from the farmers' market with kale sticking out of my vintage L.L. Bean pack.

[Laughing]

COLIN: Because we talk a lot about good food, we sometimes come off as pretentious, but the thing about the musician's life is

that you don't *have* to be broke. I work at a café for minimum wage, and I'm still comfortable because I'm not draining my wallet on beer and cigarettes every night. We do feel paralyzed sometimes when we try to talk to our other friends about the way we live without appearing snobby. Being vegan can be isolating.

Which is why it's so crucial to "find your people"—or if you live somewhere where there isn't a community yet, to build one yourself. There's a lot of talk about people pretending their lives are perfect for the sake of social media, but you guys seem like genuinely relaxed and happy people. It shines through in your music. Before we got on this call I was lying in a **hammock in the backyard on this beautiful sunny day, listening to your EPs, and it occurred to me that both of you write and perform "slow-down-and-savor" kind of music. Yitzy, you literally have a song called "Island Time."**

YITZY: It's true—we *are* enjoying our lives—but it's important to acknowledge that we're not always happy. I'm astonished at how many of my friends suffer from depression. Montreal winters are hard; I was depressed as hell last winter! I wrote a song called "No Bad Days": on the surface it's a feel-good pop song, but if you read the lyrics there's a pretty clear undercurrent about a sort of cyclical monotony. Maybe there are no *bad* days, but sometimes there aren't any *good* days, either. I think depression is so misunderstood—in my experience, it's not always like "I'm so sad"—it's often more mundane and hazy. It's been so helpful to slow down and examine my mind and the present moment. It's helped me become more objective with my emotions and recognize when I'm feeling down.

COLIN: We would be lonely if we didn't have each other. There are two pillars our friendship is based on: music and health.

Any parting thoughts?

COLIN: Veganism takes you down a rabbit hole to so many other incredible things. Mindfulness, minimalism, spirituality, meditation... it never ends. I think it's wonderful you're promoting this, as it can literally benefit everyone.

 www.colinweeks.com and www.yitzy.ca

@yitzybits and @colinweeks

Libri et Brassica

If you are ever in need of a library that doubles as a time machine, you may want to visit the Providence Athenaeum. You walk into this creaky Greek Revival (built in 1838) and half expect to see your fellow readers in frock coats and bonnets. Around the main room, there is a mezzanine with a flimsy wrought-iron railing and antique desks looking out over the atrium, each workspace separated from those on either side by walls of bookshelves. No one under the age of ten is allowed up here, for obvious reasons. And if the light is turned on in the alcove below, you can see it shining through a chink in the mezzanine floorboards. Because acquisitions have always been member-directed, you'll find titles by Mary Roach and Krista Tippett directly beneath a row of half a dozen Edwardian odes to the bookplate. The card catalog is still here (though it hasn't been updated since 1998), and you can admire the entries done in Dewey's Library Hand.

The Athenaeum is associated with Poe and Lovecraft, though I myself am far more interested in the fact that Charlotte Perkins Gilman—author of "The Yellow Wallpaper" and *Herland*, that vision of a sexless matriarchal utopia—used to hang out in the members-only

art room sneaking crackers while poring over books on Egyptology. (My surreptitious snacks of choice are hazelnuts and sesame sticks.) The history is venerable, but what I love most about the Athenaeum are the librarians, who are kind and helpful and oftentimes hilarious. When I checked out *Witchcraft and Alchemy*, Mary, the circulation manager, said dryly, "You're all set for four weeks of fun!"

Another of these lovely librarians, Dan, must have noticed my "wings are for flying, not frying" sweatshirt, because one day he followed me up the stairs and whispered, "I went vegan a year ago, but I don't have any vegan friends."

"You do now," I said.

The next time Dan was working, he ducked into my alcove again. "I went to the vegan bakery this morning and they have cardamom syrup for iced coffee, and I thought of you."

I put cardamom in *everything*, but when could I have mentioned that? I had not. This was only the first occasion on which I suspected that this man can somehow peruse the contents of my brain as effortlessly as he browses these shelves.

I slip him Tupperware containers of raisin cake and rosewater pistachio macaroons. We trade dinner pics and sloth GIFs, plot the best way to veganize a lime coconut flan recipe (agar powder, for sure), and deliberate on the proper word for a warm bedtime drink of almond milk, maple syrup, and spices (is it a toddy? a nightcap? a posset? We can always consult the library's facsimile copy of *The Frugal American Housewife*.) He apologizes for his enthusiasm, and I tell him there isn't any such thing, not with me—occasionally I can be so enthusiastic I scare people away. But that won't happen this time.

We go out for dinner at a trendy new vegan restaurant on Thayer Street, and level up: turns out that before Dan started his master's program in library science, he'd been studying to become a Carmelite friar, which goes to show you that vegans really do come in every shape and creed. It's always bothered me how seldom Catholics pause to reflect on what emulating Jesus (and St. Francis of Assisi, patron saint of animals) would logically entail, so Dan's faith is something I can respect. One rainy Monday I stay home to entertain a friend from Boston, and he texts, "I'll miss you

too. Even though I'll be in the office I always know you're around—drinking chili out of a jar in some dark alcove!" During a Saturday-morning study date in the art room, as I'm plotting my next novel about a middle school ghost-hunting club, he tells me about the paranormal investigators who recorded after-hours video of gas lamps turning on and off, the staff-room door opening and closing, a shadow figure walking up the mezzanine stairs, and a small dog barking in this very room. It's all so perfect I have to wonder if I'm a character in somebody *else's* novel.

Friday nights after the library closes, we go grocery shopping together, pour ourselves coffee with soy creamer at the Trader Joe's sample counter and debate the gustatory merits of mochi, tomato hummus, and various brands and varieties of cashew cheese. He calls these outings "a blast" or "an adventure." I haven't laughed like this since before the 2016 presidential election. On another night out, Dan and I order vegan cheesesteak wraps, and, when the food comes, I pick up my pickle and think, "I want to clink pickles, but that would be weird, right?"

Dan reaches across the table and bumps his pickle to mine.

Whispering with my friend about produce sales at Whole Foods this week doesn't just liven up the workday; his sincerity and continual delight is just the inspiration I need to write this book. Much more than that, though: it's too easy to feel alone and lonely when you've chosen a different path from virtually everyone else around you, and knowing you're doing the right thing is often a lukewarm comfort. Living as I do at the library, I certainly subscribe to the notion that we may form relationships of a sort with the people we meet in books—that these "friendships" can offer a modest degree of satisfaction—but there is no substitute for a kindred spirit in the flesh, a friend who matches you one enthusiasm for another.

A Q&A with Nicola McLean

Nicola McLean is a visual artist whose paintings are held in private collections all over the UK as well as in America, Canada, Australia, China, and Europe. She also volunteers at her local animal shelter. Originally from Derry, Northern Ireland, she now lives in the very far north of Scotland with her husband, two westies, and a rescue cat called Lily.

How do animals and the natural world inspire your art? What's your primary medium?

While I don't want to limit myself to being an artist of just one specific subject, as I find inspiration in the manmade as well as the natural, I would have to say that animals are the focus of about 90 percent of my paintings. I take commissions for companion animal portraits and, perhaps because I am surrounded by so much wildlife and farmed animals where I live, I often find myself drawn to include them in my artwork. I also love to paint the designs and patterns found in nature, such as reflections on water and the arrangement of shapes and shadows made in a tangle of grass and wildflowers, and have of course been inspired by the amazing sunrises and sunsets we get in the massive skies where I live.

My medium of choice is acrylic because it dries quickly, which suits my very impatient streak and gives me the vibrancy and bright colors that I love in my artwork. I use a mix of acrylic paint, spray paint, and acrylic ink, and will paint on any surface that suits, including canvas, paper, recycled card, and most recently, beach pebbles and sea glass.

How did you decide to go veg?

I confronted someone on a beach who was being abusive to an animal (being the least confrontational person you can think of normally!), and my husband later asked me if it was hypocritical to be concerned about some animals while eating others. Of course, the only answer was yes, so I became vegetarian. Then six months

later, while looking for cruelty-free cosmetics online, I found articles on veganism and was really angry with myself and the industries involved that it had taken me to that stage in my adult life to realize that cows don't just eat grass and make milk, of course they have to give birth to produce milk, and that the egg industry routinely minces male chicks alive because they are a "waste" product. Once you know these things, you can't unknow them, and the only reasonable action is to stop contributing to the horror by becoming vegan.

What effect has going vegan had on your health? Did you notice any differences in your creative output?

Initially I put on weight by going vegan—I felt compelled to eat any and every possible SFV [suitable-for-vegans] junk food/ processed food available! Now, I try to eat more clean, unprocessed food, but it is good to see so many more vegan options available now than even seven years ago. Going vegan was never about my own health, to be honest, so, although I do try to eat a healthy diet for the most part, that's not my main motivation for living a vegan lifestyle. Emotionally, I find it difficult sometimes to reconcile that so many people who are otherwise good and kind just don't "get" why continuing to consume animal products is wrong on so many levels. I suppose with regards to my creative output, I focus more now on trying to convey a message with my animal art—in a non-graphic way—hoping that it will cause people to think twice about how we use animals.

Can you tell us about the "art shed" your husband built for you? I always love getting a peek inside other creative workspaces!

Steve started collecting old pallets that were otherwise going to be dumped, and he used the wood from those as well as other upcycled items either donated to him by friends or sourced from the local recycling plant, such as the round windows from old washing machines, to build me a small art shed at the bottom of our garden, singlehandedly.

The only new materials he had to buy were the wooden beams for the frame and the materials for the roof—we get very strong winds where we live, so it was essential to make sure the roof wouldn't blow off! Thanks to a donation of three large windows, two

of which were fitted in the roof as skylights, I have so much light in there even during the dark winter months, and he even built a little decked area to the front of the shed where I can sit and soak up the vitamin D during the one or two sunny days we get in the summer!

What effect has ethical veganism had on your spiritual life?

I have definitely been on a spiritual journey since becoming vegan. It led me to train to become a reiki master practitioner because I learned that animals are very receptive to reiki and I wanted to be able to use it for that. In fact, I don't practice on people for the most part, but I do use it regularly on my own companion animals, the animals in the shelter where I volunteer, and distantly to animals around the world.

I've also studied intuitive animal communication and am much more open to listening to my intuition when it comes to animals, in particular, and life, in general. I do struggle with self-doubt, which makes it hard for me to believe I'm not just making things up, but I have had some really interesting and surprising results from animal communication, and it's something I want to explore further.

How has veganism helped you with the usual creative bugaboos—comparing yourself to other artists, feeling like you have nothing new to offer, self-loathing, and so forth?

I still compare myself to other artists, although I think meditating (which is something I started to do once learning reiki after becoming vegan) helps with that, as it allows me to stop thinking about ego so much—although I think it is human nature to compare and find ourselves lacking, especially on social media, which is absolutely a double-edged sword when it comes to sharing our art.

I don't suffer from self-loathing, but since becoming vegan, I tend to loathe humanity in general! Being vegan did perhaps help with [my] thinking I had nothing new to offer, because although I don't paint exclusively vegan subjects, I do have more ideas now on vegan art, and, in that regard, it isn't about me or my ego as an artist. It's about bringing a vegan message out artistically and hopefully giving people food for thought.

What are some of your favorite foods for fueling your creativity?

When I get into the zone artistically, I can often forget to stop for lunch, and very often am still painting when I should really have stopped for the day to start making dinner! During the summer months, I love salads with pecans, cashews and baked tofu using a fantastic marinade of lemon juice, olive oil, garlic powder, mint, and nutritional yeast. In the winter it's all about homemade soups—hearty spiced peanut soup is my favorite, full of chunky vegetables.

How do you find being vegan in Scotland?

Larger cities in Scotland, such as Edinburgh and Glasgow, are really good for vegans, with a great selection of vegan restaurants and cafes. Where I live, it's very remote, and I'm surrounded by sheep and cattle farms, so the idea of veganism isn't that well accepted or understood. There are only three supermarkets here, and while they do stock a few vegan items, such as burgers and sausages, it's mostly vegetarian products that they stock [i.e., made with casein or egg whites]. It is frustrating to see new products coming out online all the time and know that they will rarely, if ever, make their way to the supermarkets here. That said, because of the increase in tourism to the area in the last couple of years, one of the local restaurants did bring out a vegan menu, which is encouraging, and

not always having so much choice of pre-packaged vegan food does mean we have to be more inventive with cooking from scratch, which is no bad thing.

Parting thoughts?

It's really encouraging that veganism is becoming more mainstream, and, while the Internet can be a mixed blessing, with all that information at your fingertips, it's so much easier to find out about things that the animal agriculture industry would rather keep hidden behind the myth of an Old MacDonald-style farmed animal utopia, and you can make a decision on whether or not you want to continue to contribute to a system of abuse and exploitation from a position of knowledge. If you can live a healthy, happy life without harming others (to the best of your abilities), why wouldn't you?

- ◉ www.artbynicolamclean.com
- ◉ @art.by.nicola.mclean
- ◉ @ArtbyNMcLean

Pulling a One-Eighty

Everybody at Sadhana Forest was a hippie wanderer type in their own way: there were kids fresh out of university "seeing the world" while they figured out what they wanted to do with their lives; people in their thirties or forties who never wanted a "career" or mainstream lifestyle, choosing instead to volunteer long-term in this community and others like it all over the world; and native Indians who didn't want to fit themselves into the life their family may have been expecting them to lead.

Within twenty-four hours, I had found my particular friends. Funny how one conversation over dinner or hauling water buckets can lead you to feel as if you've known each other all your lives. After we were done volunteering for the day, my friend Diva and I would walk to the "chai shack" down the dusty road from the compound, where a mustachioed man in a salmon-colored polo shirt (who Diva said looked just like an Indian Clark Gable) would fix us little glasses of spiced tea. We'd perch on the plywood box that served as the café's seating area, shaded from the sun by a fluttering blue tarp as we sipped our chai and mulled over what we wanted to do with our lives. My friend told me she had rechristened herself; we didn't talk about how she'd settled on "Diva," but she was slightly punk, slightly androgynous, and always ready with a smile and a useful suggestion, so it was obvious it had nothing to do with the alpha-female energy of an opera singer. She confessed the name her mother had given her, and literally *any* name would have suited her better. Diva had decided for herself who she wanted to be, what she wanted to be called, and I wanted to spend as much time with her as I could. I wanted her to rub off on me.

Jane O'Hara, *Sacrifice*, metal leaf and oil on wood, 2010.
@animallounge

But at thirty, I'd traveled enough to know that no matter how intense the affection you feel for a friend you've made abroad, you are likely not going to see this person again. Maybe these connections were so sweet *because* they were ephemeral. So here we were, brimming with good feeling for every single soul in the place—humans, birds, stray dogs (the rats who skittered across the ceiling beams at night were harder to love, but we were working on it)—*except*.

There was *this one guy*.

He was in his twenties, tall, and good-looking in an older-brother sort of way. You know when you're in a new social situation and there's someone to whom you haven't been introduced, and you know the person's name, but you always feel a little bit uncomfortable about never having met each other properly? This was the one person I hadn't shaken hands with at Sadhana Forest. I didn't think anything of it at first. I couldn't be chummy with everybody.

My first week there we were both on plant-watering duties, and every time I passed him on the path, I'd attempt eye contact and a hello. He never looked at me, he never answered, and yet I'd always see him chatting away with the others at dinnertime. It started to bother me. Why the eff did this guy treat me like I was invisible?

I felt my dislike for this person calcifying for several days. Then it occurred to me: "You changed your mind about being vegan; you're the only one to say you can't do it again." I decided I was going to seek out this boy and ask him about his life. I would figure out how to like him. So, at the next mealtime I deliberately sat down beside him, said hello, and asked him a question. I remember nothing of this conversation except that I was surprised at how receptive he was. Whatever we talked about, it was pleasant. I still didn't understand why he hadn't been friendly before, but at least now I knew it wasn't personal.

Remember how I got sunstroke? Well, the trouble with being sick at a place like Sadhana Forest is that unless their volunteer job is in the "healing hut," people tend to forget about you. They're either too busy doing manual labor, rewarding themselves with a bike ride or swim in the mud pool after said labor, or so used to people

leaving that they assume you've taken off for some ashram in Kerala without saying goodbye. But guess who was among the few people who came and sat with me for a while?

My new friend distracted me from how lousy I felt by telling me about the intense romantic connection he'd made with another volunteer. We were all living in such close quarters, and yet we didn't necessarily notice when two people began to feel differently about each other. Naturally their pre-set travel plans lay in opposite directions, and in a matter of days they'd be separated for months, perhaps forever.

Was this the thought consuming him whenever I strode by with my sloshing water buckets and eager greeting? Very likely.

These days I tend to measure my progress by reversals. I'd been doing it all along, hadn't I? The despair of an evening that a novel revision would never come together turned to quiet determined action at ten, eleven, midnight, and in the morning the way forward would seem clear again. It's not "can you turn this around," but *how*. And when I feel an aversion to something, be it a type of food or a musical genre or someone else's considered opinion, I ask myself if I can change my mind about it. So far, I have managed this happy switch with cauliflower, polyamory, hip-hop, hairless cats, and many more humans. Oftentimes a strong preference—a judgment, to call a spade a spade—is an expression of the ego, and the ego is *not* a curious entity. How can you innovate if you secretly believe you already have all the answers?

"Proving yourself wrong" doesn't have to be some big dramatic show of self-flagellation and proclaiming yourself unworthy of forgiveness. It can be as subtle and as simple as knocking on a door you've assumed will never open, as easy as "hello."

A Q&A with Henry Lien

Henry Lien is a writer of speculative fiction based in Los Angeles. His debut middle-grade novel, *Peasprout Chen, Future Legend of Skate and Sword*, is set in a city of pearl one must traverse on skates. *Peasprout* presents one of the most vivid and complete fictional worlds I have ever encountered—Henry has even created *wu liu*, the deadly sport of martial-arts figure skating. The novel is also innovative in its portrayal of animals suffering for the sake of human "culture." Through her friendship with the tenderhearted Hisashi, Peasprout becomes increasingly aware of the cruelty implicit in all that she once took for granted.

You're a vocal believer in the ability of animals to help humans evolve into... well...less terrible humans! You somehow had to change in order to go vegan, of course, but how did veganism transform you—personally and creatively?

Yeah, it was totally seismic for me personally and creatively. I'm sure other contributors to this book can list in better detail some of the ways that going vegan is transforming. The most surprising thing about going vegan for me as a person and as an artist is learning that joy is contagious. On social media, I deliberately try to emphasize how much happiness veganism brings to me in my daily life and in my writing. I present it as associated with kindness, light, health, sexiness, and a call to our better selves. That call can be powerful. Many people, most of them more or less strangers, have written to me and told me that they went vegan or started moving in that direction because my social media posts were so full of joy, and they wanted a piece of that. As well as maybe a bit more sexiness <sexy winky emoticon>.

I would describe *Peasprout Chen* as a joyful novel—the reader can tell on every page just how much you reveled in the writing of it. I also got the sense that you've drawn on a deep well of imaginative and cultural experience. As a white, straight, middle-

class female—the stereotypical vegan, in other words—I'm very interested to hear how your identities as a gay Taiwanese American vegan author inform and enrich one another.

Ooh, neat question. I think intersectionality is important because most of us have multiple identities that overlap. Being Taiwanese American, being gay, and being vegan give me equal amounts of joy, and I'm particularly interested in ways that they intersect. Being Taiwanese and vegan is easy. There is a long tradition of Taiwanese vegan cuisine that is so delicious, you cry like a shameless baby for more. Further, Taiwanese people are much less hostile to veganism, in my opinion. Most of the objections to veganism that I've heard from Taiwanese people basically agree with the concept, given that we have a long tradition of it founded in religious practice, but say that it constitutes too much of a lifestyle sacrifice. I've never heard a Taiwanese person get bent out of shape about veganism the way that socially progressive non-vegan folks in the West do on a regular basis. Regarding being gay and vegan, that's trickier. I think the thing is that many socially progressive non-vegan folks in the West base their sense of identity on a commitment to social justice. They find veganism threatening because it suggests that they've missed something massive in their construction of their sense of self, so they get upset and lash out. So being Taiwanese and vegan is easier than being gay and vegan, in my experience.

I want to talk more about food and culture. You once saved a man's life by performing the Heimlich at a wedding reception, but you had to shield what you were doing from the other guests so the Taiwanese gentleman in question wouldn't feel shame! That social mores could supersede the survival instinct in that situation astounds me. When it comes to eating and wearing animals as a matter of tradition, how do you find your way through that tension as someone who still desires to participate in the culture in a way that feels ethical? How can one person play a role in helping a culture evolve into a more compassionate version of itself?

I don't think there is a one-size-fits-all answer to that question. I think that living by example is the form of activism that I get the most mileage from, and that feels like the best long-term fit for me. I never, ever censor my veganism when in Taiwanese company. It's

easy in that, as I said, Taiwan and many largely Buddhist countries have a long tradition of veganism or vegetarianism anchored in religious practice, so I'm not received with the kind of bafflement or derision that vegans who come from some other cultures might. I do make it clear that my veganism does not rise from religious practice but is simply due to the fact that I love animals. I think that secular veganism born out of a love of animals is something that strikes many Taiwanese people as new and strange but positive and admirable, and I feel a sense of ambassadorship for that. I think it makes an impression. Actually, I know it does because strangely, every Taiwanese person I meet who learns I am vegan remembers it the next time we meet and is respectful about it.

I find you endearing in so many respects, Henry, but it always makes me smile in particular when you practice the Taiwanese art of self-effacement. When you refer to *Peasprout Chen* as "this worthless novel," I like to interpret this tongue-in-cheek dismissal of your own work as a humility practice. Has veganism helped you with what I like to call "ego management"?

I prostrate myself before you in gratitude for your undeserved compliment of this worthless one's humility. Regarding ego management, I'm a pretty confident guy and the lobe of my brain responsible for humility function is damaged. I think that veganism has been helpful in making me realize that if I emphasize how much I love something, be it my own writing or the animal I'm not eating, it comes across not as boastfulness or self-righteousness but as something more joyful and positive. When people hear me talk about how much fun I'm having working on the

Peasprout Chen books, okay, maybe it merits a little to moderate eye-rolling, but I think people generally see that this guy's doing what he loves and he's just expressing that love, rather than being boastful. Same thing with veganism. When I talk about how much I love animals, people don't go, "Here comes that self-righteous vegan guy, is it me or did it suddenly get scold in here?" Instead, they go, "Hey, look at that sweet tenderhearted guy showing his love. And OMG, look at his baby parakeet!!" So yeah, being vegan has helped me focus on centering that love slightly outside myself, and that's been a graceful way to manage my own ego.

I so admire your ability to write ethical vegan characters without coming across as having an authorial agenda. (So far, I've erred on the side of subtlety, myself.) Do you feel a responsibility as a vegan artist to address these issues in your work?

Responsibility isn't the right word. I feel a strong compulsion to bring in vegan and animal welfare issues into my work because I'm writing from the heart, and I write for myself first and for all others second. I also feel strongly that we need reminders of what sheer goodness looks like. It's easy to write bleak or cynical depictions of humanity. I like to include in every work at least one character who makes noble decisions, and one of the truest ways for the characters to do that is to show consciousness of the value of the lives we share the planet with. I often feel ashamed to be part of the human race. Thus, I often like to write characters that make me proud to be part of the human race, as a way to say, "Wow, look! We can be beautiful. And who wouldn't want to be beautiful?"

🌐 www.henrylien.com
📷 @henrylienauthor
🐦 @HenryLienAuthor

All This Power, How Can I Be Afraid?[IX]

(AN EXPLORATION OF VEGAN HIP-HOP)

Like a lot of white people I know, since the 2016 presidential election, I've been looking for ways to become a truer ally to marginalized communities. It finally, *finally* clicked for me that one practical way to stick it to white supremacists is to support the work of artists and entrepreneurs of color on a much more deliberate basis—to obtain goods and services from POC-owned businesses, and to buy, share, and promote the music, literature, and images of artists of color. This could mean going a mile or two out of your way to buy bread or cupcakes from a Black-owned bakery or requesting that your local library order a book by a marginalized author to add to its collection. It certainly means seeking out emerging and undeservedly obscure artists and purchasing books and music in addition to reading and listening to it for free online. I read *Aphro-Ism: Essays on Pop Culture, Feminism, and Black Veganism from Two Sisters*, in which Syl Ko writes that schools and organizations value Black bodies so they can say they champion "diversity," only the word means nothing without respect for Black *ideas*. So being an ally also means consuming Black podcasts, think pieces, and essay collections, ruminating on and disseminating what we are learning.[103]

My iTunes library is overloaded with melancholy predominantly white British pop/rock bands like Elbow and London

Students from Cynthia King Dance Studio perform "Hands Up" at the first Black Vegfest on August 11, 2018.

IX From "The Beast" by Conscious Mindz.

Grammar. Black artists get heavy play too—Nat King Cole, Sarah Vaughan, Nina Simone, Ella Fitzgerald, Bill Withers, Marvin Gaye, and assorted funk and soul tracks left over from the year and a half I dated a deejay—but there is only one living musician in that roll call, and he is no longer recording. I wanted to grow to appreciate Black music being made *now*. Early research for this book yielded tantalizing mentions of vegan hip-hop—this was around the time that Grey's viral hit "Vegan Thanksgiving" was making the rounds on social media for the second November in a row—and I was excited to learn that artists and groups like Dead Prez, KRS-One, and the Sugar Hill Gang have been rapping about food justice and vegetarianism since the 1980s and early '90s. I had a vague idea that hip-hop is first and foremost a culture as opposed to a musical genre, but I'd never understood the difference between hip-hop and rap. And the N word makes me so uncomfortable I stuck a Post-It note over the title of Dick Gregory's autobiography for the times I was reading it in public. But when these artists use the N word, maybe they're doing it for similar reasons.

My vegan hip-hop education begins with businessman and former radio host Keith Tucker, who founded a community plant-based eating initiative called Hip-Hop Is Green in 2009. In a talk at the Resistance Ecology Conference co-presented by Kevin Tillman of the Vegan Hip-Hop Movement, Tucker explains that hip-hop was established in 1973 in the South Bronx by Clive Campbell, better known as DJ Kool Herc. I start to understand the distinction between hip-hop and rap when Tucker explains, "Hip-hop is *not* rap music. Hip-hop is a forty-year-old culture."[104] (Hip-hop legend KRS-One puts it this way in his interview for the 1997 documentary *Rhyme & Reason*: "Rap is something that is being done. Hip-hop is something that is being *lived*." [105]) Tucker lays out the nine elements of hip-hop and tells the audience that his mission is to add a tenth (definitions supplied by The Temple of Hip-Hop blog):

1. deejayin' ["speaking, even rapping while presenting recorded music"[106]]
2. emceein' ["rhythmic talk, poetry and divine speech"[107]]
3. breakin' [street dance]
4. graffiti art
5. street knowledge [the "accumulated wisdom of

urban families"[108]]

6. beatboxin' ["body music and body language"[109]]

7. street fashion

8. street language

9. street entrepreneurialism ["grassroots business practices"[110]]

10. health

Hip-Hop Is Green exists to provide free vegan meals and hip-hop entertainment to Black teens and their families. Tucker and his team of volunteers have brought in vegan chefs and musical artists for such evenings in Seattle (where Tucker is based), Portland, Oakland, St. Louis, Chicago, Detroit, Brooklyn, Baltimore, and the District of Columbia, with more cities to come. "Rapping about social and environmental issues is totally different from rappers rapping about money," Tucker says. In their presentation for Resistance Ecology, Tucker and Tillman articulate the issues: urban food deserts denying fresh affordable produce to Black communities, Black Americans suffering disproportionately from diabetes and heart disease, the concept of political empowerment through decolonizing one's diet. Later on, it will occur to me that perhaps the reason I'm not finding as many Black vegan artists outside the hip-hop world is because so many Black vegans channel all their creativity into community outreach and advocacy. They can do more practical good with cooking lessons for their neighbors and big-picture social justice work than they can by foregrounding animal rights and environmental sustainability, as white vegans tend to do. Black vegan chefs and nutritionists know these are critical issues, but they also understand that the average Black American must turn his health around before he can concern himself with animal cruelty or the fate of the planet.

I start downloading tracks on iTunes. If there are classic anthems for this movement, they have to be "Beef" by KRS-One and "Be Healthy" by Dead Prez. I listen to hip-hop as I cook and clean and walk to and from the library, or when I'm driving my mom's car while I'm back in New Jersey. I start a YouTube playlist of tracks by Wu-Tang Clan, Conscious Mindz, DJ Cavem, and Sa-Roc, and I sometimes listen while I write or sew. Exploring an unfamiliar musical genre is very much like trying new vegetables and giving your taste buds time to adjust: the more I listen, the more I enjoy

it. In addition to Dead Prez albums packed with political insight—
"They ain't teachin' us to solve our own problems," regarding an
educational system that is built to fail people of color[111]—Stic.man
(half the Dead Prez duo) also has a "fit-hop" album to psych you
up for working out; he went vegan (and got fit and sober) after a
gout diagnosis in his early twenties.[112] "The Forty-Year-Old Vegan"
by Chokeules (a white dude, incidentally) is another track I enjoy—I
always grin when he raps "Belly of the beast, no beasts in my belly."[113]

Grey's EP, *Missed Calls*, is another favorite. I start following Grey
on Instagram, and when he posts an invitation to dinner at the
Seasoned Vegan in Harlem the night before Black VegFest, I snag
one of the twelve tickets. I always feel awkward going to social
events on my own, but with this crowd there's no need to worry: I
approach three women waiting on the sidewalk outside the
restaurant, and they absorb me into their conversation right away.
Tenille is as delighted as I am that our names rhyme, and we joke
about creating our own TV show. She's a travel agent who bakes
"slutty brownies" (a brownie and chocolate chip cookie in one) to
supply to vegan-friendly bakeries in her spare time. Sarah, a
hairdresser who lives only a few blocks away, shows me the tiny
"Mexican sea monster"—the Axolotl salamander—tattooed on her
inner elbow. Risa, a jazz and blues singer, is more soft-spoken, but
on the subway afterward she gives me loads of cookbook and
restaurant recommendations.

Grey and his partner Nikki Ford arrive with hugs for everyone
and apologies for getting lost on the subway. They've just
announced on social media that morning that they are expecting,
and we toast their baby with alkalized water. The evening passes
in a delightful blur of non sequiturs (Sarah says my daemon is a
deer because I have "gentle eyes") and conspiracy theories. ("It
might be true," Grey says of the notion that the moon landing never
happened. "They lie to us about everything else.") He sings a few
of Sebastian's lines from *The Little Mermaid*, and Sarah shows him
the clip of Ariel and Eric's wedding scene with the priest's split-
second boner. The last time I was here, I'd ordered a Seasoned
Vegan specialty—"crawfish" made from burdock root and cooked
in a butter-garlic sauce—but this time I order the zucchini mac (that
is, cheesy zoodles) and a slice of cheesecake with strawberry-chia

coulis. Nikki and Grey order three entrees between the two-but-really-three of them.

The next day it's pouring rain for the first-ever Black VegFest in Bed-Stuy, but apart from a few delays in the speaking schedule, everything seems to be running smoothly. The festival founder and director, Omowale Adewale, an author and plant-based coach and trainer, seems to be in four distinct places at any given moment. For

Black Vegfest founder Omowale Adewale (second from left) with festival organizer Nadia Muyeeb, chef Jillian Marie of Sabrosa Vegana (NYC), artist Graciela Erica Brooke Tibaquira, and festival organizer Francis Pena.

breakfast my friend Jennifer and I eat the most scrumptious seitan BBQ ribs, collards, cornbread, and mac 'n cheese from the Soulful Vegan, a family of restaurateurs who've driven here all the way from Chicago. We listen to talks and panels on grassroots political organizing and intersectional veganism. I know racism exists on a spectrum from blatant to almost invisible, but it doesn't occur to me that a Black person might have to wait longer for an ambulance until I listen to Sala Cyril of the Malcolm X Grassroots Movement. "They don't come for us the way they come for other folks," she says of the necessity for what she calls "emergency-preparedness activism."

Jennifer and I razz the young volunteers at the entrance to the bouncy castles for not letting us in (eighteen and under, alas), savor passionfruit-sugarcane juice ("we made it especially for you," says the raw-food vendor) and *jugo de chicha* (an Ecuadorian drink of rice milk, lime zest, and ginger), and listen to the musical acts through an intermittent downpour. Along with local hip-hop artists SunnStarrr and Philly Stallone, we hear Debra Diane, a young singer-songwriter from Detroit *(see page 215)* and tear up watching middle-schoolers dancing in caution-tape tutus to protest police murders of unarmed Black citizens *(see page 115)*. Emcee Fred "Doc" Beasley laments that "most of our entertainment has no social value," but everyone on

stage today is rapping and singing and moving to offer something better. Grey takes the stage at four o'clock, and I get chills when he performs "Black Excellence"—"young man, don't you know you invented everything, everything, everything?" This is a new song, but I feel sure it's already changed more than one life.

There's no freestyling on the Black VegFest stage—I imagine a time limit isn't conducive to it—but after watching *Rhyme & Reason*, I really hope I someday get to see it done live. Now that I'm getting over this trepidation about intruding on another culture, I can appreciate how much talent and lightning-fast thinking goes into the freestyle—how much these artists have to practice in order for a freestyle to sound effortless. And it *does* have to be impromptu; Erick Sermon of EPMD says your audience can tell if you've composed it beforehand, and Tre from The Pharcyde (better known these days as Slimkid3) advises the viewer not to freestyle unless they can do it with substance—otherwise they'll be called out for "saying a bunch of nothing."[114] The words come fast and urgent, but listen carefully to a good freestyle and you'll hear a stream of incisive social commentary. In his freestyles, KRS-One will often use the term "overstand," which entered the hip-hop vernacular via Rastafarianism—a play on words that distances the speaker and listener from Western ideology. "It's been said that people with overstanding can do more than read from life's book, but can help write it," as Bob Marley is quoted.[115]

Of course, mainstream hip-hop culture has its problematic aspects like any other, systemic misogyny being the most egregious: the headline of Shanita Hubbard's Huffington Post piece in the wake of #metoo, "Black Women Love Hip-Hop, But It Doesn't Love Us Back," sums it up. It would be great to see more women artists in this community and lyrics and videos from high-profile hip-hop artists that don't demean and objectify women or glorify violence—even though that's what record labels seem to expect of them.

Like any other movement, its ultimate success depends on individual members living up to the ideals that movement espouses. In May 2001 the United Nations declared hip-hop an international culture of peace and prosperity, and the eighteen principles of the "Hip-Hop Declaration Of Peace"—put together by a collective

of artists and community leaders, including KRS-One—outline a lifestyle and philosophy of non-violence, honesty, education, community service, the sharing of resources, and the dignity of all elders, children, women, and men. The Fifteenth Principle reads,

> Hiphoppas respect and learn from the ways of Nature, regardless of where we are on this planet. Hiphop Kulture holds sacred our duty to contribute to our own survival as independent, free-thinking beings in and throughout the Universe. This planet, commonly known as Earth, is our nurturing parent and Hiphoppas are encouraged to respect Nature and all creations and inhabitants of Nature.[116]

The vegans in the hip-hop community are trying their best to live by this principle, and in doing so they're also following what KRS-One calls a "philosophy of self-creation"—making a wealth of great music in the process.[117]

Listen to The 10th Element of Hip-Hop Mixtape: Ready to Live from Hip-Hop Is Green:
- https://soundcloud.com/hiphopisgreen

Then check out my vegan hip-hop playlist on YouTube—and if you like a track, share it and buy it!
- http://bit.ly/cometparty-hiphop

A Conversation with Josephine Skapare

Josephine Skapare is a self-taught freelance illustrator and pattern designer who lives in Stockholm, Sweden with her young family. She and her partner, who is a freelance journalist, chose their surname together: "Skapare" means "Creator" in Swedish.

Tell me about your "vegan epiphany"!

It has grown on me, step by step, since I was a kid. The long version starts with a four-year-old me—the stubborn kindergarten type—who learned that dead animal-sausage was made out of intestines. I remember how disgusted I was by this, and I started telling people I was allergic, so I wouldn't have to eat it. But it would take until I was about thirteen years old before I started exploring the veggie world. When me and a friend in school wrote an essay on Mad Cow Disease, we both stopped eating meat and became lacto-ovo vegetarians. Veganism was unfortunately not on our radar back then. However, for me it has always been an act to care for all living creatures. The benefits for the environment and health is a great plus though, of course! All in all, since I learned that meat is actually dead animals, I've been struggling to understand how so many people still put that in their mouths.

I was a lacto-ovo vegetarian for quite some time, and for short periods during my late teenage years I tried being vegan. But I always fell back on cheese and the fact that it was simpler to eat dairy. And the vegan choices back then weren't even close to what one can find in stores today! Having to deal with anorexia from ages fourteen to seventeen did make me a bit too aware about the food I ate, but that was never related to my vegan journey (which a lot of people thought). For me, it's always been about the animals.

In 2014, I joined something called "the big vegan challenge" here in Sweden. This offered a chance to go vegan for thirty days, with weekly pep through newsletters and inspiration. As I had been thinking about going vegan on and off for a few years, it was the perfect thing for me. And my partner joined in. We cut out caffeine and alcohol at the same time, but the vegan part was the only thing we could stick to for the whole month.

Ever since then, I've embraced the vegan lifestyle, and it just keeps growing on me more and more each day.

Veganism and feminism and family—how do all those values fit together for you?

My kids are vegan too, even though they are still quite tiny (Elvin is two and a half, and Elmond is six months). I'm really looking forward to seeing how they will grow up to understand all this. And as part of my vegan creative journey, I actually started the first (at least first Swedish) lifestyle magazine for vegan parents. I've made two issues so far, but unfortunately, I won't be able to do any more in the near future. I also have some kids' book ideas that I'm working on. I want to make "classic" kids' books with a vegan norm. You know, where they drink/use oat milk instead of cow's milk, etc. I'm so glad I can happily tell my kids what their food is made of and show them how it grows!

I have been thinking a lot about veganism and feminism since I had my first child. As I've been sitting there breastfeeding and feeling very thankful for being able to give my kids such a great start in life, I thought about all the tiny calves who are just taken away and don't even get to taste their mothers' milk—which is meant for them—and the mothers, the cows, who are forcibly impregnated over and over again to keep up milk production. I came to think of this quote by fellow illustrator Andy J. Pizza: "Creativity is like breastfeeding, the more you pump the more it flows." So true, but we should pump some more creativity into this world instead of animal milk, am I right!?

If parents told their kids what the meat on their plates actually is, the world could be a lot more vegan in a quite-near future. But people don't tell their kids. Yet people are of the opinion that we, vegans, are the ones choosing for our kids. We all make choices, it's

just that some of us make active ones. I do respect people's right to make different choices, but it really bothers me that people eat dead animals when they don't have to. I wish animals could make the choice for themselves—I don't think ending up on someone's plate, or being pureed into baby food, is on their list.

Oh, and by the way, I actually got the question once if breastfeeding is vegan. Ever heard that one? I'm thinking about lettering the quote "vegan is a feminist act" or something like that. What do you think?

I love it! (And for the record, readers: since all warm-blooded mothers produce milk especially for their babies, the only way human milk is not vegan is if somebody else were to drink it without consent. Bizarre, I know—but then, that's what we're doing when we drink other species' milk.) Speaking of free-flowing creativity: in what ways has your artistic practice changed or evolved since you went vegan?

Well, at the time when I went vegan, I was working at a content agency as a graphic designer. And I was really frustrated that I didn't have the time to create all the arty things that I wanted to do (and was thinking of constantly). Since I was going back and forth trying to be vegan for so long, I didn't think it had had any effect on my creative journey, but in fact, I create art because I want to make this world a better place.

I PRETEND I DON'T CARE WHAT PEOPLE EAT... BUT IT REALLY BOTHERS ME THAT THEY EAT MY FRIENDS, YOU KNOW.

© Josephine Skapare, *Friends*, digital illustration, 2017.

I think about that quote from *Dirty Dancing*, that "Baby is going to save the world, and Lisa is going to

decorate it" (not an exact quote, but if you have seen the movie you know what I mean). I'm like the exact mix between them. I want to save the world—well, at least make it a better place by inspiring people to eat more vegan—and I want to do it by decorating it. Not by looking pretty, like Baby's sister Lisa, but by making art that inspires others to take the leap. And things for us already-vegans of course!

All in all, one could say that my veganism has inspired me to make more art that I love, and thereby lead me to pursue a career of my dreams.

And what a career you are building! The illustration work you share on Instagram always puts a smile on my face. You typically use a bright palette, and your style could be described as playful, but there's always an underlying substance to your images (and practicality, too, in the case of your visual recipes and city maps). What advice do you have for artists who are thinking about weaving ethical themes into their work?

That's exactly how I would wish someone to describe what I do! The main thing is to be honest, both to yourself and in your work. What do *you* think? Use your inner force of why you want to embrace a vegan lifestyle. My *Friends* print is an example of that *(see facing page)* Those words are exactly how I feel about eating meat— but it makes it more accessible by having a pig say, "I pretend I don't care what people eat, but it really f***ing bothers me that they eat my friends, you know." When non-vegans see it, and really read it, they kind of laugh at first. But when I explain that I actually feel that way, they can get quite uncomfortable. So, use what drives you, and in your own words. The more specific you are, the more human and universal it gets. Just be honest and convert it directly into your best piece ever (or just a regular piece of work, no pressure, ha ha). You don't have to change the world with every piece, but the more of us who share our hearty opinions, the more people will get a chance to explore new ways of thinking—and acting—in their everyday lives.

I love that—when you share your insight in your own style, you give someone else an opportunity to think new thoughts! Now to end on a light note: what's your favorite vegan treat?

One of my favorites is chocolate balls made of black beans, soft dates, cacao, and rolled oats. I'm working on a recipe illustration for this; it's such a classic here at home! They are delicious to freeze as well; if you freeze them flat like thin cookies, you can make the best ice cream sandwiches. Yum!

◉ www.josephineskapare.com
◉ @josephineskapare

Soft Animal Bodies, Yours and Mine and Theirs

The Squam Art Fair happens twice a year (June and September): a Saturday-night denouement of a fiber and fine arts retreat on Squam Lake in New Hampshire. To get there, you walk through the woods—where you may have been lucky enough to glimpse a Luna moth earlier in the week—and eventually you will see votive candles flickering inside a row of "ice lanterns" leading down to the warm, wood-paneled Deephaven Dining Hall. As always, the hall is strung with fairy lights and lined with carefully curated displays of yarn, clothing and jewelry, pottery, woodcarving, soaps and potions, and novelty-print project bags, most of it locally produced. The mood is festive, and admittedly a bit manic. Everyone's been looking forward to dropping ample amounts of cash on the one of a kind.

This particular June I'd taken fiber artist Rebecca Ringquist's embroidery class, and her pre-printed samplers were on display

in a large basket, squares of cotton cloth neatly rolled up and tied in orange ribbons. One of her designs read LOVE WHAT YOU LOVE, MAKE WHAT YOU MAKE in all-caps hand-lettering, with ovals of varying sizes to be outlined and filled in using the various stitches she'd taught us, plus smatterings of dots where French knots should go. These words, inspired by Mary Oliver's best-known poem "Wild Geese," capture the spirit of this retreat better than anything else in this room.

The vast majority of Squam Art Workshop attendees are white, female, and middle- or upper-middle-class. Some are professional creatives—pattern designers, craft bloggers, and such—but the typical "Squammie" has built a career in the corporate world that has allowed her material security but precious little time for artistic pursuits. She fills her world outside of work with collage books and handknit shawls and inspirational memes, and at Squam no one will sneer that she isn't a "real" artist. For this sort of person, a four-day, $1,400 art retreat on a wooded lake in New Hampshire is the ultimate act of self-care. Those who have struggled with depression and low self-esteem have confided that becoming part of the Squam community has saved their lives.

This is something people often say about "Wild Geese," too, as Krista Tippett points out in her 2015 *On Being* interview with Mary Oliver (who passed away while I was editing this book). Readers treat this poem like a prayer, a resounding validation of every desire long suppressed. These words give them courage to make the art they want to make instead of doing what the world expects of them: "You only have to let the soft animal of your body / love what it loves."[118]

These words are wonderful and important and true, but I see a problem here: the artist has not paused to consider the soft animal bodies on Styrofoam plates in her refrigerator. When she attends a retreat like Squam Art Workshops, she moves through the dining-hall buffet line loading her plate with sausage and bacon and salmon, and pours dairy cream into her coffee. She affirms her life by disregarding the lives of many others.

Reluctant as I am to point this out—because many of these women are my friends, and they are good people—this type of

self-care equals self-absorption. If you Google any permutation of "the trouble with self-care," you will find many perceptive think pieces about how the concept has devolved from poet and essayist Audre Lorde's righteous advice to Black and queer activists into the ultimate marketing ploy, how "self-care" can be a sweet, sweet soma lulling us into a sense of comfortable impotence. We indulge in "treat yo' self" culture because we can always find a reason why we've earned a new leather handbag, or a beer, or a cheeseburger. "Don't give me any of that stuff about bacon having a mom," a friend says, "I've had a bad day and I deserve it." Here is a false binary, instigated by capitalism, that to take anyone else's welfare into account will push you past the brink of exhaustion.

What I hope my omnivorous friends at Squam come to understand is that you can nurture your own spirit and assert your right to be here without denying that right to any other creature. In a 2017 *New Yorker* piece on self-care, Jordan Kisner writes, "When you endorse yourself as both vulnerable and worthy, especially when that endorsement feels hard, you can grant that same complex subjectivity to others, even to people whose needs and desires are different from your own. At its best, the #selfcare movement offers opportunities *to see and care about vulnerability that's unlike yours*."[119] (Emphasis mine.)

Book critic Ruth Franklin writes that Mary Oliver "offers her readers a spiritual release that they might not have realized they were looking for," to which her enduring popularity is a testament.[120] You need only read two or three of her poems to see that Oliver subscribed to Tennyson's "red in tooth and claw" image of nature, and it's clear she spent countless hours observing its brutal goings-on—birds tearing into the snowy breasts of other birds, raccoons watching a turtle lay her brood and scurrying in to filch the eggs as soon as she departed. Oliver even took some of those eggs for herself. But she also counted Shelley and Thoreau among her dearest "friends," and she did not overlook their ethical vegetarianism. "I am often stricken with a wish to be *beyond all that*," she wrote about not wanting to eat animal flesh. "I am burdened with anxiety. Anxiety for the lamb with his bitter future, anxiety for my body, and, not least, anxiety for my own soul. You can fool a lot of yourself, but you can't fool the soul."[121] Still, she

believed her occasional craving for meat to be a natural one and that the suffering animals experience to become our food *is* largely unavoidable.

Except that it *is* avoidable. My diet, my art, and my life are all proof that human-instigated animal suffering is unnecessary, as are the lives of millions of vegans all over the planet. We can save our own and each other's lives through art, and those lives can and should come with hands, wings, tails, and hooves. Because making art is not your purpose here; your purpose is to make art *and* to perform deliberate and consistent acts of compassion, so that you may become, as Mary Oliver wrote, "the tiniest nail in the house of the universe, tiny but useful."[122]

A Q&A with Fiber Artist Heidi Braacx

Heidi Braacx is the owner of VeganYarn.com, a wonderland of hand-dyed (and sometimes handspun) yarns made of bamboo, linen, tencel, organic Fair Trade cotton, and other plant fibers. She writes, "We're not here to judge other people's yarn choices...our goal is to be a positive presence in a wool-dominant yarn world, where people who want awesome artisan yarn made from plants can enjoy knitting again... even dedicated wool-people enjoy a change of pace from time to time."[123] Heidi lives with her family in British Columbia.

You were only seven when you learned how to knit. What sorts of things did you enjoy making as a child (knitting and otherwise)? Do you come from a family of crafters?

When I first learned to knit, I realized how many awesome things could be made with a rectangle. I loved my stuffies and had a ton of them, so my first projects were hats, capes, blankets, and scarves for them. My family is not crafty at all but definitely creative in their own ways. My parents encouraged my natural curiosity in reading and music and were happy to support my craftiness with plenty of supplies.

As you point out on your website, when a knitter walks into a yarn shop and asks for vegan yarn options, usually they'll be directed to the "Acrylic Wall of Shame." How did you get started developing your line of animal-free yarns? How do you choose which fibers, yarns, and dyes to work with?

I started out by buying any yarn I could find that was plant-based in retail stores. After a while I'd earned enough from sales to get a wholesale account with a distributor, and now I buy mainly from mills directly. Sourcing is still the most challenging part of my work, but over the years I've found some good ones. That was a long, slow process, actually.

How do you respond to knitters and other fiber artists who believe there are compassionate and sustainable ways to work with wool? I know of several textile artists who eat plant-based but weave and stitch with fiber they say comes from animals who aren't ultimately killed for meat.

Mainly I don't engage with that unless someone genuinely wants to know why wool isn't ethical or sustainable, because when people don't want to know, they're completely closed off. The belief that wool is both ethical and sustainable is so strong in the fiber arts community that most are unwilling to reconsider, and evidence alone won't convince them, at least not all at once. As with other moves toward a more compassionate lifestyle, I think it ultimately needs to come from within. When we connect our personal values with our actions, we start to see what needs to be done. I feel that by being present in the marketplace, I'm gently encouraging people to reconsider their views and supporting those who have.

What are some of your favorite materials for natural dyeing?

It's deeply satisfying to get colour from plants I've grown and harvested, or wildcrafted myself. Wildcrafting is a style of harvesting from nature that means considering the needs of plant and animal life in the area, and responsibly collecting only what will allow them to continue to thrive, and no more. Wildcrafting can also double as invasives removal, so it's great to be able to use invasive plants that don't belong in our area.

Libertas Lace (60 percent organic cotton, 40 percent linen), dyed with wildcrafted or garden-grown plants.

Is there a part of the dyeing process that's most pleasurable for you?

I think it's all pretty even. I enjoy having some quiet time to myself to work, and to enjoy the pleasure of a daily rhythm. I'm not naturally task oriented, but I've learned over time the satisfaction of a day well spent getting things done. It helps knowing that I'm doing work that I find meaning and value in.

You're also a musician. How long have you been playing the violin? Tell us about The Cranky Molluscs! Do your creative practices inform each other in any way?

I've been playing violin since I was ten, which was late for most kids while I was in school, but now that I'm an adult it doesn't matter so much, and it's simply for my personal enjoyment and catharsis. The Cranky Molluscs was a fun project for my best friend Karina and I to hang out and visit together while doing something we both enjoyed. We're both big time fans of Yann Tiersen, so we learned a bunch of his music to play together. Karina also got me into Astor Piazzolla. The combination of violin and accordion lends itself so well to tango music, and I just love tango! I don't know if

they tangibly inform one another, but together they're the most significant forms of personal expression that I have.

What effect did going vegan have on your physical and emotional health? Have you noticed any link between these changes and your creative output?

I didn't have any dramatic physical changes apart from decreased menstrual pain and a little weight loss. Emotionally, I felt like I was doing something significant and lasting to help others. Feeling inner peace that comes with living in line with my values is huge for me.

Do you have any other thoughts as to how a vegan lifestyle may have enhanced your creativity?

Having a greater sense of peace and less tension or fear cultivates curiosity. Curiosity and creativity are closely tied in my mind, and I'm more curious when I'm mentally and emotionally well.

When life gets stressful, how do you create some space and ease for yourself?

To an outsider, I'm sure it probably seems like I have it made, so why would I ever feel stressed in the first place? Well, I'm partly in this career because I haven't really thrived in any other. I have Anxiety Disorder and OCD. These things make it difficult for me to be in a traditional work environment on a regular basis. I'm truly introverted, so I do best when I have long periods of solitude to recuperate from social interaction. The flexibility in hours allows me to take breaks when I need them or to work longer hours when I want to. Running a business does come with stressors for sure! There's never a guarantee that I'll sell anything from day to day, but luckily, I do. I can't rely on a regular paycheck, so all I can do is do the work, and hope I'll do well.

For my self-care, I have a "toolbox" of favorites that ease stress. I enjoy listening to audio books or music while I work, I've found a few forms of exercise I really like (hiking, cycling, and powerlifting), and occasionally I go to a Korean family-style spa. For ten dollars an afternoon, I can soak in the hot tub, the sauna, chill in the salt room, and enjoy the many other simple luxuries there. It's nothing fancy, but I always leave feeling like a wet noodle!

What advice do you have for someone who wants to start an ethical vegan business?

Do it! Ha ha! This world needs more ethical vegan businesses and businesspeople. Apart from that, try to find ways to surround yourself with a community that helps you feel supported, that shares your values. Unfortunately, when you run a business based on certain values, like veganism, some people will feel like they have to tell you you're wrong and all the reasons why. By having support from others, you'll have a consistent reminder that you're on the right track, and those negative opinions are not the only opinions out there.

Last and most important question: fave vegan treats??

Probably the hardest question here since I'd have to narrow it down! I'm super lucky to have Vegan Supply, a vegan grocery, nearby, so I have access to some pretty amazing treats. I really like Primal Strips' Hickory-flavor jerky and Denman Island Chocolate Mint bars. It's really hard to get now since they don't seem to sell in Canada anymore, but Tartex vegan pâté is incredible.

 www.veganyarn.com

@veganyarn

A shawl knit in Vegan Yarn Albireo, a fingering-weight bamboo/organic cotton blend.

The Handmade Wardrobe

Java excites me for two reasons: tempeh—invented here by Chinese immigrants, likely a happy accident in tofu production—and batik, a long and beautiful tradition of hand-printed plant-dyed textiles with patterns made with a wax-resist. Yogyakarta is one of the primary centers of batik production in Indonesia, and I've been looking forward to fabric shopping here since my friend Seanan and I first planned our two-month tour of Asia. The fabric stalls are no less captivating for their orderliness, and I get the idea that the women who staff them enjoy the bartering—passing the calculator back and forth—as much as I do. At a larger shop around the corner, I find four yards of the most exquisite warm-blue cotton with a delicate watercolor effect beneath a red-orange pattern that looks like coral. Traditionally, batik is drawn by hand, but this design appears to be stamped. Equally delightful is the calico cat asleep in a pile of fabric under a table in the back.

It didn't occur to me until I got home that the batiks I bought may not actually be vegan. It seems obvious now—what kind of wax did I think they used, anyway?—but at the time I was too enraptured by all the lovely colors and patterns to wonder about it. Vegans don't use beeswax or eat honey because the bees are treated similarly

to factory-farmed animals: wings torn off, forcibly reproduced, killed once they're past "using." Bees produce honey for their own consumption, and, given that we are reliant on them to pollinate our crops—we literally cannot survive without them—it's only fair we let them keep it. I use maple syrup instead.

But even if it had occurred to me to ask about the beeswax, I'm not sure that I would have received a definitive answer. To learn more about batik production, I go to the Fleet Library and browse through every book they have on Indonesian textiles. Beeswax turns out to be the most environmentally responsible ingredient possible, since a nontraditional alternative—paraffin wax—is made from bleached petroleum. The cotton fabric is problematic too; plant fibers aren't necessarily sustainable or cruelty-free. "Conventional cotton is the world's dirtiest crop, and poor protections mean that farmers and the environment are exposed to these harmful chemicals in huge numbers, with significant health implications," writes sustainable fashion consultant Summer Edwards. "There is also a large degree of forced and child labor involved in the global conventional cotton supply. The high costs [of] GM cotton and the requirement to purchase the patented seeds each year are the direct cause of high rates of farmer suicide due to crippling agricultural debt. To avoid these impacts, make sure your cotton clothing is organic."[124]

Whether we make our own clothes or buy them off the rack, we need to be asking these questions about each step of the garment production process. When I sew a dress for myself, I can say for sure that it hasn't been *assembled* in a sweatshop, but I can't vouch for the raw materials. I don't know what the working conditions are like in the factories where my flax, hemp, and bamboo yarns are milled. A wool-loving friend of mine directed me to an ethical fabric source list, but the crafter who compiled it also blogs about working with leather, which is as environmentally unsustainable as it is cruel. That list is a helpful resource only to a point.

All this seems like enough to steal every last sip of enjoyment out of a home sewing practice, I know, and whenever I toss a tiny scrap of fabric into the trash bin, I think of how fashion and textiles are the single-most wasteful industry on the planet. But I freecycle, reuse, and repurpose as much as I can, keeping in mind that there

are no perfect choices, only *better* choices. As for the long list of materials vegans can't use, you've probably heard it said (on *The Great British Bake-Off* if nowhere else) that limiting your options allows you to think more innovatively. Jess Meyer, an avid knitter and sewist who goes to Squam Art Workshops, says, "When I stopped knitting with wool and other animal fibers, I found myself working with yarns I hadn't before, and that facilitated opportunities to be more creative, to learn about different construction methods, et cetera."[125]

I've been sewing since I was a kid, though it's only in the last few years that I've achieved something like basic proficiency. Neither of my grandmothers were crafters, although my great-grandmother was an accomplished crocheter, and my grandfather used to hold my yarn as I wound it by hand just as he did for her when he was a child. Years ago, I inherited a stash of vintage thread and notions from elderly relatives to which I'm continually adding, since sewing supplies are my favorite thing to browse for in thrift and antiques shops. My sewing machine is a New Home from the early 1980s, a gift from my dad to my mom. She only used it to sew me a few Halloween costumes when I was small—a tiger, a bunny, and a witch—but I feel a sense of continuity all the same.

It may seem ironic given second-wave feminism's reaction against every form of domesticity, but I see sewing my own clothes as an act of empowerment—a freedom and a luxury my grandmothers didn't have. I pick the colors, the patterns, and the fibers. I choose to present myself to the world in a garment that is one of a kind instead of something someone on the far side of the world got paid pennies to stitch together. And if a seam unravels, I know who to blame for the shoddy craftsmanship.

Truth be told, I save my filthiest language for when I'm home alone working on a sewing project. Whenever I struggle with my New Home, I tend to brood on the M.R. James story "The Malice of Inanimate Objects" even though there is *always* an explanation for wonky tension or bunching thread—perhaps the thread has come unlooped from one of the guides, or I've installed a new needle flat-side front. The lesson's the same as in writing: walk away from it, think about something else for a while, and eventually you'll figure

out how to fix what isn't working. The process doesn't *have* to feel so fraught, if you can just allow yourself that space.

Scenes from my life are woven into every garment I make. Inside a teal-and-aqua dress with a not-quite-identifiable botanical print (berries? acorns?) is the craft market in Kampala, where my sister helped me bargain for three yards before choosing between two brightly patterned wall hangings for her brand-new house. I put on another dress with a delightfully twee Lady-and-the-Unicorn print and remember the book launch for which I made it, the four kinds of cupcakes I baked, and the friend of a friend who said, "I know I don't know you, but hearing you speak about your work, I felt like I did. I really appreciated the way your words find each other." I can point to the first row of colorwork of my sweater-in-progress and say to my new friend Casandra (who makes soy candles and crochets with organic cotton), "This is when we first met up for coffee and stitching at that new bookstore-bar." My sewing and knitting practices have led to a closetful of fun and colorful clothing, but the most important thing they've given me is confidence.

Making your own clothes is time consuming, and depending on the fabric or yarn you choose, you often don't save any money in doing so. And yes, there are almost as many questions to ask about materials and dye ingredients and labor conditions as there are when you assemble your wardrobe off the rack. Either way, though, we need to ask: Is the dye from this fabric polluting a river somewhere in the developing world? What is life like for the person who stitched these jeans? Who lost their skin so I could wear these shoes?

A Conversation with Nava Atlas

Nava Atlas is a visual artist and the author of *The Literary Ladies' Guide to the Writing Life* as well as many vegetarian and vegan cookbooks, including *Vegan Holiday Kitchen* and *Wild About Greens.* She lives with her family in upstate New York.

You've written that you were disturbed by meat when you were little and avoided eating it as much as possible. Was your future career as a visual artist and author as apparent as your future vegetarianism?

From a very early age, I remember my first loves were drawing, reading, and writing. I lived for the once-a-week art class and library day as oases in the abject boredom of my early school days. One ray of light was an elementary-school teacher who was very big on creative writing, and I discovered the edge of humor I've always enjoyed injecting into my writing and artwork.

At home, I was always drawing. Often, my drawing had elements of text in it—a foreshadowing of my interest in creating limited-edition artist's books as well as illustrating my early cookbooks. I was also an avid writer of letters to people. Long and hilarious, with drawings in them. Remember letters? Does anyone ever write them any longer? I think that's a very sad loss, but much as I long for the lost art of letter writing, I can't see that ever returning.

When I was young and even in college, much as I adored books and was a voracious reader, I don't think I saw myself as an aspiring author; I saw myself as more of an artist and illustrator. I'm disappointed that I've trailed off from drawing. I now do a lot of my visual work digitally. But I do hope to get back to it soon!

Tell us about illustrating and publishing your first cookbook, *Vegetariana: A Rich Harvest of Wit, Lore and Recipes*, in 1984. How did you conceive of the project? What were your favorite parts of the process?

That was quite an experience. It came about at a time when I was a struggling young freelance illustrator/graphic designer in NYC. My husband, also a "starving artist," loved the meals I made at home. He had always aspired to be a vegetarian and was happy that, as a non-cook, he had married one! He kept asking me to write down what I cooked so that I could make it again. Since I'd been cooking for myself since high school, when I became the first vegetarian in my family, this wasn't a daunting task.

After some time, I had amassed a number of recipes and got the idea of combining my skills in illustration and graphic design with my love for cooking and literature. I collected quotes and folklore about food, both general and specific, as the basis of the illustrations in *Vegetariana*. I would say that I loved that whole process—researching the quotes and folklore, mostly at the main library in NYC, illustrating them, and creating the recipes. It was all of a piece, and with my "beginner's mind," it was all very pleasurable. In any case, long story short…through a few synchronous events, including finding agents and just the right editor, it didn't take too long to get it published. It was successful out of the gate. There weren't that many vegetarian cookbooks out at the time, unlike today when there are a zillion vegan cookbooks on the market.

I was so naive about the publishing business that it was laughable, but the publication of *Vegetariana* set me on an unexpected path of cookbook author. Interestingly, I've thought about doing an updated edition of *Vegetariana* (I would take out the dairy and eggs) from time to time. I've noticed that most of the literary quotes in the book are by male authors (which annoys me about myself!), and now I would include a lot more women. And also, the print quality of the book has never been good. The drawings are a lot more detailed and delicate. Do you think I should do an updated edition?

YES! Because as many veg'n cookbooks as there are on the market now, there's still nothing like *Vegetariana*; its beautiful

illustrations and literary flavor give it a storybook feel, whereas most traditional cookbooks are too product oriented to remind us that we are each a part of a longstanding movement. And from an artistic standpoint, it's a perfect marriage of interests—that's how all those hours of drawing and research and recipe development could be so deeply enjoyable. I'd love to hear how you respond to young artists who might be so bent on creating something new and exciting that their ambition may be blocking their flow.

I live near a state university (SUNY New Paltz), and last spring semester I had an intern. My most frequent advice to her was to fail often, and to fail hard. In school and in all our endeavors (especially women, I think), we're trained to try to be perfect on the first go.

But it doesn't work that way and, if anything, makes us seize up and become self-conscious.

Most often, I need to allow myself a false start or two or three on a particular project, because, with each attempt, I get closer to the heart of what I really want to express. It rarely happens on the first try, even after all these years!

And young creatives also need to allow themselves a few spectacular failures. I think we learn more from those than from our successes. Most people won't see our failures, in any case, but they'll be there for us to learn and grow from.

Female artists absolutely have to work harder to override their perfectionism. Let's talk about *Secret Recipes for the Modern Wife*, your satirical vintage recipe book. (To give my readers a taste, I laughed out loud at the last two ingredients in your "Grounds-for-Divorce Meat Loaves": "bizarre vegetable garnishes" and "two mediocre attorneys.") How do you work that paradox of using midcentury recipes and women's magazines to create feminist art?

Secret Recipes for the Modern Wife came about at a time when several friends of mine were going through divorces. They'd tell me their tales of woe, and I fashioned them into "recipes" about relationships. I had used midcentury images in other artworks of that time period, notably the artist's books "Sluts and Studs."

There's something so iconic about midcentury American images. They delineate not only entrenched gender roles, but also

draw a line between "good girls" and "bad girls"—the happy housewives and the femmes fatales. These images didn't hold up a mirror to society, rather, they set the narrative, giving women narrow parameters for what their lives could possibly be. And 99 percent of the time, no matter what role they were depicted in, women in midcentury media were white.

What *Secret Recipes* speaks to is how women in heteronormative relationships are still so accommodating. We swear that we won't fall into society's prescribed gender roles (as depicted in "Gender Role Casserole"), but soon after the "I do's"—we do! Same-sex couples have had to figure out a different way to navigate family life. It seems like it's still a quandary for straight couples. Though it has gotten somewhat better, women today still shoulder the lion's share of childrearing and domestic duties.

With the irony and dark humor in my work, I'm asking questions. I would never pretend to have answers.

The midcentury imagery of women in narrow roles segues perfectly to my more recent series, *Deconstructing Elsie*, which uses midcentury Elsie the Cow ads to explore the intersection of patriarchy and animal oppression.

It's only been in the last couple years that I can look at my vintage knitting patterns and favorite black-and-white films and see right away how white and classist and heteronormative it all is. Noticing the connection between patriarchal values and animal exploitation is a similar process of waking up.

How do you see yourself growing from here?

Going, or growing, forward, I still feel like I have a lot to do and a lot to accomplish. I want to celebrate women's voices in visual books and with my growing website, Literary Ladies' Guide. I want to continue to be part of the growing global vegan community, which is so intersectional when it comes to human, environmental, and animal justice issues. I'm looking forward to my next cookbook, *5-Ingredient Vegan*, coming out in the fall of 2019—it's very much a "Vegan 101" kind of book for people who are busy, lazy, or beginners. I feel fortunate that I've been able to pursue my passions and follow my curiosity, but one can never grow complacent. There's always a learning curve, and it sometimes feels steep, but just coasting along would make for a very dull life!

⊚ www.navaatlasart.com
⊚ www.literaryladiesguide.com
⊚ www.theveganatlas.com

A Mirror Facing a Mirror[X]

From the moment I run into her in the gender-neutral bathroom at MoMA PS1, I know exactly how I'd put Sue Coe in a novel. Picture your best friend's eccentric auntie: hair in two long dark braids under a black beret, slim black duds, and sandals designed for walking. Here is a woman who charges her crystals in saltwater and confides that she smoked too much pot in her youth as if she isn't still lighting up most nights. This character comes off like she's living in her own little world of frankincense and vintage jazz until the second she looks you in the eye and delivers some blistering insight that will completely alter the course of your life. (And all that time you thought she wasn't paying attention. Silly you.)

I was already vegan when I found Coe's work. But in real life, yes: through her art, she could have been that person for me. Martha Sherrill was spot on in a 1994 profile in the *Washington Post*: "Sue Coe has blue eyes and a snaggle-toothed smile and a sweet kind of underground charm. She's not a hypocrite, just a good old-fashioned Marxist-Leninist who's worried about becoming a hypocrite."[126] Coe is the original-godmother of animal-rights artivism. After growing up in Liverpool right next door to a hog "processing plant"—"a cruel-looking building with no windows, run by a cruel man"[127]—Coe spent her twenties politely asking for entry to slaughterhouses all over the UK and US so she could sketch and make notes. Her body of work foregrounds the pain and indignity of animals raised for food, as well as the humans paid too little to kill them. Last fall I curled up in an armchair at the Fleet Library with her first book, *Dead Meat*, feeling equal parts nauseated and inspired by the sketches and paintings of schoolboys kicking a decapitated pig's head as if it were a soccer ball, a cow so riddled with cancer it's eaten away one eye and much of her face, and an elderly man, the "skinner," who is missing most of his fingers. So, on a Saturday morning in early June, I hop on a Greyhound bus specifically to see her new exhibition, *Sue Coe: Graphic Resistance*, and to hear her speak about it. I've been looking forward to this for weeks.

X From *Dead Meat*: "My quest—to be a witness to understanding collusion—has become like a mirror facing a mirror. I require witnesses. Reality has to be shared for it to be understood." Sue Coe, *Dead Meat* (New York: Running Press, 1996), 72.

Go Vegan and Nobody Gets Hurt / Copyright © 2010 Sue Coe / Courtesy Galerie St. Etienne, New York.

I'm here an hour early, so I head upstairs to the exhibition. Most of the paintings and prints on the wall are animal-rights themed, but other work is anti-capitalist, and the largest piece by far, "Woman Walks into Bar—Is Raped by 4 Men on the Pool Table—While 20 Watch," was painted after said crime occurred in New Bedford, Massachusetts in 1983. The museum labels compare Coe's work to that of George Grosz, Kathe Kollwitz, and Chaim Soutine. Her early newspaper illustrations, mostly for the *New York Times,* are on display in one glass case—"Operation Desert Sham," a piece on police brutality titled "Blue Plague"—and recent zoo sketches in another. *Men make grunting sounds, thump their chests, bang on the glass. The gorilla ignores them.* She's commemorated the death of Marius, the young giraffe shot by his Danish zookeepers (in front of a bunch of schoolchildren, no less) because his genes were judged to be "superfluous." There are also stark black-and-white woodcuts from her 2017 book, *The Animals' Vegan Manifesto*.

The artist reappears at my right elbow. "After the talk we'll be selling these prints to benefit Skylands Sanctuary in New Jersey," Sue tells me. Twenty dollars each. I can't believe it.

Just before one o'clock, my friend Jennifer slides into the empty seat beside me in the front row, and Sue Coe sits down for her gallery talk with the curator, Peter Eleey, an affable white man in his forties.[128] Eleey asks her about the very beginning of her career, and Coe says she moved to the US because "there was no feminist movement in England at that time." Soon after arrival, she waited an entire day at the *New York Times* offices hoping for work. "I was promised a job," she says. "Twelve hours later, I was still there. Night fell…"

"It sounds like getting booked," Eleey quips.

Coe eventually got that assignment, but there was a catch: she had to illustrate a recipe for duck soup that would appear in the Sunday edition. "So, I drew the French Revolution," she says. "A duck being led to the guillotine." Her early years in New York City were predictably down-at-heel; she lived in one of those boarding-house hotels, drawing on the floor and using the windowsill for her refrigerator. Coe is very critical of her early work, pointing out the irony of using sharks, wolves, and dogs to symbolize corporate greed and acquiescence. She would never do that now.

Eleey asks Coe about her intended audience. "I think about sixteen-, seventeen-, eighteen-year-old kids in Texas and Missouri who are radicalizing and going vegan," she replies. "That's who I want to protect. I want to listen to them." The only other humans whose opinions matter are her subjects in the slaughterhouses. "They'll see I'm drawing them, and they'll hold a position. That's generosity. If they don't like [a drawing], no one will ever see it."

Then she says something that astonishes me: "If I can't make you vegan, you need to tell me how I failed." I hope she doesn't truly believe this, because by that yardstick we're *all* failures. Undoing thousands of years of cultural conditioning is much too much responsibility for a single work of art, no matter how powerful. You can only hope you reach the viewers and readers who are *almost* ready to understand.

Which leads us to the most obvious question: "Are you vegan?"

"No, but I could be," Eleey replies. "I don't eat much meat."

"That's not a good answer." The audience laughs. (We're virtually all animal-rights folks; of course, we are.) Coe asserts that veganism is the most effective way to combat climate change, and Eleey agrees. "But my point was—"

"You didn't *have* a point." Coe is so earnest that her interruption doesn't come off as rude. (As Sherrill writes, "It's impossible not to like Coe, but you also don't want to start disagreeing with her. Particularly after you've seen her work."[129]) "You're an intelligent and sensitive person, and you know what you have to do," she tells her curator. "There's something in you that is responding to my art."

Most people's faces don't reveal as much as mine does. I know that, but I can't help reading the blankly polite look on Eleey's face as a *lack* of response. This man has spent countless hours studying and contextualizing Coe's work. He chose to feature her at one of the most prestigious art museums in the world. How big a failure must Coe believe herself to be, if her own curator isn't convinced?

"The animal-rights work is the easiest to dismiss," Eleey says. He's not saying *he's* dismissing it, but there's a whiff of fraudulence to his role in this exhibition all the same. That's the art establishment for you: virtually never anywhere near as innovative or forward-thinking as it perceives and promotes itself. Of the fifteen artists with

long-term installations at MoMA PS1, only three are female, and the only two artists of color are from Latin America. And to add insult to irony, we can smell the stink of bacon from the museum café. "How do we stop it?" Coe asks. "We stop consuming it." But whoever ordered the hipster-gourmet BLT across the corridor isn't ready for it to be that simple.

From there the interview unspools into full-on animal-rights rhetoric, frank and impassioned. Lagoons of shit. Economic racism. From now on, Coe won't let her curator get a word in.

Eleey eventually thanks us all for coming, and the audience crowds the prints table. It looks like Coe will be able to send a nice big check to Skylands. After another turn about the exhibition, Jennifer and I go to a vegan sushi chain for an early dinner, carefully laying the prints we've purchased on the seats beside us. Mine depicts a variety of animals—rhino, giraffe, elephant, dog, badger, and three human children—gathered around a large glowing hourglass that's almost run out. At the top, in white letters on a black background: *e-m-p-a-t-h-y*.

When I look at this print—at any of Coe's work, really—I think of something one of my characters said once: that life's too short for subtlety. In this reality of methane emissions and bulldozed habitats and steadily rising sea levels, that line has never felt more true. We are all of us failing at "making a difference," but some of us are failing less than others; and by that standard, Sue Coe is an unambiguous success.

Photo by Derek Goodwin.

A Conversation with Cynthia King

Cynthia King is the director of Cynthia King Dance Studio in Brooklyn, New York, which she founded in 2002. Her brand of vegan ballet slippers is used in dance studios all over the world. We chatted over a breakfast plate of pineapple and honeydew melon at Cynthia's studio.

How do you talk about animal rights with your students?

I make it sound totally abnormal when I hear what they eat. "Wait a minute. You eat birds? I thought we liked birds." A young student in my class, cute little kid, seven or eight at the time, was telling me about his backyard chicken coop. He said, "My favorite animal is a chicken," and I said "I love chickens too! They're so sweet. That's why I don't eat them." And he said, "Oh, well, I eat chicken." And I said, "But you just told me you love chickens!" And he goes, "But I only eat the killed kind." And I said, "That bird that's in your yard: *that's* who they kill." He's a teenager now, and he's

vegan, partly because my vegan son was his teacher too. I do a Thanksgiving challenge, and whoever does it gets their picture on the wall, and I post it on social media. Last year we had fourteen kids say no to turkey (meat in general) on Thanksgiving. I have literature about turkeys. We always talk about them in November. I always tell them something about the animal, like "Oh, I didn't know turkeys either, but when I went to a farm [sanctuary] I met this one turkey who really liked Bob Marley, and he would stay near the music with me. His name was Alfonse."

What kind of reactions do you get from their parents?

They might take the kid aside and say "well, Ms. King's a little crazy," but I've never had anyone say it to me. Part of it is that they don't want to get on my bad side since I'm their kid's teacher. Once in a while I've had people say, "But she already has ballet slippers," but what school doesn't have their own dress code? Deep down, I think they know I'm right.

You were only ten when you went vegetarian, right?

When people do it young, they always do it for the same reason—it's always for the animals. You're not thinking about heart disease when you're ten. I had a very close, deep relationship with my dog—he was my confidante—and one day I made the connection.

How do you express your passion for animal rights through your choreography?

I've always been inspired by the way animals move. Telling the truth about animals through dance with children portraying the roles is a great way to get them to embody it, to feel it and understand it. I have pieces with cages, and it's so funny how the kids are like, "Ms. King, I want to be in the cage!" How they clamor to be in that role. They get to act out something so dramatic, and a lot of times work for kids is just happy and smiling, terribly flat and two dimensional. To give them a chance to embody what it's like to be an animal is a useful tool, and it's moving for the audience to see. It's almost like seeing animals acting it out.

Human kids portraying non-human kids.

They do a great job of the drama. But it does help to have people wanting to be at your school, to have a waiting list—to have people clamoring to work with you. That you have to establish first: to be able to say, "I have a kick-ass school," real quality, something that people want. *Then* you can hit them with veganism all you like. Starting out it wouldn't be as easy.

Let's talk about Black VegFest: I got to see your students perform a dance protesting police murders of unarmed Black Americans called "Hands Up." I was thinking over all the dance performances I've seen, and nothing shook me like that. Nothing was *relevant* like that. It was strange to feel so sad and so excited at the same time.

Being moved is exciting. That was actually an abbreviated version: it's got twice the number of performers on stage. We've performed it a lot in public, and sometimes I use a different sound effect instead of the shots fired in the beginning because it's very loud and could be a trigger (literally). The other soundtrack has sirens playing, and the people just fall. There's a version of that piece of music—Janelle Monáe's "Hell You Talmbout"—with many more names on it. The saddest thing is that they also put out a version without any voices, so you can fill in your own, newer victims.

Will your students continue to perform it?

We're asked to do it all the time. You'd asked about any feedback I've gotten, and it's been great. I designed that costume, and people always talk about that. A crime-scene tape tutu is apropos for other protest pieces, too, especially for things about girls and their bodies. We do it at a lot of different events—our next performance will be at the New York City Hip-Hop Is Green dinner at Brooklyn Borough Hall. The first year we did it there was a controversy about the gunshots, and we did it anyway. When the gunshots happened, the lights changed to red, so clearly it was a theatrical moment; nobody was getting shot in the theater.

Everybody was moved and stirred, remembering what dance is supposed to be. The kids who've been in it have gotten very positive feedback from the audience. The lesson of "something is happening in the world; we can create something about it" is not lost on them. They feel very special being part of it.

Is there a palpable difference in the atmosphere at CKDS compared to other dance studios?

There are a lot of great artists and schools in Brooklyn, but in this country, there are a lot of "Dolly Dinkle" dance studios, which is dancer slang for "rinky-dink." People are lined up facing front, doing the smiley "Good Ship Lollipop," two-dimensional stereotypes of little girls—a lot of sexualization of girls. Horrible, creepy things. When people come here, I'm clear from the very beginning that this is not that kind of place. We don't draw attention to appearance—calling girls "pretty" and "cute"—we only talk about how they dance, how they move, how strong they are. How much they've improved, how high they jump, and how their posture is tall. That's an important part of the culture of this school: teaching dance as art. It's not a display. You don't get trophies or stickers here—you get a dance education, and there's nothing better than that.

What about costume choices?

I do a presentation on sustainable dance studio practices at conferences, and I go to those events as an activist. We'll talk about reusing materials, recycling, not using balloons, using vinegar to clean the mirrors, and then we get into veganism. I have slides about the leather industry and pollution. Getting into the dance world with new ideas is hard when it's so often Dolly Dinkle all the way, but you've *got* to do it in your own industry. Whatever you do, that's where you have to do it. I bring feather and leather literature and I'll go from booth to booth asking, "What are these made of?" I have a story about each animal, and my story about feathers is that ostriches take turns fanning each other in the heat. It doesn't get any sweeter than that. Think about that, people. Would you want their feathers to be ripped out of them? Their skin is used for leather, too.

I love your attitude of "this is my business; these are my rules." We need to be less accommodating to make faster progress. You can say "this is unacceptable to me" in a way that is calm and clear and respectful.

Other people have rules that they're not apologizing for. Apologizing for being compassionate?! I don't think so! I'm not telling them they can't eat meat; I'm just saying they can't bring it into the building. I have a "no fur" sign on the door and literature

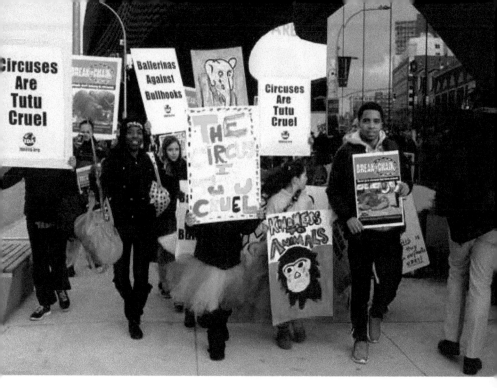

CKDS students protesting Ringling Brothers at Barclay's Center, Brooklyn, 2018.

for everything here; if someone is wearing a Canada Goose jacket, I will hand them the literature and ask them to read it. It's usually someone who's never thought about it before.

Do you have any advice for creative entrepreneurs when it comes to articulating their values to potential clients and customers in a way that wins them over?

Talk about veganism as if it's the norm. Never apologize for it. It might sound a little snarky, but I also say things like, "Of course everybody knows the future is vegan." It helps to have that kind of confidence in it. It's nice being older in this world, too, because people argue with you less. Having gray hair is fabulous. When you get older, people think they're *supposed* to have respect for you. When people say, "to each his own," I say, "if you're not hurting someone else, only then 'to each his own.' Go ahead and wear purple. Wear stripes and plaids together!"

 www.cynthiakingdance.com

@cynthiakingdance

With Gail at Maple Farm Sanctuary. Photo by Chrissy Toti.

Where's Wilbur?

E.B. White is universally regarded as a writer of extraordinary sensitivity and insight, yet to the discerning reader, *Charlotte's Web* is a case study in cognitive dissonance. In the opening scene, the farmhouse kitchen is redolent of coffee and bacon, but Fern never notices the contradiction between saving Wilbur and continuing to eat pig-flesh simply because White himself wasn't willing to make that connection. He and his wife moved to Maine in the 1930s to farm in between their writing and editing work, and White got the idea for *Charlotte's Web* when he lost one of his pigs to illness. He was determined to let the pig's fictional counterpart live, yet in real life he never stopped killing and eating these animals. Years later, when his granddaughter heard that White intended to slaughter a pig the next day, she had her father drive her to White's farm late at night so that she could tack up a poster she'd drawn of Charlotte's "SOME PIG" spider-web on the side of the pig pen. In the morning White saw the sign and slaughtered the pig anyway.[130]

In *The Story of Charlotte's Web*, Michael Sims writes that White "knew that empathy is a creative act, an entering into another's reality. Empathy and curiosity happily coexisted in his spacious imagination."[131] But White's imagination was not spacious enough. "A farm is a peculiar problem for a man who likes animals," he wrote in a publicity letter a few weeks before the publication of *Charlotte's Web*. "Day by day I became better acquainted with my pig, and he with me, and the fact that the whole adventure pointed toward an eventual piece of double-dealing on my part lent an eerie quality to the thing. I do not like to betray a person or creature, and I tend to agree with Mr. E. M. Forster that in these times it is the duty of man, above all else, to be reliable."[132] White acknowledged his "duplicity," but he never found the courage to resolve it.

But I like to think he *would* have, were he alive and writing today. These days a white, middle-class man like White can say "no, thanks" to a BLT and no one will cock an eyebrow. "Bacon had a mom" memes are all over the Internet, tempeh and seitan analogues have the smoky smell and flavor of the real thing, and farm sanctuaries post heart-melting photos and videos of the pigs and other animals they've rescued on social media.

My new friend Chrissy volunteers at two such sanctuaries in Massachusetts: Maple Farm in Mendon and Unity in Sherborn. Jim and Cheri Vandersluis started Maple as a goat dairy, but having to sell the kids for meat became increasingly unconscionable. "Many times, Jim and I stood at the gate listening to our baby goats cry as they were driven away," Cheri wrote in an article for SATYA magazine. "It was at one of those horrific moments when Jim and I looked at each other with tears in our eyes and began our journey to a no-kill life. It was a frightening time for us because the goat milk and the kids were part of our income in supporting the farm."[133] Economic considerations would have stopped most farmers from listening to their conscience, but not Cheri and Jim. They've been vegan for many years now, and the sanctuary stays open with the help of dozens of volunteers.

I tell Chrissy I want to volunteer with her. Funny how it's taken me so long: I've been vegan for seven years, but I've never owned a car, and most farm sanctuaries aren't accessible by public transportation. But Chrissy will drive us, and I am psyched. There is

a sort of karmic justice in spending an afternoon shoveling the poop of animals I used to eat.

Chrissy leads me through the main stable, greeting the animals by name, telling me how old they are, where they came from, and whether or not they're friendly—and if they *are* friendly, how they like to be petted. Some species, like llamas, alpacas, and Guinea hens, avoid human company as much as possible. A gander with two broken wings snaps at my shins whenever I cross his path. But individual personalities within other species are often immediately apparent. Some ducks make conversation, and others ignore us entirely. Some goats are shy or aloof, and others amble over to be petted. They nibble on our jacket sleeves and nudge their horns against our broomsticks and wheelbarrow handles to scratch an elusive itch. Mario, a pygmy goat with an extravagant beard, arrives at Maple Farm after a bear attacked his shelter and likely ate his companions, which is why he's been christened "the escape goat." Mario is eager for affection but isn't too obnoxious about it, which is why he quickly becomes our favorite. "You never know what these animals have been through," Chrissy says.

In a smaller barn overlooking rolling green pastures, I give a twenty-six-year-old former dairy cow named Gail a gentle pet on her front flank and watch her muscles twitch under her luxuriant brown fur. "You've got to rub her more vigorously, so she knows it's not a fly," Chrissy tells me.

It's early July the next time I come to Maple Farm, and Gail looks like a completely different animal. I didn't realize cows could shed, but it makes sense: her new coat is thin and short and kind of grayish, much more suitable for hot weather. This time I give her a nice firm rub on her front flank. By the end of July, Gail's coat has thinned to a white down, and she licks my kneecaps, her tongue like coarse sandpaper. It hurts a little, but I'm happy to serve as her saltlick.

We work, too. Together the volunteers sweep sodden shavings and dung pellets out of the stalls and dump them by the wheelbarrow-load onto a tractor trailer before scattering fresh shavings on the cement floors. One Friday, Chrissy and I clear out the pen of an eight-hundred-pound pig named Jonathan who hasn't

been eating his fruit, and it's rotted in the hay. She says the stink is worse than dung, but I don't find it so bad.

If the volunteer who usually does it can't come, then we'll peel and cut up fruit for the goats' and pigs' lunch, all of which are discards from local grocery stores and food banks. Because produce is past its prime when it *arrives* at a food bank, it's often furred over with mold by the time it arrives at Maple, and thus much of what is donated ends up in the compost heap. Separating the spoiled food from the plastic containers and breaking down the boxes takes longer than you'd think. Another volunteer explains that the food pantries likely just want to keep this stuff out of their own waste stream, and that Cheri and Jim are afraid that if they complain they'll lose the donations altogether. It makes me mad that people think pigs will eat moldy fruit. If *you* wouldn't want to eat it, then neither would they.

This and other realities of running a farm as a charity organization become more and more apparent each time I come. Maple Farm relies on donations and volunteer labor. Jim and Cheri have obviously worked hard all their lives, and they're not young anymore. I tell Chrissy I hope they'll be able to transition into semi- (if not full) retirement in the next couple of years. I certainly wouldn't want to spend my sixties and seventies politely dealing with people who show up unannounced expecting the sanctuary to adopt an animal they don't want anymore.

One afternoon, as I'm dumping a box of squishy black bananas, I find myself thinking of an article I read about the futility of international volunteerism, how a group of unskilled young Americans went to Tanzania to build a school and the locals had to sneak onto the building site after dark to re-lay every last brick so the structure wouldn't collapse. My first day at Maple I met another "volunteer" who did nothing but stand around chattering as the rest of us cleared the stalls. And what are those food-pantry volunteers thinking when they deliver open boxes of inedible produce? I resolve to ask myself on a regular basis, "Am I doing actual, measurable good here, or am I just doing it to feel virtuous?" I suppose that's the reason I enjoy slinging poop: because somebody's got to do it, and today that somebody is me. I can measure my usefulness by the shovelful. People like Cheri and Jim

do practical good every single day, and while the care and affection they give the animals isn't measurable, it is practical *and* consistent.

Real-life farm animals may not be able to communicate in human language, but they are just as unique and delightful and desirous of comfort and safety as their fictional counterparts. Animal protagonists are long out of fashion in middle-grade fiction, alas, but I'd still like to write a vegan reimagining of *Charlotte's Web* someday; perhaps that would be another way to do some measurable good.

With Osa at Unity Farm Sanctuary. Photo by Chrissy Toti.

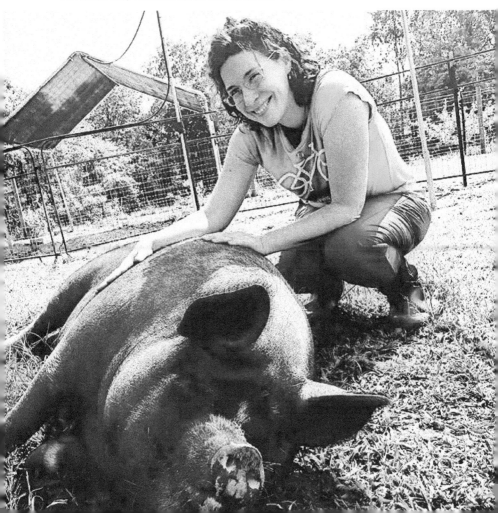

A Conversation with Janyce Denise Glasper

Janyce Denise Glasper is a fine artist and writer based in Philadelphia, PA. She blogs at AfroVeganChick and FemFilmRogue. Janyce has a BFA from the Art Academy of Cincinnati and an MFA from the Pennsylvania Academy of the Fine Arts (PAFA). We sat down for this conversation over soy lattes and veggie ciabatta sandwiches at Franny Lou's Porch in Kensington.

In your blog recap of the Black Portraiture[s] Conference in South Africa, you mention how Dr. David Driskell—one of the leading scholars of African American art—says self-portraiture allows for "a positive trajectory of self." As someone who draws her own image, how has your veganism over the past six-plus years changed how you see yourself?

When I first became vegan, it was purely for animals; I was a vegetarian for fourteen years prior. I started taking dairy out of my dietary equation after watching documentaries like *Forks Over Knives*. Inhumane animal treatment and my own ancestral history have these interesting parallels. Self-portraiture is looking at my futures and different inheritances that have come from the great unknown. Art and veganism together have a natural relationship.

I didn't start using vegan art supplies until a few years ago. Going back to pencil and paper from trees or cotton sources feels genuine. Frida Kahlo's self-portraits contain a history of pain and suffering, and overcoming that, and sharing that through art. When

I'm making self-portraits, I'm thinking about my own past and present: emotional pain and mental pain as a starting point.

You've also traveled to Grenada (in the Caribbean) to learn more about Fair Trade chocolate production, writing about how discouraging it is to see people eating Snickers or Twix bars at a Black Lives Matter event. Have you been able to have a productive dialogue with these well-meaning activists about making those connections?

I'm still getting over the high of being in Grenada. It was such an astounding place, being around where chocolate grows naturally. I enjoyed the House of Chocolate Museum, which showcases the history of how this amazing colorful little pod became so instrumental in that country. I learned about the three types of trees and the awful history of the cacao trade. Cacao pods used to be monetary. People would buy things with them—animals, slaves, children.

My housemate and I are planning a series of events about Fair Trade chocolate, sugar, and coffee. We want the community to be aware of where these items are coming from, and to showcase the importance of globalizing Black Lives Matter. These are still black lives in other countries that are being treated unreasonably to harvest these products. I'm working on a presentation called "From Cotton to Cacao" about how chocolate is "the new cotton." lauren Ornelas' Food Empowerment Project research, all the work she does for that nonprofit organization, is very inspiring. Seeing that there's a whole other darker narrative to chocolate has been heartbreaking.

Let's circle back to art materials. Say you've trained in a certain medium for years, and then you go vegan and you want to use materials that are in line with your ethical beliefs. But there might be a certain material you *have* to use if you want to make a certain thing.

Going vegan brings a sense of awareness of where these materials come from. For example, I love lithography—you can draw something on a stone and duplicate it. But at the same time, you have to use a leather roller to roll out the ink, and the ink itself contains animal byproducts. I have a photographer friend having the

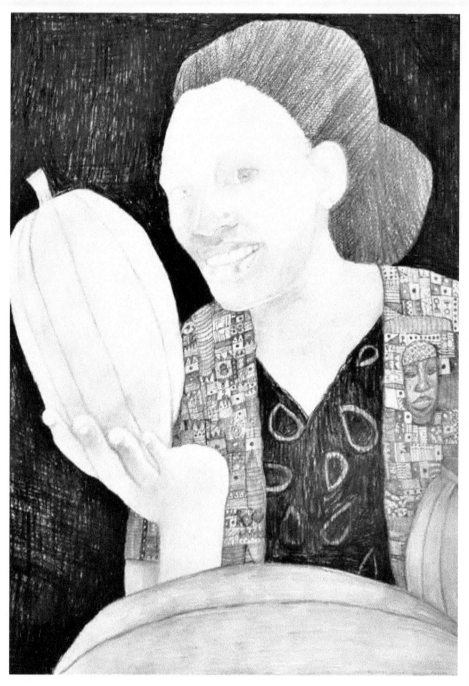

Janyce Denise Glasper, *Fruit of the Cacao Pod Laborer*, pencil, 2018.

same kind of emotional outlook. She has to use silver gelatin and a certain non-vegan Polaroid film. That's why I'm going back to basics, but it's harder for her.

As for oil paints and oil bars, I'm thankful that Winsor-Newton has a list of the colors that are vegan. Holbein watercolors are all vegan except for ivory black. It's nice to know that companies are actually thinking about veganism and letting vegans know that they can still use these products.

You've been vegetarian since your early teens—having suffered from what you call "meat depression" as a child.

My mom, and other relatives, were always pushing my siblings and me to eat everything on the plate. Once, it was really late, and I couldn't finish because it was so disgusting, but my mom sat there and waited. It was traumatic. "You eat this ham, or you eat nothing at all." My mom also knew I hated ham. School food wasn't great either; you're going from one bad place to another.

I've been a vegetarian since age fourteen, and I moved away from home at seventeen, but I wasn't eating well then either—a lot of pizza and ice cream. My diet got better once I turned vegan. I started to realize that vegetables have these potentials: making macaroni and cheese out of butternut squash, or amazing soups out of sweet potatoes. You find all these uses for things you don't eat often. I didn't eat avocados growing up. They're so versatile.

Being vegan has turned me into a more creative person in the kitchen—it's like mixing paints on your palette, throwing different colors together that you didn't think would work, but they *do* work. That's how it is when you're cooking in the kitchen with these different vegetables, turning them into things. I love zoodles. I love a zoodle salad and hot zoodles with alfredo sauce and cherry tomatoes.

Do you find that experimenting in the kitchen warms you up for more experimenting in your artistic practice?

It certainly does, especially since my work is shifting toward food—about chocolate, primarily. The whole experience of making my own chocolate [in Grenada] was something that I had to recreate in painting. The act of grinding, and then tasting that bitterness, that pure chocolate flavor.

Do you think you're a happier person now?

Yes. It feels empowering to get up every day knowing that you're not contributing to the pain and suffering that animals are going through day, noon, and night.

Plus taking control of one's destiny, health-wise?

I definitely feel that. Poverty can play a role in how people eat if they lack certain key tools of maintaining a fulfilling diet. The most affordable foods, the most convenient, seem to be foods without nutritional value. However, even in food deserts, it is possible to access healthy fruits, vegetables, and whole grains. McDonald's and corner stores prey on income vulnerability, but farmer's markets and grassroots farming co-ops are forming all over the country to break people away from bad food addiction. They're educating low-income families to prepare in-season fruits and vegetables and grow their own herbs at home.

I love how mindfully and joyously you express your creativity in every aspect of your life. What advice do you have for the person who wants to make art (or to live more creatively in general), but feels stymied for whatever reason?

First think about something that you really love or admire. For example, you're drawn to a pattern or a color or a series of interactions. Look at these images behind you *[gesturing to a batik wall panel]*, where you have these elongated figures wearing colorful fabrics surrounded in a beautiful batiking process: concentrate on that thought and learn how you can mimic that. Start off by taking a class. When I started continuing education classes at PAFA, a lot of my classmates were saying "I'm doing portraiture for the first time" or "I'm drawing landscapes for the first time." It's important to have a beginning. Find someone who does something that you would like to do. Then create as well as only you can make it.

- afroveganchick.blogspot.com and femfilmrogues.blogspot.com
- blackartwriter
- @afroveganchick, @janycedeniseglasper, @femfilmrogue

© Dan Piraro, Bizarro syndicated daily comic, August 5, 2007.

Twilight Zone Redux

As a child of the eighties, I can claim Jim Henson, *Beetlejuice*, and *The Goonies* as firsthand creative influences. Another movie that kindled my instinct for storytelling was *Starman*, John Carpenter's 1984 road-trip drama. Jeff Bridges plays a benevolent alien who takes human form by cloning Karen Allen's dead husband, leading her on a three-day road trip from Wisconsin to Arizona to meet his spaceship at the bottom of a crater. I was really young the first time I saw this movie, but certain scenes were indelible: the Voyager space probe hurtling past the stars, beaming out an invitation to Earth; the brilliant blue ball of light rising out of the spacecraft wreckage and gliding across the lake in search of sentient life; a young widow drinking cheap red wine over home movies on an old-fashioned projector, eyes riveted to her husband's laughing face.

Watching this film again recently, my mouth fell open when Starman opens Jenny and Scott's scrapbook and uses a lock of Scott's hair to acquire a human body, the embryo turning to fetus turning to newborn and so on right there on the sitting-room rug. My first novel is about a scientist who clones her ancestor by the same means—effectively bringing someone back from the dead, just as Starman does—so I'm not kidding about those creative influences.

It's not a great film by any means, but *Starman* offers sensitive lead performances and social commentary that is satisfyingly unsubtle. At a truck-stop diner, Starman is appalled to find the body of a deer fastened to the hood of a pickup truck:

Starman: Dead deer? Why?
Jenny: People hunt them, to eat, for food.
Starman: Do deer eat people?
Jenny: No.
Starman: Do people eat people?
Jenny: No, no, of course not. What do you think we are?
Starman: I think you are a very primitive species.[134]

There is more than one knuckle-headed hunter at that truck stop, as it happens, and they're about to beat the crap out of Starman before Jenny helps him escape. This unflattering portrayal aligned with my worldview at the time, since my father always spoke of hunters as barbarians who got their jollies from shooting innocent creatures in the woods. Alex Hershaft, cofounder of the Farm Animal Rights Movement, tells me the 1975 CBS documentary, *The Guns of Autumn*, left a lot of Americans with that impression. "Hunting was men's earliest ego outlet," as Australian biologist Jeremy Griffith puts it.[135] It wouldn't occur to me until young adulthood that the predator-prey relationship exists between human and cow too; the only differences are that the domesticated animal has no hope of escape and the steak eater can pretend he isn't taking a life by proxy.

The "carnivorous alien-invasion scenario" sometimes comes up when herbivores and omnivores get to talking about their differences, and many writers and filmmakers have explored this hypothetical: what would happen if a technologically superior species alighted on our planet and decided on *us* as their primary food source? What logical protest could we make? It seems to be an argument each artist comes to on their own, making for a delightful number of variations. Syndicated cartoonist Dan Piraro has offered several over the years in his *Bizarro* column, one of which appears courtesy of the artist on the previous page. Storytellers have speculated about extraterrestrial life for hundreds if not thousands of years, and we started with the alien-invasion scenario even before NASA's heyday in the late 1960s, when pacifism was

turning out new vegetarians every day, and everybody was glued to their TV sets watching Armstrong and Aldrin take their historic stroll along the lunar surface. That classic *Twilight Zone* episode "To Serve Man," which first aired in 1962, was based on a short story by Damon Knight published in 1950. In this scenario, the aliens deceive us through a figure of speech, matter-of-factly announce the deception, and ultimately take our feelings and desires into account insofar as we ever took the pigs' and cows'.

The animal-rights subtext in Michel Faber's novel *Under the Skin* "is as subtle as a ten-car pile-up," writes one Goodreads user.[136] This is one of those stories that's difficult to discuss without dropping major spoilers, but I'll do my best. There's a chilling passage in which the anti-heroine watches one of her human captives scratching a message in the dirt: M-E-R-C-Y. She is bemused by this, because "the word was untranslatable into her own tongue; it was a concept that just didn't exist."[137] In an interview with the *Barcelona Review*, Faber says, "The trouble with our carnivorous society is that we have millions of people eating vast amounts of meat but not wanting to take moral responsibility for how it's produced. Animals can be cruelly treated and even genetically turned into monsters, as long as it all happens in secret and the result is disguised in a neat supermarket package."[138] Alas, Faber admits in the same interview that he is not a vegetarian himself.

Same goes for Mary Doria Russell, author of the sublime novels *The Sparrow* and *Children of God*: her human astronauts land on a planet inhabited by two sentient races, both with advanced language, society, and culture—and are horrified to discover that one species systematically culls and consumes the other. The title of the first novel is a reference to Matthew 10:29—"not a single sparrow falls to the ground without God's knowledge"—yet Russell writes about eating cows on her blog with an air of "life is short." For other creatures, it is.

Dick Gregory, the comedian and civil rights activist, employed this theme in a book published in 1973 encouraging African Americans to seek political empowerment through healthy eating. "By the time I was standing at the head of the table with my carving knife, I suddenly had the strangest thoughts," he writes in *Dick Gregory's Natural Diet for Folks Who Eat*. "I got to thinking that there

might be some beings on another planet somewhere who are as intelligent compared with us as we are compared with turkeys...I could just see myself in some strange planetary oven, being basted and roasted. It would be one thing to roast white folks brown; they'd be trying to figure out how to 'undone' us Black folks. I even thought about myself lying on a platter all filled with stuffing!"[139] Gregory goes on to imagine a butcher shop run by aliens, in which the categories of meat available would be not from cows, pigs, and chickens but Caucasian, Oriental, and Black. "After that little fantasy, I couldn't eat my Thanksgiving dinner." Gregory remained a committed and vocal vegan until his death in 2017. I was reminded of his disconcerting reverie when someone posted a photo of a grocery sale marker advertising Boneless Skinless Children's Thighs at a savings of eighty cents a pound, which smacks of subterfuge by a vegan employee. (One Reddit user quipped, "Do not leave children unattended at Whole Foods."[140])

But of all these variations, ethologist Jonathan Balcombe's is the most pointed: "If we heard of an alien civilization that takes babies away from mothers, eats the babies, and also consumes the mother's milk, we would probably not want to meet them."[141] This is the argument that most effectively shuts down the debate: one party says "That would never happen though," and the other replies, "That's not the point." (Besides: never say never.) In his 2013 TED talk, psychologist James Flynn says our IQ levels are higher than our grandparents' because our educational philosophy has evolved toward abstract thinking, and he offers the example of attempting to dialogue with elder generations on civil rights:

> When we said to our parents and grandparents, 'How would you feel if tomorrow morning you woke up Black?' they said, 'That is the dumbest thing you've ever said. Who have you ever known who woke up in the morning that turned Black?' In other words, they were fixed in the concrete mores and attitudes they had inherited. They would not take the hypothetical seriously, and without the hypothetical, it's very difficult to get moral argument off the ground.[142]

These abstract thinking skills allow us to envision ourselves in someone else's place, and to alter our behavior and mindset

accordingly—or at least that's what ought to happen. Self-help gurus and humanitarians talk a good talk about the uniquely human capacity for empathy, but most of us find it difficult to cast ourselves into the mind and heart of another, human or otherwise, so preoccupied are we with the differences we perceive. But as a species I believe we are subliminally aware of this defect, and that, through science-fiction and fantasy narratives like these, we are attempting to work through what I call "the empathy paradox": why do we care more about the tribulations of humans who don't exist than for the real-life animals who suffer and die to become the food we eat?

Humanity is enthralled with stars and orbits, the prospects of colonizing Mars and intergalactic space travel, reports of unidentified flying objects. We are obsessed with the possibility of transcending our own technological limitations, but we are striving for the wrong sort of progress. The real work of transcending ourselves begins in our factory farms and laboratories. It begins on our plates.

A Conversation with Alec Thibodeau

Alec Thibodeau is a visual artist based in Providence. We met up for milkshakes at Like No Udder, a vegan ice cream parlor for which Alec painted an interior mural and a cut-out board where kids can get their picture taken. His postcards and buttons are for sale at the register.

Your print *Funktionslust for All of Us* is so gorgeous!

Funktionslust is a German word, and it essentially means what each of us is good at—being able to live a life where we're expressing what we do well and what we're talented at. I learned it from this book called *When Elephants Weep: The Emotional Lives of Animals* by Jeffrey Moussaieff Masson. The book explicitly uses it within the context of animals being free to do what they're meant to do: what *they're* good at, what *they* like.

How did you start to recognize the *Funktionslust* of other beings?

When I was growing up, there were certain meat dishes that would gross me out, and, when I was in my late teens, I started a gradual transition into vegetarianism. When I was in college, I worked in the science library, and I had all this time to sort books and walk around and tidy up. I happened upon a section of books on factory farming. There was this one book talking about chicken debeaking, and I thought, "Wait, that actually happens?!" I was nineteen years old. No one told me about this, except for this really obscure book tucked away in this science library on a college campus. *How come people aren't talking about that?*

I've always been somebody who's been willing to try different things. I've been a musician, I've done stage acting, I'm primarily a visual artist, and I'm learning about computers now. Veganism felt like an interesting personal challenge, and it was also stimulating this intellectual curiosity I had.

How long have you been vegan?

It's about fifteen years now. And I don't see any reason to go back.

So, you found that book and thought, "my eating eggs is contributing to this system"?

I was still experiencing cognitive dissonance. There are a lot of people out there—and I was one of them—who say, "Yeah, I know this is bad, but what are you going to do?"

How I respond to that is, "I can make you a list of very simple things you can stop doing immediately."

I know. And I think about this every day: what you put into your own body is the one decision you shouldn't have to defer to anybody on, regardless of who it is. If you're going to live as a free individual—with *Funktionslust*—at the very least you should be able to say, "No, I'm not going to have that," and nobody should be able to hassle you. But at that time, I didn't know how yet. I didn't know any vegans. I remember buying tofu when I was a teenager, because I'd heard about it. I opened it up, and it's this weird wiggly block of white stuff, and it doesn't taste like anything compared to what I had been eating. I tried to cook it, and it didn't go anywhere. But if you're a kid in the middle of anywhere now, you can go online and find amazing tofu recipes. Someone who is motivated can find answers.

Tell me about the pro-vegan mural you did that's in the collection of the City of New York.

It's a mastodon: a combination of sandblasting and painting. Current research shows that humans wiped them out. Humans have been creating an imbalance in the environment for about ten thousand years. Animals are the basis of my artwork, so it feels like it would be wrong for me to exploit them, because they're my livelihood. People like them because the first artwork was *of* animals. The cave paintings. There are these beautiful renditions of these animals, and they're not necessarily hunting scenes. People were observing what was going on around them.

I've done drawings of people before, but it's loaded to do a drawing of a person, right? It's always *of* somebody. We are coded to be social animals, to recognize faces, to size people up. It's fun to

draw animals because the work can hit someone in a more immediate way. The things with animals on them, people like them more.

My sense is that you've figured out what you like, what you're good at, and what resonates, and you've found that sweet spot at the center.

It's been nice. That piece in New York is supposed to be permanent. It'll be up there long after I'm gone—it's literally set in stone.

© Alec Thibodeau, *Funktionslust for All of Us*, screen print, 2018.

Does that blow your mind?

I feel honored. Little kids get to see it every day, and they can touch it! So much art can't be touched. You can't go into a museum and rub your hands over a Picasso. It's a life-size mastodon, and kids can ask questions about it and see an animal at scale. They don't have to experience going to a zoo to see a big animal and compare themselves in size. I was inspired by a pond in that neighborhood, where in the 1800s there were mastodon bones found when the city was dredging it.

Before versus after you went vegan, how you felt when you were creating—did you notice a difference?

Veganism is a practice, it's a mindset—having a sense of discipline, getting up every day and reaffirming it, helped me organize my thoughts and my creativity. It made me a more conscientious person in terms of how I fit in with the rest of the world. Every artist thinks, "What is the point of this? Am I doing this just to amuse myself?" Which a lot of artists do, and there's nothing wrong with that. I have a six-year-old niece in Maine, and we have this drawing we're working on. It's an accordion-style piece of paper, so I'll do one panel and mail it to her, and when we've filled it up, we'll start a new one. She's really talented. That's an audience of just her and me, but it's making a connection with someone. I don't think I could make art that wasn't ultimately destined for someone to see.

Veganism was a way to organize what's important to me. Being an artist, being a vegan; it all fit together. I felt like I needed to make some sort of contribution, even if it was just on an aesthetic platform. Making nice things that resonate with people, bringing a little bit of joy into their lives. That's worthwhile. And it's really humbling and wonderful to know that most people who see my work have that reaction, and I don't even get to see it. But I can imagine that they're out there, and they're responding, and that's sustaining.

At the time, I felt I needed to do something radical in my own life to make up for what was very chaotic about the world. There needed to be some sort of order imposed, even if it was just me imposing something on myself. I saw a lot of cruelty and violence and suffering that people were causing to other people and to animals, and I thought, "I've got to find a way to wrap my head around this." Veganism was a piece of what I was doing in my life at the time: I had this studio downtown I was sharing with other artists, and everything was clicking. I felt very dialed into making work and being vegan. I had studied art in school, but a lot of these techniques that people appreciate in my work now were self-taught later on. I dove into pen-and-ink techniques, and researching vegan art supplies, and looking at the work of other artists. I'm more optimistic than I used to be. Maybe I have a more nuanced view of the world now.

What kind of art do you see yourself making in the future?

It would be fun to do more 3D stuff, but I do like making work for reproduction: prints, postcards, seen by lots of people (and my drawing style evolved to handle that—I developed this style of making lines that would translate to screen printing). More animals, ideally bigger pieces. After the New York project, I had this momentum where I thought I'd do more public art, but it's a tricky field to get into. There's a lot of risk. I was one of four finalists for this piece in New York, and I happened to be the one who got it, but the other three finalists had to make a presentation and spend time researching the site too. And it's usually a big budget over a period of years, and I like things to turn over more quickly.

◉ www.huetown.com
◉ @huetown

Foraging for rosehips at Horseneck Beach, MA.

The Edible Woods

I have always wanted to be the kind of person who ventures into a lush green forest with an empty basket. While some scroll through their Instagram feeds envying other people's six-pack abs and exotic vacations, I'm wishing I could be one of those foragers harvesting elderflowers for cordial or showing off a massive haul of hen-of-the-woods mushrooms. It's the most practical hobby imaginable: not only are you finding free food, some of which you rarely see in the grocery store (like ramps and fiddleheads, which are very pricey because Whole Foods is paying people to forage them for you), but it's likely more nutritious because Big Ag hasn't wrung all the vitamins out of it. Foraging simultaneously appeals to my *Parable-of-the-Sower*-grade apocalypse anxiety and my fantasy of living in a pretty little cottage in the forest with a well and a vintage hand pump right in my kitchen. At any rate, I want to stop *talking* about living closer to nature and actually learn something that will allow me to do so.

Local farms and nature reserves often sponsor guided walks, but finding someone to take you on a one-on-one hike is

an expensive proposition. Foragers can be very territorial, which doesn't seem so stingy when you consider that some people over-harvest with no concern for sustainability. And there's only so much you can learn from a book.

My roommate Rachel and I go on a guided mushroom walk at Ballard Park in Newport, Rhode Island, a beautiful wooded nature reserve that was a working quarry in the nineteenth century. Our guides, Emily Schmidt and Ryan Bouchard, explain the symbiotic relationship between trees and fungi and say they don't recommend gilled mushrooms for beginners, as there are about a dozen deadly gilled species. ("There was a guy who survived eating a death cap," Ryan says, "and he said it was really, really good."[143]) The edibility of most of the mushrooms you'll see is questionable, so you've really got to learn one species at a time.

Nature astonishes us: there is a mycelium growing under the earth in Oregon that is bigger than a whale (it's the largest known organism on the planet, and likely the oldest[144]), and a tree can be dying for longer than the longest human lifespan. But my biggest takeaway from this walk is that if you want to start foraging by learning your mushrooms, you have to be very, *very* patient. I decide to start with foods there's no chance of mis-identifying and learn my way from there.

Dandelions

In his *Complete Herbal* (first published in England in 1653), the English botanist Nicholas Culpeper informs us that dandelions, "vulgarly called Piss-a-beds," can help clear liver, gall, and spleen obstructions.[145] "[T]he distilled water is effectual to drink in pestilential fevers, and to wash the sores." Praise Heaven I suffer from none of these ailments, but I still want to forage them for some sort of beverage. Dutch "plant activist" and vegan cookbook author Lisette Kreischer posts a photo of her "dandelion elixir,"[146] luminous yellow in a perfect vintage bottle, and I *want* that color even more than I'm curious about the taste.

It's early June, so the dandelions aren't growing as riotously as they do in the spring. I'm staying with my parents for the month, and I avoid foraging in suburbia because pesticide usage is so common—they say you're safer foraging in urban areas, ironically—

but then I figure if someone's using pesticides on their lawn, then there wouldn't be dandelions growing. So, one early evening I walk the fifteen minutes to the public library, like I used to when I lived at home in my early thirties. I actually have to search for dandelion flowers, but the next morning they are abundant. How have I not noticed how quickly plants can grow? And in all that time walking to and from the library almost every day, I never noticed the tiny wild raspberries growing under blades of grass on the lawn of our local suffragist's ancestral home.

Lisette's Instagram caption offers a method but no measurements or proportions. After simmering on the stove and sitting for twenty-four hours my dandelion collection yields 2 ¾ cups of decoction, to which I add ¾ cup apple cider vinegar and ¼ cup agave (Lisette recommends rice syrup, but I use what I have on hand). My "elixir" comes out worryingly murky (probably because I didn't pull off the green bits at the base of each flower, the involucres—a word I had to Google for), but it tastes as I imagine it should: like grass, admittedly. But it also tastes like the hour after our return to the family vacation house in the Poconos, chasing my sister through the chest-high grass in the backyard while my grandparents pushed the lawnmowers out to the tree line and back. It tastes like a nine-mile ramble in Tipperary with my best friend, sitting by a stream in a bluebell wood in the dappled sunlight, and eating dandelion heads we plucked from the side of the road.

It's too much vinegar and not enough sweetener, but I drink it anyway, three fingers of murky golden liquid in a drinking glass filled to the top with seltzer and ice. I give my mom a taste, and she pulls the same face she makes after a bite of kimchi or a sip of kombucha. One week and I've finished the jar.

Wild Cherries

Two wild cherry trees stand at the bottom of my parents' yard, here long before the house was built in the early '90s. On the far side of the five-foot wooden fence lies an unruly tangle of trees and undergrowth, beyond that a field that hasn't been tilled in years. There's a fluorescent green hammock I brought back from a trip to Colombia several years ago, strung between an oak and one of the cherry trees.

At least three groundhogs have tunneled under the neighbors' shed. Their names are Charlie, the big one, and his offspring Frank and Charlie Junior, as christened by my stepdad. I watch from the kitchen window as they waddle across the lawn under the cherry trees. It's mid-June, and the fruit has begun to drop.

My mom and stepdad have lived in this house since I was twelve, but this is only the second time I've harvested the cherries intending to bake anything with them. Most people would say they're too sour for eating raw. The first time, a few years ago, my niece and I picked them together and baked them into miniature pies using a muffin tin. This time I'll stew the cherries beforehand and do little lattices on top.

One warm Sunday evening, I move through the grass in my bare feet picking cherries, smaller and a brighter shade of red than the kind you get at the grocery store, and then, for the better part of an hour, I stand at the kitchen sink halving the cherries and discarding the pits. I don't remember the de-pitting taking so long last time, and I have to toss several because there are bugs inside. But the dozen mini pies we get out of this will be worth the trouble.

Does it count as foraging if it grows in your own backyard? Perhaps not. But free food is free food!

Rosehips

In July we celebrate our friend Casandra's birthday at the campground at Horseneck Beach on the South Shore of Massachusetts. The dunes above the rocky shoreline are covered in thorny swaths of pink and white beach roses, most of which are past their prime. But "[i]f you keep an eye on any single [wild] rose after it blooms, you will notice that once it drops its petals, the base of the former flower begins to swell into a green orb," Leda Meredith writes in *Northeast Foraging*. "That is a rose hip in the making."[147]

At first, I thought they were beach plums, which shows you how little I know. The hips are mostly pale orange, and at least I can tell they're not ready for picking. But we'll be camping here again in mid-August, and I resolve to forage. In the meantime, I learn that because three rosehips contain as much vitamin C as one large orange, folks living in rural England during World War II would harvest them for medicinal rosehip syrup used in hospitals (at home and abroad) after lemons and oranges became scarce.[148] I

learn from another northeast foraging guide that this species, *Rosa rugosa*, was brought here from Asia by colonial seafarers.[149] Most sources say rosehips are best harvested after the first frost, when the orbs turn dark red and grow much sweeter, but the last time I camped in New England in the autumn I couldn't get warm no matter how many layers of sweaters and blankets. And anyhow, if the birds think they're ready to eat, then so do I.

So, we come back to Horseneck, and at sunset Rachel and I harvest a basketful of red and dark-orange rosehips. The next morning, I'm still picking the tiny prickles out of the flesh between my thumb and forefinger. More Googling: jam or jelly? vinegar? cordial? Dan suggests infused vodka. Home again, I buy a bottle of Everclear from the liquor store down the street, trim and wash the rosehips, run a few handfuls at a time through the food processor (seeds, hairy pith, and all), pour everything into a half-gallon Ball jar, and give it a good shake before leaving it on a high shelf to infuse. Turns out we've gathered six pounds of fruit, enough to make rosehip liqueur *and* cordial for the teetotalers *and* vinegar for salad dressing. When I go to Newport with Dan in mid-September, I'm excited to see the cliff walk dotted with hedges of *Rosa rugosa*, and though we haven't had a cold night yet, most of the rosehips are between slightly overripe and rotting. I'm glad Rachel and I harvested them when we did.

···

I was midway through drafting this chapter when my friend Marika came to visit. After writing together at the Athenaeum, we were walking down Benefit Street when Marika suddenly plucked a small green apple from a tree and ate the whole thing in a few bites. How had I never noticed that the trees lining this lovely historic street bore edible fruit? No one else was eating any of it, apparently, and it seemed unlikely any of the owners would mind if we took some. They were tart and sweet, like little Granny Smiths.

Now there were apple trees everywhere we looked. Marika told me that in the middle ages, fruits like this were called "lady apples" because women would eat them to sweeten their breath. She climbed trees and tossed them down to me, and we walked through the city together, chatting away as we snacked on foraged apples.

Miniature Wild Cherry Pies

I love baking muffin-sized pies: they're so neat and cute and portion sized.

Pastry crust *[essentially Julia Child's classic recipe, veganized]:*

2 ½ cups plus 2 tbsp. organic unbleached flour
¾ of a stick (6 tbsp.) of chilled vegan butter (I used Earth Balance)
¾ cup plus 3 tbsp. vegan shortening (I used Spectrum)
1 ½ tsp. salt
⅓ cup cold water

Filling:

3 ½ lb. wild cherries
¼ to ⅓ cup maple syrup
1 tsp. vanilla extract
¼ cup cornstarch whisked in 2 tbsp. water

You'll also need:

- A muffin tin (ideally two in case you have enough ingredients for a dozen plus two to four extra pies)
- A rolling pin
- Pie weights (alternatively, you can use unbleached/undyed paper baking cups weighted with dried beans or legumes)

Optional: 1 tbsp. organic cane sugar plus 2 tbsp. melted vegan butter for brushing and sprinkling on the lattice crust

Prepare the dough ahead of time: mixing salt into flour, add butter and shortening in chunks and work together in a stand mixer or by hand, adding cold water until fully combined. Refrigerate dough for two hours.

Take care to remove the pit from every cherry. (I texted Dan when I found one in my pie—my own fault—and he replied, "At least it wasn't a Band-Aid!") In a saucepan, stew cherries on medium heat, stirring in maple syrup, vanilla, and the cornstarch mixture once the cherries have begun to release their juice. Stew for twenty to thirty minutes, stirring regularly, until the liquid has mostly evaporated.

The filling should be somewhat sticky but not too thick.

(Table runner crocheted by my great-grandmother Antoinette.)

Preheat the oven to 400 degrees Fahrenheit. Roll out the dough to ¼" and use a pint glass or other wide-mouthed cup to form even circles to press into muffin tin for pie bases. (You don't have to grease the tin.) You'll need the pie weights to prevent the dough from rising as you pre-bake for twelve minutes until lightly golden. This makes a nice sturdy crust that will hold the filling.

After pre-baking, lower oven temperature to 375 degrees. Take the muffin tin out of the oven and fill with stewed cherry mixture, pressing down gently into cup with spoon. The cups should be no more than two-thirds full. Cut dough into ribbons roughly 3/8" wide and create a lattice top with four ribbons each for "warp" and "weft," pressing ends against the rim of the pastry base to seal the pies. You don't want to see any filling through the lattice or else the cherry juice will bubble over (even if you haven't overfilled the cups). See bit.ly/cometparty-lattice for a quick lattice-making demo.

Brush lattice tops with vegan butter and sprinkle with cane sugar, if using, and bake at 375 degrees for 30 minutes until lattice is golden.

Yields at least one dozen. Best enjoyed warm. Forks optional but napkins recommended!

Rosehip recipes generally instruct you to halve the fruits and scoop out the seeds, but this is unnecessarily tedious. For these infusions I roughly chopped the whole fruits in a food processor and skimmed off the seeds after shaking the jar (or while warming on the stove, in the case of the cordial). The seeds will rise to the top, and you may skim off a cup or more.

When your infusion is ready, pour the contents of the jar through a mesh strainer into a large bowl, pressing the pulp with a potato masher to extract more liquid. Strain a second time through cheesecloth into a clean sanitized jar. (These infusions make lovely gifts; I purchased recycled-glass bottles from SpecialtyBottle.com, or you can just reuse bottles from the grocery store.)

Vinegar

 1 lb. rosehips, trimmed, rinsed, and chopped
 one 17-ounce bottle of white wine vinegar or white balsamic vinegar

Pour ingredients into a half-gallon Ball jar (a quart jar is a bit too small), shake well, skim seeds, reseal, and store for up to one month, shaking periodically.

Once you've clarified your infusion, you can either keep it in the fridge (if you'll be using it within three months) or pasteurize for long-term storage at room temperature. To pasteurize: clean, sanitize, and warm the storage jar in the oven at 150 degrees Fahrenheit. Meanwhile, simmer vinegar on the stove for ten minutes, being careful not to boil. Let cool and pour into sanitized storage jar. Yields 2 ⅓ cups.

Liqueur

- 1 ½ lb. rosehips, trimmed, rinsed, and chopped
- 1-liter bottle of Everclear or vodka
- 1 cup simple syrup *(see note)*

Infuse fruit in liquor for up to one month. After clarifying, add simple syrup and shake well to combine. (Needless to say, this stuff is *powerful*. You definitely won't want to drink it straight! Mixes well with prosecco or seltzer.) Yields 4 ¾ cups.

Cordial (Non-Alcoholic)

- 2 ½ lb. rosehips, trimmed, rinsed, and chopped
- 1 ½ gallons filtered water
- ¾ to 1 cup cardamom simple syrup *(see note)*

Simmer fruit in half gallon of filtered water for at least an hour, but the longer the better, skimming off the seeds at the start and adding a second half gallon of water when the mixture has boiled down. I let mine sit in the pot for a few days in the refrigerator for good measure. Skim liquid, return solids to stove, add final half gallon, and simmer for another half hour. Skim and clarify into two sterilized half-gallon Ball jars, adding half the infused simple syrup into each and shaking thoroughly to mix.

Store in the refrigerator. Drink straight or cut with seltzer. Yields 12 cups.

Note: How to Make Simple Syrup

Simple syrup is made by dissolving one part (organic, Fair Trade) cane sugar into one part boiling water and allowing to cool. You can do this on the stove, but a more efficient method (which I learned while working at VO2 Vegan Café in Cambridge, MA) is to pour the boiling water into the sugar in a Ball jar, seal the jar and wrap in a kitchen towel, and shake gently until the sugar is dissolved. This way you can store the simple syrup in the jar without having to wash a pan.

For cardamom simple syrup, add ¼ cup whole cardamom pods to the jar, shake well, and let infuse for up to three days. Use the leftover syrup in your morning coffee or in homemade lemonade or gingerade.

A Q&A with Tanya O'Callaghan

Tanya O'Callaghan is a bassist who has worked in studios and with musicians, bands, and shows as diverse as Dee Snider (Twisted Sister), Steven Adler (Guns 'n Roses), Maynard James Keenan (Tool), The Riverdance, Nuno Bettencourt, The Voice, and many more. Originally from Mullingar, Ireland, she's now based in Los Angeles.

Were you a musician before you picked up the bass?

I was not actually; I came to music late. Although a major music fan and avid concertgoer throughout my teens and my dad having an amazing vinyl connection I was subconsciously taking in growing up, there are actually no musicians in my direct family. I was a full-blown animal-rights worker from eight to eighteen years old. I spent *all* of my time other than having to go to school at shelters volunteering, working on rescue missions and organizing fundraisers for animal charities. Everyone thought I was destined to be a vet, or at one point I took a notion of becoming a marine biologist, until I discovered I would have to dissect sea life, and sadly I have a biological predisposition to extreme sea sickness, so that idea did not come to fruition. *[laughs]*

You stopped eating meat when you were only five years old. Tell us about the animals you were friends with back then.

Right from when I could walk, I was bringing home strays. My granny on my mum's side lived with us for many years, as my mum was her primary caregiver and she would let me climb in her window to sneak animals in and try to hide them from my parents. One time I placed a pregnant cat in her wardrobe, and suffice to say that was quite the discovery by my parents. So, we ended up with mamma cat and kittens becoming part of the O'Callaghan family upon relocation to the garden shed. Another young memory is of a

chicken somehow ending up in our housing estate and me taking responsibility for her along with my tail-less cat at that time, Lucky. And so, I had an odd duo of Clucky and Lucky.

Tell me about your experience of going vegan—was it a quick decision for you, or did you move toward it over time?

So, after stopping eating meat so young, I was a vegetarian in theory, but I didn't eat a lot of dairy by nature, I never liked drinking milk or eating yogurts, so other than cheese I was pretty much plant based, potatoes and veg all the way. Growing up in small-town Ireland, we'd never heard of vegans, nor did I know what that was until my teens.

Then I met a vegan in my mid-teens, and it blew my mind talking to this guy. Once I discovered the horrors of the dairy and egg industries, I started to research and phase out all animal products. I have to hand it to my parents for all their support, although at the start of my veggie declaration, and out of pure health concern and lack of information available at the time on how a veggie diet is perfectly healthy, my mum did try to hide meat in dishes because she was getting ridiculous information and was terrified I would die from a protein deficiency. *[laughs]* Then at some point around seven years old or so, and after an awesome Indian doctor coming to our town and stating that the majority of his country are vegetarian and perfectly healthy, my parents took a look at me running around like a little maniac activist full of energy and figured "hey, she seems to be doing just fine."

It must have taken a lot of courage to move from Ireland to LA to pursue your music career. Have you found a supportive creative community in LA? What advice would you give to a young adult who's contemplating taking a leap of that magnitude?

It is not for the faint-hearted, moving to the far side of the world on a wing and prayer. I made a giant leap of faith because I could have stayed in Ireland and made a decent living continuing to play in multiple wedding and corporate bands; I had carved a name for myself in the Irish music scene with original and covers bands, but I just didn't feel excited anymore even though I was very busy with multiple bands.

To summarize a long story of many ups and downs, I've learned from experience that there are many sharks in this industry and in general, especially when you're young, talented, and new in town: experiencing all the flakiness you can imagine, and people promising you all sorts of opportunities, but the majority being smoke and mirrors. Thousands of business-card exchanges later, these past few years most certainly nudged me from a somewhat (although street-smart) naive young woman to a very sharp intuitive woman. I now have an *amazing* group of friends in LA; I'm so blessed with my circle of friends and supportive musician colleagues. There is a huge difference between friends and acquaintances—know that—so make sure to surround yourself with good, supportive people who want to see you do well and whom you support in their goals. You need all the emotional and creative support possible when making such a huge life shift.

Has veganism had any effect on your self-esteem and your mental and emotional well-being?

Hmmm, that's a great question. I think because I've followed this "way of life" all my life, it's not something I've really thought about, but more just that I couldn't possibly comprehend living any other way once I discovered the truth about the meat and dairy industries all those years ago. It's always just felt like a no-brainer to me, and so simple and clean. Being firm in one's beliefs and knowing you're living the lifestyle that is morally right for you is good for your emotional well-being by default. I could never in my wildest dreams imagine eating meat or dairy now because of the images that come into my mind when I see those products; no matter how you dress it up, dead flesh is dead flesh, and "milk" is now a glass of pus, antibiotics, and hormones to my eyes. Once those dots are really connected, taste goes out of the equation, and you see what your brain now knows. Nobody wants to see animals suffer for their food; the industries have just done an incredible job of hiding it in plain sight and using super clever marketing to make us feel better about buying their products. Cognitive dissonance is a global phenomenon.

How do you stay centered in the midst of a busy touring and recording schedule?

It can be easy to get exhausted and burned out when touring heavy or just juggling multiple projects. It's important to try to keep somewhat of a routine when touring, that can get tricky with long hauls and time zone changes, but personally that's what keeps me functioning, trying to stick to a relatively normal sleep schedule in whatever time zone you land, and eating clean. I never eat crap just because it's there. I'll always have healthier snacks, nuts, fruit, popcorn, to get me by until I find some healthy fuel. And yoga, I'm not a pro by any means, but I try to do a little wherever I am, even just fifteen minutes in the hotel room, or at the venues. Stretching your body is important when flying and traveling a lot. And I always have books with me and the essential oils I love, little things to have a sense of home on the road. And when time permits, getting out and seeing the country, cities, towns you're in. Travel excitement trumps any exhaustion level; there's nothing like being somewhere totally new.

Tanya with Forgiveness, a rescued veal calf at the Gentle Barn Sanctuary in Santa Clarita, CA

Which foods do you reach for when you have a long day ahead of you?

My one vice is coffee, and if it's a super long day it'll be a large iced one with coconut milk or whatever other milks are available. If I'm flying, I'll pack snacks because airplane food makes me feel sick, all the additives, I guess. I'll usually have nuts, maybe a pre-made wrap, some popcorn, dark chocolate.

I'll have a big breakfast if I know it's gonna be a long day, oatmeal with lots of goodies loaded on top. If it's a long day locally, studio or rehearsals, I'll make the band come on a food adventure nearby on our break! It's especially fun if the band members are all heavy meat eaters and you bring them for an amazing vegan meal and watch all the pleasantly surprised faces. Some of my funniest memories are of taking the entire Dee/Twisted Sister crew (all big, burly, old-school road dudes) and the band out to vegan joints, everywhere from Germany to Bolivia, Bulgaria to New York—their faces at first, but then great food is great food, and many an amazing meal was shared.

⊚ www.tanyaocallaghan.com
⊚ @tanyaocallaghan_official

Straight-Edge Cinderella

"I'm tempted to say that it's less a high-energy diet and more a periodic inducer of euphoria," blogger Andrew Perlot writes of his raw-food lifestyle. "This afternoon I came back in from a ten-mile run and some other exercising and devoured four large cantaloupe[s]—some of the best I've ever had. For the next three hours I was just blissed out."[150]

"*Four* cantaloupes in one sitting!" I laugh to Rachel. "I'd be so sick of cantaloupe I wouldn't be able to eat it again for years." It is a peculiar irony how junk-food vegans tend to react with skepticism to those of us who adhere to raw-food, liquid, or fruitarian diets, as if we ourselves haven't been on the receiving end of so much cynicism and hostility from meat eaters. We call these diets "too restrictive," but maybe the truth is that euphoria is scary. What might you be capable of if you could feel light and satisfied and happy *all the time*? You take on a new kind of responsibility when you probe the edges of your potential, and most of us prefer the certainty of the small and the familiar.

I've been wanting to do "Rawgust" for years—eating as close to a raw-food diet as is feasible for the whole month of August—and maybe it's been a mix of all these things keeping me from trying it. I have to remind myself of psychologist Carol Dweck's mindset theory, that for all my talk of the link between plant-based diets and creativity, I myself exhibit a fixed mindset regarding raw-foodism. You can't call yourself open-minded unless you try the things you're initially skeptical of, and *not* with an attitude that leads to a predetermined outcome. For instance, if I go into a month-long raw-food experiment expecting to feel tired and unsatisfied no matter how much and how well I eat, then that is likely what I will experience. Conversely, if I expect to feel lighter and more energetic, then will I?

Besides, I want to learn how to cook without cooking—raw foods can't be heated past 115 degrees Fahrenheit—and I often say I want to acquire a new skill or try something different, but if I don't lay out a specific challenge for myself then I'm unlikely to follow through. So, the last week of July I start Googling for raw recipes and decide on my parameters: as raw as possible, no caffeine (excepting

kombucha), no alcohol, a minimum of refined sugar. Cutting out coffee is going to be the toughest part—I know it's to blame for the energy slump I feel most afternoons, and after reading *Sistah Vegan* I've been thinking about how Dr. Harper refers to coffee and chocolate as "your addictive substances." Even when you buy Fair Trade—the only ethical choice when it comes to these products—over time you may start to feel uncomfortable with how reliant your system becomes upon them. There are much healthier and more sustainable sources of energy.

I order a copy of Jennifer Cornbleet's *Raw Food Made Easy for One or Two People* and bookmark the walnut pâté, zucchini hummus, no-tuna pâté. On the evening of July 31, Rachel and I joke about stuffing my face before the little green numerals on the oven display turn to 12:00, although I've already been eating a lot of big salads over the past couple days. I have a quart of my favorite Italian gazpacho left over from a trip home to New Jersey. This isn't going to be hard.

We go to Trader Joe's, and I load up on produce, dried fruit, and raw nuts, and, when we get home, I put the food processor to work making my friend Dianne Wenz's recipe for basil cashew ricotta. I massage and marinate broccoli and red onion in a balsamic-mustard dressing. I've already got cashew chèvre with chives (cultured using miso) in the fridge, and I've also made a batch of tangy delicious beet kimchi. Parsley's the only thing keeping the walnut pâté from looking like cat food, but umami-wise it is on point. With so many mezze items in the fridge, getting my lunch together is fast and easy, and I can fix myself a big salad for dinner using two or three of the sides. I eat the dips with carrot and celery sticks, although I do occasionally cheat with seaweed crackers. Sure, now and again I dream of an all-you-can-eat Indian lunch buffet, vegetable samosas and mint chutney and chana masala on basmati rice, but not nearly as often as if I were doing this challenge in the fall or winter. I use up my refined-sugar allowance on weekly trips to Like No Udder, the vegan ice cream parlor down the street, but I only get one scoop instead of my usual two or three.

Five days into Rawgust, I decide on a three-day juice fast. I'd attempted this once before, soon after moving to Boston in the spring of 2013. I was living and working in a residence hall for

international students, and my boss and I had become good friends. I kept my juicer in his kitchen. Sometimes we'd do classic combos like carrot-apple-celery-ginger, and other times we'd experiment and wind up with something sludgy. I juiced a head of broccoli and will spare you an explanation as to why I regretted it. (Don't juice sweet potato, either; it tastes like the dry cleaners.)

Alex was talking about wanting to clean up his diet—*Fat, Sick, and Nearly Dead* was the health documentary of the moment—and I wanted to see what effect a juice fast would have on my energy level, mood, and creativity. So, we decided to try it—three days without food, only fresh juice—starting Sunday, April 14. Day one was fine and dandy: we just kept juicing and drinking until we weren't hungry anymore. Day two started off well, but you will recall what happened at the Boston Marathon on April 15, 2013. Alex hurried downtown to round up our students, and I reached for a bag of cashews as I listened to the news updates.

Barring calamity, this time I'm determined to last the full three days. Day one is hard even though I'm drinking until I'm full (176 ounces total over the course of the day). I tell myself, "If Dick Gregory can drink nothing but juice for years to protest the Vietnam War, then you can go without solid food for three measly days." I've loaded the fridge with beets and honey crisp apples and luscious fat cucumbers, but it is *also* still full of the surprisingly satisfying raw salads and dips I made at the start of the month. Watermelon juice may be the elixir of the gods, but I want the *feast*.

The second and third days are much easier, and I don't even drink as much as I did on day one. My teeth start to feel a bit furry, but a quick Google search tells me this is normal, and to make it go away I can drink apple cider vinegar or a bit of grated ginger in hot water. And another funny thing happens: I go from daydreaming about dal and rice and cashew mac 'n cheese and oyster-mushroom po'boys to lusting for broccoli and nut dips. After the third day, waking after midnight to answer the call of nature, I grab the walnut pâté from the fridge and savor every bite. I've tricked myself into loving raw food.

The zucchini hummus from Jennifer Cornbleet's cookbook turns out on the thin side, so I add almond milk and nutritional yeast

and blend it into soup instead. I try a pizza recipe from a popular raw vegan food blog, and while the bell-pepper-and-three-seed "crust" is a bust—you're supposed to bake it for three to five hours at the oven's lowest setting, but it's still wet after hour six—being half Italian, the raw tomato sauce (with miso paste and sun-dried tomatoes) is nothing short of a revelation to me. I use the sauce for zoodles instead, and because working my new deluxe spiralizer reminds me of a Play-Doh Fun Factory, I end up eating zoodles for three days straight. A cashew-avocado "alfredo" is my other favorite sauce. One night I eat nothing but fruit for dinner—strawberries and green grapes and cherries and figs and wild Maine blueberries, much more flavorful than the farmed kind—and it is *wonderful*. A smoothie is the perfect fuel for an evening writing session—I get a nice shot of energy without any jangling nerves or insomnia. The one time I cheat with a plate of soul food at Black VegFest— mistakenly thinking there are no raw-food vendors—the food is delicious, but I lose a bit of my spring.

Otherwise I feel sharp throughout the afternoon, I can tell I'm losing a bit of weight (not that I needed to), and with the additional fresh produce in my diet I'm especially well hydrated. I go out to restaurants and watch my companions eating barbecue cauliflower sandwiches and seitan bangers and mash, and I feel content with my big salad. When I walk into Dunwell Doughnuts in Brooklyn with a friend, I take a happy little whiff of the sugary air and walk out again—it's so much better than the slow, heavy feeling I get after actually eating a doughnut. A few years ago, my friends knew they could rely on me to show up at any party with a dozen frosted vegan cupcakes, but these days I'd rather bring something sweetened with dates, and even then, I'd prefer fruit for dessert. I have reprogrammed my taste buds.

This experiment has been unavoidably meta—the diet having fueled the work of writing about the diet—and I own that I'm even more invested in its success than I already am when it comes to eating vegan. I'm still skeptical about a hundred percent raw-food diet because it can too easily start to resemble a purity contest—*I NEVER have to read labels because I ONLY eat whole foods*—and Andrew Perlot is probably not going to convince me to stop eating garlic, but the concept of a high-raw diet is very appealing. That way

I can hopefully maintain this energy and mood level without losing beans, roasted eggplant, sweet potato, Brussels sprouts, and the occasional indulgence. I can enjoy eating and sharing a meal as much as I always have, perhaps even more so.

Mind you, I am not a nutritionist or a dietitian, but as someone who has now tried pretty much every system of eating apart from "breatharianism," I can tell you that intentionally adding more fresh fruits and vegetables to your diet is going to make you feel better in ways you won't anticipate. How often do we convince ourselves we know which foods are best for us without ever experimenting to find out how right (or wrong) we actually are? That old new-age advice about "releasing what's no longer serving you" applies not just to toxic relationships, foods, and habits, but to those things that are only fair and passable too. When there is food in the world that will make your cells sing like an interfaith choir, why subsist on anything else?

Cabbageless Kimchi

Merriam-Webster defines kimchi as "spicy pickled cabbage, the national dish of Korea." While the side dish is traditionally made with cabbage, you can use any vegetable that won't get mushy during fermentation, so root veggies are ideal. The bacteria you're feeding in the fermentation process come from the raw materials. Cabbage may be the primary ingredient, but funny enough, scientists at Chung-Ang University in Seoul found that of all the vegetables used in their trials, cabbage actually had the lowest total bacterial count—garlic had the highest. Here's my recipe for cabbageless kimchi, with apologies to the purists. Use as much organic produce as possible.

 1 large daikon radish

 2 watermelon radishes

 1 medium beet

 2 large carrots

 1 medium onion

 1 two-inch piece of ginger, grated

 1 Granny Smith apple

 3 tbsp. minced garlic

 Sriracha (to taste)

 2 tsp. sea salt

Peel, chop, and mix everything up, sprinkle salt, and massage the veg until the salt has drawn the water out. Spoon the mixture into a glass jar or crock, pressing *very* firmly, pouring the liquid on top and weighting down the veg with a smaller jar or pint glass. It's important that the veg not rise above the water line, or you might end up with mold on the surface. Put the jar inside a bowl in case the kimchi juice overflows a little. In theory you can leave it to ferment for weeks, but after four summer days my jar smelled quite fragrant enough! Once refrigerated, the kimchi will keep for several months.

Plant-based physicians often recommend juicing only vegetables; fruits are best consumed whole because the juice gives you too much glucose or fructose in one shot. That said, I'm still going to juice a watermelon every now and then—or at least the rind, which contains antioxidants, potassium, zinc, and vitamins A, B6, and C— and an apple usually elevates a green juice from medicinal to tasty.

Classic Carrot Zinger Juice

1 lb. carrots

1 small apple

7–8 stalks of celery

3-inch piece peeled fresh ginger

Talk about an energy elixir! Carrot juice is also very refreshing on its own. Yields approximately 18 oz.

Serenity Juice

1 large beet, peeled

2 large cucumbers

1 large honeycrisp apple

This one has a lovely mellow flavor—not too sweet. Yields approximately 35 oz.

The Perfect Green Juice

1 large Granny Smith apple

1 lime, peeled

1 two-inch piece peeled fresh ginger

rind of one medium-sized watermelon

Green juice that doesn't taste too...you know...*KALE-y*. When I make watermelon juice plus a green juice using the rind, I keep both in the fridge and drink them over the next couple of days. Yields approximately 24 oz.

Bunny Birthday Cake

> 1 ¼ cups carrot juice (just under 1 lb. carrots)
>
> 1 frozen banana
>
> 1 tsp. cinnamon

Juice carrots and blend with banana and cinnamon. It's worth dirtying two appliances! Yields approximately 16 oz.

Raw Protein Smoothie

> ½ frozen banana
>
> 1 ¼ cups plant milk
>
> 1 tbsp. tahini
>
> 1 ½ tbsp. hemp seeds
>
> 1 tsp. cardamom
>
> pinch cloves
>
> 1 date (or 2 tsp. maple syrup; not necessary if the banana is very ripe)

I'm not a fan of most protein powders, but I do love a smoothie that fills me up. Yields approximately 16 oz.

Heaven in a Glass

> ¾ cup frozen blueberries (*freeze fresh in-season berries if possible*)
>
> ½ frozen banana
>
> 1 ¼ cups coconut water and/or plant milk
>
> ¼ tsp. vanilla powder
>
> 1 tsp. dried lavender buds (optional)

My all-time favorite smoothie. Use the best-quality vanilla powder you can afford; I prefer Wilderness Poets brand. Yields approximately 16 oz.

A Conversation with Lacresha Berry

Lacresha Berry (Berry for short) is a Queens-based playwright, actor, singer-songwriter, and teacher with a master's degree in costume design from New York University. She's performed her one-woman shows in schools and theaters across the US, and she's also a tour guide for Black Gotham, an immersive visual storytelling project celebrating the African diaspora in New York City since the seventeenth century. We met up for lunch at Champs, a vegan diner in Williamsburg.

Your new play *Tubman* reimagines the abolitionist icon as a high-school student in twenty-first century Harlem. How did you get the idea?

I'd been a one-woman-show performer since college. I had started to study Anna Deavere Smith, Sarah Jones, Staceyann Chin, Whoopi Goldberg—a lot of these solo performers inspired me. I grew up in Kentucky, and I wrote a show with seven songs and monologues about famous Kentuckians. I basically wrote *Brown Girl Blue Grass* to make Black Kentuckians visible. That was very personal and very autobiographical, and I was very passionate about it. It was an homage to my father (who passed away in 2010) and my family. So, I was coming off of that.

In 2016—with the election campaigns and all the police brutality—I saw a Facebook post that read, "In times like these, what would Harriet Tubman do?" And I was like, *yeah*, what would she say? How would she feel right now? My genre of one-woman-show-ing is taking historical voices and putting a narrative to them, taking the research and creating a story from it, connecting the dots. The stuff that wasn't said. Making a bridge. I taught history at the time—juniors and seniors. What would they listen to? The songs came next, because I'm a singer and a songwriter first. Then it came to me that Harriet is a girl in the classroom who's overlooked—or maybe she's *too* looked at, to the point where everything she does

is under a microscope because she's a Black girl in school. What if I missed a lot of the Harriets in my classroom because they were "unruly"—an arbitrary category put on Black girls? I'm coming from a Black woman's body too. How I was raised was "adults speak, and children listen." You don't have a voice until you reach eighteen. My mom was an awesome role model, so not any shade on her, but just the society that we lived in during the '80s and '90s. When I became a teacher, I didn't want to shut my students down in the same way that I was shut down. How can I deliver the story without indicting anybody but the adults who are part of the system? I didn't want to indict the child; I wanted to indict the adults who don't reflect on the behavior that we provoke in students. I think we do a lot of provoking.

Then I started reading Monique W. Morris and Kimberlé Crenshaw, two major voices on the criminalization of Black girls in schools.[XI] They did a study about girls who were kicked out because they were playing with their braids in class. I read about one girl in the news who got her hair cut off by her teacher. A girl fell asleep in class—she had sleep apnea—and she was suspended. These are seen as criminal activities when you're in a Black girl's body. So, Harriet Tubman is facing expulsion in 2018 because she's using her critical thinking.

As a teacher—a *good* teacher, one who's considered proficient and greater—you have to consistently self-reflect. You have to ask yourself the hard questions: "Am I biased? Am I coming in with a skewed view of what these students are?"

You started performing *Tubman* pretty quickly.

It was crazy. I finished performing *Brown Girl Blue Grass* in September 2016. It was so successful in Kentucky they had me back four times, so they said, "Why don't you just debut *Tubman* here? Will you be ready by February?"

[nervous laughter]

I said, "Well, I *can* be." I finished writing the show in January and I had to memorize it by February 17, 2017. I got to my Airbnb and studied my script for eight hours a day until the show went up.

XI Monique W. Morris wrote *Pushout: The Criminalization of Black Girls in Schools* (2015), and Kimberlé Williams Crenshaw is the author of *Black Girls Matter: Pushed Out, Overpoliced and Under-Protected* (2016).

Why do you prefer the one-woman show over ensemble acting?

I can control the narrative. I do a lot on YouTube and Instagram to change the narrative, or reframe the narrative, or create a brand-new one, and make sure that we're all seen in various ways and not just one way. I do a lot of work on that in the beauty and hair world *and* in the theater world.

I love what you said in your interview with Kim-Julie Hansen about why you want to be photographed—"I want people to see what a vegan looks like. This is what a natural-hair woman looks like, this is what a Black girl from Kentucky looks like."[151] We think of selfies as self-indulgent, but they can serve a political purpose.

Harriet Tubman was the second-most photographed person in the nineteenth century. (The first was Frederick Douglass.) In daguerreotypes from 1865 on, you had to sit down and pose for fifteen, twenty, thirty minutes. That's much more deliberate than a ten-second recreation of your surroundings. She always wore white, and there was a certain way she held herself that was very deliberate. Even in the 1800s, they were focusing on their image, and that was relevant to what I was already doing. I was like, "How can I do that for myself outside of the *Tubman* show?"

She did other things that sounded like me: she walked a *lot*, and I've walked all the way here before. Champs is five miles from my house. I have a dog now, and I walk her everywhere. I named my dog after Tubman—her name is Minty [Harriet Tubman's nickname]. And she was doing her best work in her late thirties and forties, when she was a spy, a nurse, working for the Union army. That picture of her that was circulating when she was "young"? She was forty-one or forty-two. We're so obsessed with youth that we tend to think forty-one is "washed up," but I'm thirty-nine and I'm just beginning my work.

We need more artists like you who are being vocal about their veganism, but in a way that's like, "This is who I am, and this is what I do."

And not attacking people. Some people are very hardcore, but I'm not into that. I can be right, or I can be effective. I'm not going to call someone a murderer, especially in communities of color—that's just not a word we should be using in general when it comes to

us. Racism in vegan spaces has been difficult too. I was part of a vegan Facebook group, and, after three police killings in a row, I was feeling so sad and helpless, but when I mentioned it in the group they were like, "This is a group for animals. We have enough groups fighting for human rights." So, I left. It just didn't align. We have to be compassionate across the board.

That's what I've dealt with—being a vegan and being active. People focus on the aesthetic as opposed to the ethical choices we're making. They get caught up on "there's only white vegans," or you should only be a certain size. I wasn't in veganism to lose weight; I was listening to my body, and eventually the ethical work came. Lately most of my work has been in the cruelty-free beauty world.

But it's so funny, my students always say, "Miss Berry, you are *strong*. O-M-G, Miss Berry!" I think that's why I always go back to teaching, because [the students] are literally a boost. They give me so much more life than I ever asked for.

What's your advice for aspiring artists who are working on their self-esteem?

We've *all* been there, and oftentimes it's what we've allowed ourselves to think for a long time— which might not ever be true, but it *feels* so real. Tell your thoughts they're lying to you. Consistently practice. Find somebody you find value in and start sharing your work with them. When I was in high school and college, I went to open mics. I wasn't good, but I got it off my chest. Having a platform

Berry performing *Tubman* in 2018.

for self-expression, even if it's just to one person, will help your confidence. I know it's a cliché, but I'd talk to myself in the mirror, perform in the shower. Put yourself around people who are going to uplift and empower you. Don't listen to the negative self-talk. Try to find things that stimulate your senses to help you create more work. I say to my students, "You've got it already; it's just tapping into it." I try to pass this on to my students: agency and advocacy. "I'm worth this, I want this, I deserve this." I want to make sure my students get that from the time we spend together in class: advocating for yourself.

www.berryandconyc.com
@berryandco, @airtubman, @berryberrystylish
Lacresha Berry

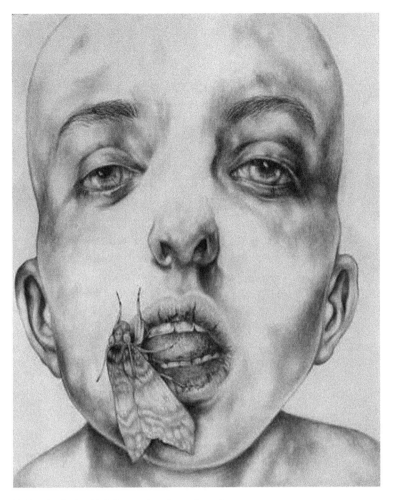

© Meneka Repka, *Moth Face*, colored pencil, 2016.
@noochdesignco

The Gold in the Shadow

My favorite store in Providence is called RISD 2nd Life. They sell secondhand art supplies to students of the Rhode Island School of Design, but anyone can shop there. Paint, canvases, yarn and fabric scraps, half-full pads of drawing or watercolor paper—and they always charge you less than the prices advertised. I've found some quality stuff on the bookshelves too, like a book of comics and

collage art called *Freud for Beginners* by Richard Appignanesi and Oscar Zarate, first published in 1979.

I opened to a page at random: an antique diagram of the human brain, the fine-print labels along the periphery oriented upside down. The brain portion of the original illustration has been replaced with a modern cartoon of an impenetrable labyrinth. Here is the caption: "We are normal (psychologically healthy) when our quest for knowledge is uninhibited."[152] Over the last several years, I've developed a bit of a knack for automatic reappropriation of pop-psych insights for the vegan cause—that's how *my* brain works now—so my immediate reaction was, "oh dear, then nearly *everyone* must be neurotic." Because most people's desire for knowledge of the food they eat is severely inhibited by culture, habit, and livestock- and dairy-industry propaganda. It's hard to argue that neurosis isn't profitable: for pharmaceutical companies, for individual therapists, and for the ever-expanding health and wellness industry. Madeleine L'Engle writes in *A Circle of Quiet,* "I look at many of the brilliant, sophisticated intellectuals of my generation, struggling through psychoanalysis, balancing sleeping pills with waking pills, teetering on the thin edge of despair, and I think that perhaps they have not found the answers after all."[153] Why do we keep on expecting we can solve our problems through intellect alone? How is it that we live in such a profoundly dysfunctional world yet are repeatedly told the dysfunction lies in ourselves—that to address the irregularity within is all we can reasonably hope to accomplish in this life?

There is a book called *We've Had a Hundred Years of Psychotherapy—And the World's Getting Worse* that attempts to answer these questions. (I overheard a librarian at the Athenaeum recommending it and felt a shiver of serendipity. The library doesn't have a copy, so I ordered it online based on the title alone.) It's a lively if occasionally infuriating dialogue between "renegade" psychoanalyst James Hillman, who studied with Jung in the 1950s, and the newspaper columnist and novelist Michael Ventura. Hillman believed that therapy as it is commonly practiced actually disempowers us. "Its balanced, middle-ground position wants both the individual and the system to survive, by accommodating the individual as best as possible to the system. The system as such,

however, remains outside its purview."[154] Let them *believe* they're getting better, right? Let them think the drugs are helping. Hillman continues, "If therapy imagines its task to be that of helping people cope (and not protest), to adapt (and not rebel), to normalize their oddity, and to accept themselves 'and work within your situation; make it work for you' (rather than refuse the unacceptable), then therapy is collaborating with what the state wants: docile plebes. Coping simply equals compliance."[155] My own experience jives with this anti-government conspiracy-theory view of therapy, even though I considered all of my therapists to be kind and capable individuals. I had questions no one seemed willing to help me articulate, never mind answer.

Here is the pivotal irony of the personal-growth movement: because in therapeutic and self-help circles, you are meant to "question everything" if you are truly "doing the work." But what that really means is "question everything *but* capitalism, white supremacy, and using animals for food, clothing, and entertainment." Unsurprisingly, Hillman and Ventura themselves are mired in patriarchal systems of thought; this book was published in 1992 and reading it twenty-six years later I fume at the authors' reverence for Jefferson, Picasso, and Descartes (a notorious abuser of canines). In their dialogues, Ventura includes answering machine messages from irritated girlfriends, ostensibly because he and Hillman then riff on the indignity of call waiting, but the reader is left with the unsavory impression that Ventura thought he had to hide from all the women he was sleeping with in order to finish this manuscript.

I was raised to smile and nod no matter what load of nonsense might be coming out of a person's mouth, and so it is an uncomfortable feeling to read someone's work with the sense that they're not diving as deep as they like to think they are. Another Jungian psychoanalyst, Robert A. Johnson, has written quite eloquently about the human shadow—those qualities which polite society compels us to keep so well hidden that we don't even know they're there—and while suppressing weird urges and explosive emotions is necessary to some extent, we still have to acknowledge and explore the shadow in order to reach psychological wholeness. Jung called this transformative process "individuation," and it is the work of a lifetime. Hillman says that individuation is experienced as

loss—"a loss of inflations, a loss of illusions"—and Ventura recalls Jung's adage that to know oneself is the most terrifying thing in the world. But leave that darkness entirely unexplored, and you will end up foisting what you deny on everyone around you. Look at all the destructive behaviors famous artists get away with *because* they're famous, not to mention the less conspicuous forms of self-annihilation suffered mostly in private.

Problems of the therapeutic model aside, what I find fascinating about this program of "inner work" is that the shadow contains much more than the worst of what it means to be human—the despair and self-loathing, the fantasies of revenge and murder and incest. Johnson writes, "Sometimes the shadow has tremendous positive strengths that the ego won't claim because it would mean either too much responsibility or a shattering alteration of one's puny self-image."[156] It's that false puniness that prompts us to throw up our hands and whine, "What's the point of trying to change? What difference can *I* make?" Another anti-psychiatry psychiatrist, R.D. Laing, had a terrific answer for that: "Who are we to decide that it is hopeless?"[157]

When we give up our power because we are afraid of it, we ignore what Johnson calls "the gold in the shadow"—the inner trove of insight we artists are meant to be mining in the first place. I'm developing a theory that eating and otherwise using animals impedes the individuation process, if not preventing it entirely. We cannot grow into the people we claim we want to be while we are still ignoring the suffering of creatures who value their lives.

"George Bernard Shaw said that the only alternative to torture is art," Johnson writes in *Owning Your Own Shadow*. "This means we will engage in our creativity (in the ceremonial or symbolic world) or have to face its alternative, brutality. Any repair of our fractured world must start with individuals who have the insight and courage to own their own shadow."[158] (Interesting, isn't it, that Johnson should quote Shaw of all people—my favorite vegetarian crank!) In *Life Without Envy* I wrote that we could "resolve" our shadow selves through compassionate self-inquiry, but I was wrong. The shadow cannot be dealt with once and for all in the therapist's office or by casting oneself into some sort of shamanic altered state; it must

be engaged with on a daily basis through reflection and ritual and, yes, our art.

Is it even possible to practice self-analysis without self-absorption? To arrive at some sort of mental and emotional maintenance system that will align with our moral compass *and* reliably facilitate our creative work? It is very tempting to tell you that veganism is that system for me, but that would be much too simplistic. Lots of vegans I know have been talking about "vystopia," a word recently coined by Australian psychologist Clare Mann to name the particular anguish we feel amid the "trance-like collusion" of the meat-eating world, and it's true that some days it seems impossible to feel sane and centered in the face of such widespread cruelty.[159] But it seems to me that ethical veganism is one route a person can take toward addressing their existential anxiety (without any jargon or other obfuscations), a method that did not in a hundred years occur to some highly intelligent people. James Hillman says that "you can only see what your eyes allow you to see,"[160] but the trick is simple: you need only acknowledge that you are missing something, and in doing so you begin to retrain your sight.

A Conversation with Melanie Light

Melanie Light is a filmmaker based in Bristol, England. Her short film *The Herd* is the first work of vegan feminist horror, and it won several awards on the international festival circuit in 2015. Melanie has worked in the film and TV industry for over twelve years, and she's currently developing a couple of feature film projects.

What are you up to in LA?

I came out here to meet people and put myself on the radar. Somebody wants me to direct a thriller-ghost story, so we're putting a lookbook/pitch together. On Sunday, I went to a vegan women's Meetup in a park, and people were asking why they hadn't heard of my film. I said it's because I'm an individual—I produced it, it's online, but I don't have a marketing campaign. I do it all on my own. I'll send it to famous vegans, and sometimes they'll say they've seen it, but they never seem to share it. Maybe it's not vegan enough.

Or it's *too* vegan.

It's feminist, that's why. I said, "Has anyone thought about the fact that it's mostly women doing everything, but it's guys who are the face of the movement?" Nobody had noticed it. At home we complain about it all the time, compare notes on what's happening. We knew this guy who went to an animal-rights event in Spain but didn't turn up when they were doing the activism because he was finding different vegan women to have sex with.

[scoffs] Of course he was.

And then they turn up, do a quick video, and they're off again!

There's a huge reluctance to acknowledge the sexism and racism in our movement. People don't want to see it because it's like, "We're all the *good* guys."

The only guy I think is worth following—because he calls out all the other guys as well—is Jake Conroy, who does a lot of stuff with Greenpeace. He's sound as f***, but I don't trust the rest of them. You don't get a hall pass. In the UK a lot of vegans are supporting right-wing politicians like Tommy Robinson (leader of the English Defence League), who is a fascist. People say, "if you're there for the animals, then it doesn't matter," but human rights and animal rights go hand in hand. There's a group of us in Bristol who've started calling people out. We found out about a vegan guy messaging a fifteen-year-old girl on Facebook, asking her to show him her breasts, and someone got a screen grab of his messages. We told him to get the f*** out of our movement. But when I shared what had happened on Facebook, the only people who commented on how gross he was were non-vegans. This is all really annoying me at the moment—I think it's because I'm in the US and following the Kavanaugh stuff.[XII]

[heavy sigh]

We have issues with men taking advantage of women in the UK, but we're more like, "well, that's the way it is, isn't it?" We normalize it so much more at home. I was here in LA this time last year when the Harvey Weinstein stuff was kicking off, and the power of everyone bonding together and working to make a difference! We have the BAFTAs at home, and nobody really does anything for #timesup. They're too scared. Which is why I want to make the baddie character in the film I'm working on British!

Did I hear you went vegan after reading Ed Pope's script for *The Herd*?

I was vegetarian, unintentionally already kind-of vegan. Me and Ed have known each other for years through horror circles, and when he sent me the script, I was like, "I cannot make this as a vegetarian. I'd be a f***ing massive hypocrite." I'd already stopped drinking milk, I never liked butter, and I'd always found eggs a bit weird and gross. Once I was at work at a bar, and one of the guys

XII We had this conversation in September 2018, during the confirmation hearings for Supreme Court nominee Brett Kavanaugh. The next day Dr. Christine Blasey Ford testified that Kavanaugh sexually assaulted her in high school.

Still from *The Herd*, 2014.

was like, "I'll have a chicken period sandwich"—*[gags]*—the thought of that, and the fact that I hate having periods.

I had to watch a lot of dairy videos before making *The Herd*, because I needed to understand exactly what was going on. There was no way I could ever go back after that. Everything was as vegan as possible—catering, makeup, costumes—because I didn't want to be a hypocrite. Sometimes it's like, "Why didn't I do this when I was in my twenties? I could have done this a long time ago." I love that making *The Herd* has pushed me into activism. Even as kids we would go on BUAV[XIII] anti-animal-testing sponsored walks, we'd collect money for the RSPCA[XIV], but I didn't put two and two together, and my parents weren't vegetarian or vegan. But my mother, my brother, and I all went vegetarian at the same time; my brother and his wife are now vegan, and they both have environmental and animal welfare jobs, which is really cool. It's filtering down through family members: my cousin's vegetarian, my sister's gone vegetarian. There's no hope for my dad though.

Same. That's why I believe in reincarnation!

I feel so appreciative that Ed brought me this script, because it helped turn my life in this direction, to find the people I always needed to be part of. Now I live in Bristol, which is one of the

XIII British Union for the Abolition of Vivisection, now Cruelty Free International.
XIV Royal Society for the Prevention of Cruelty to Animals.

most vegan cities you could ever live in. Three minutes' walk from where I live is a vegan café, which is my local. You'll drive down the motorway and there'll be a big banner saying, "Stop the badger cull!" As soon as I moved there two years ago, I started helping a campaign group called Animal Justice Project that deal with vivisection. Animal testing is almost worse than farming, because you can understand how people are trained to see animals as food, but animal testing is just psychotic. It's happening at universities, and these students think they're saving lives when the labs are doing the same tests year after year. It's completely pointless. I've written a short about animals in labs, but I need forty grand to make it.

I can't even imagine how challenging it must be to get a film made. How do you manage your disappointment when things don't go as you'd hoped?

You create your own destiny if you keep pushing forward. Only you can make things happen, and it does happen eventually, it just takes *ages*. All of my really good friends don't work in the film industry, so if I see them, I can rant. Sometimes I'll send them a message and just get it off my chest. Or I'll put up a moan-y tweet, because that's honest. I've spent my whole life being disappointed in various contexts. You just get on with it.

It's weird because I made *The Herd* such a long time ago, and it's only this year that people in the industry have started seeing it, because everyone's jumping on this women-in-film bandwagon. Everyone's trying to make films about gender equality, racial equality, equality-everything apart from animals. I don't want someone to give me a job out of tokenism—although if it gets me directing a feature film, I'll do it. You're so used to things not working, I never believe it until it's actually happening.

Because you're used to being self-reliant.

It's a positive mental attitude. You have to keep going forward and surround yourself with people who are like that as much as possible. I'm a lot happier if I'm surrounded by other creative people. When you see other creative people being successful, that spurs you to keep doing what you're doing. My biggest downfall is looking at what other people have done and comparing myself to them,

which is the worst thing you can do. But I turn it around: "How the f***
are they doing it? I need to be doing this too." They're usually men
I'm comparing myself to and knowing I can do better than, because
we have to do ten times as much work as they've ever had to do.

What other advice do you have for aspiring artists?

I recently gave a talk on creativity at Vegan Camp-Out—using
what skills I have to get a message across. We all are individuals,
and we all have our own skills. A girl came up to me in the evening
and said, "Your talk was brilliant. I paint at university, and I was
worried about putting animal-rights messages into my artwork, but
now I've realized that's absolutely fine." In the vegan world, there can
be the pressure of who's-more-vegan-than-you-are, but once you
know who you are and what you're capable of doing, you can use
that to be a voice for the animals.

🌐 www.melanielight.co.uk
📷 🐦 @misartressmel

Scuba Diving as a Spiritual Practice

The guidebook calls them "coral gardens," but I like to think of them as cities. Fishes of all sizes and colors dart in and out of buildings that look like bouquets of Scottish Highland heather, human brain matter partway unfurled, or hundreds of fingers reaching for the surface. The spangled sunlight on the ocean floor reminds me of night-swimming in my father's pool, how the floodlight could make a pocket of magic inside an ordinary suburban childhood.

The fishes draw me back to the present, though. There are shimmers of impossibly blue creatures no longer than the pad of my pinky finger; solid black fishes, the Goths of the neighborhood, and their more cheerful-looking black-and-yellow cousins; and a pair of blue-and-purple iridescents gliding swiftly above the coral as if they have somewhere to be.

My favorite fish shows herself only once. She is the size of my hand, with slender orange, black, and white stripes on her body and a vivid streak of violet running all along her periphery. I follow her awhile, marveling aloud into my snorkel as if I'm not alone. How has this species evolved? What could possibly be the evolutionary purpose of those brilliant stripes? The coral isn't so colorful that it could serve as camouflage. Is she poisonous?

All this life along the ocean floor, so much more than I will ever be able to see, and all of it completely indifferent to the shadow I cast, the small disturbances I make as I tread water to rinse my mask. I feel insignificant, and it is a good feeling.

In the city market, it is the fish who is insignificant. My friend and I pass a fishmonger's stall where a middle-aged woman crouches behind a low metal table, her hand clamped on the body of a steel-blue fish as long as my arm. He is still alive, writhing and thwacking helplessly against the woman's hand. As she brings the butt of her cleaver down hard on his head, she's got this incongruously gleeful expression on her face. *Silly fish! Why are you struggling?*

Warm- or cold-blooded, skin, fur, or scales: we *all* fight to live.

These are scenes from an epic backpacking trip around Asia with my dearest friend in the world, a playwright and novelist whose talent is mind-bogglingly disproportionate to the recognition he has so far received for it. We spend a week in the Banda Islands of Indonesia (colonially known as the "Spice Islands"), and my friend decides to take the four-day course for his scuba diving certification. (Banda Neira is one of the least expensive places in the world to do it, in case you are interested.) As much as the prospect of all that time underwater appeals to me—I've only been scuba diving once before, but the high lingered for days—I opt instead to write and read on the beach and at our already-favorite café. (*Gotta hustle!* my friend keeps telling me, half facetiously. But he is right.)

At the end of our two-month trip, we go diving together at Tulamben, on the east coast of Bali. The USAT Liberty, a cargo ship torpedoed by a Japanese submarine in 1942, lay on the beach until 1963, when volcanic tremors from the eruption of Mount Agung thrust the wreck twenty-five to one hundred feet underwater. As we swim, marveling at the abundance of life darting in and out of the

intricately coral-crusted ruins of the century-old ship, I keep looking to my friend and thinking two sorts of thoughts. The first is "I love you so much and I am OUT-OF-MY-MIND HAPPY that we are doing this." The second is "How can you eat these creatures?"

Variations on "friends-not-food" flit through my head as we shadow a sea turtle. *Would you eat turtle soup? Maybe not if it were on the menu tonight at dinner. But what about tomorrow, or the day after that?* I make myself remember that I spent an entire year as a "fish and chipocrite," one of those people who calls herself a vegetarian because she wants to believe that fishes don't feel like mammals do.

Here are some pertinent facts about fishes. They feel pain when hooked. They bleed. They suffer by "drowning" in the air, and they exhibit a form of collective intelligence humanity cannot hope to emulate in another million years of evolution. The first time I went diving, off the coast of Santorini, I watched a school of tiny purple fish shift direction at the same angle simultaneously, as any school of fishes will do. But when their iridescent scales caught the light all at once—*oh!* I will never be a good enough writer to put adequate words around the awe I felt in that moment. As Carrie Arnold explains in *Scientific American*, "[O]ne cluster of genes controls a fish's propensity to join others in a large group; another set of genes influences how well a fish swims in formation, parallel to its neighbors. Together, the behavioral traits and sensory abilities of schooling fish produce dazzling maneuvers that help fish avoid or defend against predators."[161]

How is it that a fish can be a miracle if glimpsed through a scuba mask and delicious when he ends up on our dinner plate? When I asked Heidi Braacx, an indie yarn dyer and spinner (*see page 131*), if she could recall any pivotal childhood interactions with animals, she told me about a period when her family was living on a sailboat and how vividly she remembers having a "massive meltdown" when her father wouldn't listen to her pleas to release a fish he'd caught for their dinner. You can see Heidi's reverence for ocean creatures in colorways like the ultra-blue "Ponyo's Brothers" (named for the Hayao Miyazaki film in which an ocean sprite—drawn like an anthropomorphized goldfish—yearns to become human) and the brightly-flecked "Sea Goddess," which reminds me of the

fishes I encountered while snorkeling off that deserted beach at the northern end of Banda Neira.

I think back over the time I've spent underwater watching fishes and turtles and even a shark the length of my arm go about the business of living, and it seems to me I was closer to God there in the sea in my wetsuit and goggles than I have ever been inside a church. In *A Plea for the Animals*, Matthieu Ricard (himself a Buddhist monk) writes about the early eighteenth-century philosopher Jean Meslier, who left the Catholic priesthood because he "considered indifference or cruelty to animals by Christians as one of the proofs of the nonexistence, or the malice, of their God."[162] As a "Catholic in recovery" myself, I find that conclusion devastatingly rational.

On the other hand, there are several aspects of the faith I was born into that still resonate for me, and humility is foremost among them. It is good for my soul—and good for my creativity, by extension—to step inside a church built a thousand years ago and think of the hundreds of artisans who dedicated their lives to building and decorating it. It is good to slip a few coins in the donation box and light a candle for my mother and for our departed loved ones, to pause and remember the fleetingness of my own lifespan. In this same way, it is good for my heart to venture into the water and feel a sense of reverence for creatures who have as much claim to divine consideration as we do.

A Conversation with Debra Diane

Debra Diane is a singer-songwriter from Detroit, Michigan, who studied media and communications at Temple University in Philadelphia, PA. In 2017 she started a nonprofit organization, Lead the Way, to organize a fundraising concert for victims of Hurricane Harvey, and subsequent Lead the Way benefits have raised funds for college scholarships.

How long have you been veg?

I haven't had meat in eleven years. We never really celebrated Lent, but when that time came around my family said I should give up something, so I gave up meat and didn't go back. That was in middle school, seventh or eighth grade. It was for health and for the animals, because I'd watched one of those [slaughterhouse] documentaries and I thought, "wow, this is *crazy.*"

I went vegan at the end of high school. This guy came to my church—he was very old, he was beautiful, his skin was amazing, he'd brought all this vegan food, he was running around the church saying "it's the best way to live, *and* I don't have to use Viagra!" He was so old, and he had a five-year-old son.

Living proof!

So, I was like, "Wow, you've brought all this good food, you can run, you're healthy. I might as well try it." I did have to try more than once, because sometimes I'd forget something had milk in it. I wasn't looking at the labels yet. I had bad acne all over my face and I thought, "Maybe this can help." And it did clear up my skin!

Your parents were supportive?

Definitely. My little sister [also] went vegan the day he came to our church, so our mom started cooking vegan meals for us. I was very lucky, because a lot of people would be like, "Well, we're still cooking this meat, so I don't know what to tell you."

How do you fuel yourself for songwriting and performing?

[flips the camera view so I can see a plate of peach slices on the table] When I first went vegan, honestly, I was a junk-food vegan. I ate a lot of things that were technically vegan—Oreos, purple Doritos. When I went to college, they didn't have a great selection of vegan food, so I started going to the grocery store and buying a bunch of vegetables. That's when I started eating more plants instead of junk food, and it really changed me. I started drinking chlorophyll—

That's a thing?!

Yes! You can look it up online, or you can find it at health food stores. Sometimes I'll take black seed oil, too. My boyfriend and I like to make things with sea moss, like raw cheesecake. Sea moss is so good for you. I started making more dressings, like a spicy cashew dressing, and I can use that for anything. I make macaroni with cashew cheese; I use it as a nacho dip. It's fun, cooking at home. Also, I don't eat soy. Processed meat [analogues] are cool for when you're transitioning and you still want that taste, but salads are better. Greens and fruit. In college I wasn't eating bread, either. I was so healthy in college!

Are you focusing on Lead the Way right now?

Yes! The last one we did was my favorite so far—we did a back-to-school event, so many kids came, it was so fun, and everything was free for them. We had fifty-plus bookbags, and I was so sad

when they were gone. I wish we'd had more. Right now, I'm working on a Toys for Tots event, and I'm going to raise five hundred dollars. It's a small school, so I'll be able to give toys to the whole school and give a concert. And after that I'm going to start getting things together for my college scholarship event. Last year we raised five hundred dollars to help somebody go to college. And I'm still doing music and shows here in Detroit.

Are you doing any songwriting at the moment?

Yes, I am working on a song right now. Being at Temple really helped my songwriting because I was a member of a poetry collective called Babel. They're so dope. Poets and musicians. We had shows throughout the school year, and we each had to come up with a new song or poem for every event. It really helped with the writing process. We'd write together, we'd need to get it done.

When did you start learning music and writing songs? I'm wondering if and how going vegan altered your creative process.

I never thought about that! In middle school, I was very shy because I was homeschooled before that. It's not like I wasn't around other kids, because I played a lot of sports and we went to co-ops, but I was *so* shy. I started playing the guitar in seventh grade and doing choir in eighth grade, and that's around the time I went vegetarian, so it's possible [there was a connection]. I did write some songs around that time, but none I really like. There's one my mom loves, it's called "Pretty Brown Girl," but I don't care for it.

That's always going to be the case. Ten years from now I'll look back on the work I'm making now and be like, *ugh!*

You cringe!

It's inevitable.

In high school I started singing and playing the guitar for real. I was learning songs on YouTube and singing in choir concerts. I started singing in coffee shops and at grand openings, and when I started high school I opened for artists in Detroit.

Tell me more about learning to play the guitar.

In seventh grade they had a guitar class and I thought, why not? I never told anybody I wanted a guitar because I never tell people what I want for real. That winter my sister got a guitar for Christmas, but she never used it—so the story goes that I stole her guitar.

Which songs were you learning how to play when you started? Now that you're writing your own, whose music would you say has influenced you?

I remember learning how to play Pink's song "Perfect," "Man in the Mirror," a whole bunch of songs with the same chords. When I sing people tell me I remind them of India Arie, but I think it's because she's got a guitar, she's Black, and she has an afro sometimes, although I guess we do have the same low tones. I do remember listening to her when I was learning, but I try to sound like *myself*. I'm more inspired by real-life stuff I'm going through.

In high school you used to sing in homeless shelters. What kind of feedback did you get from the people you were playing for?

They loved it. It was really touching—it motivated me. A song I choose [to play] can mean so much to someone in the room. You never know when you're performing how people are reacting—sometimes they're dead silent with straight faces, sometimes they're making "wow" faces, but you never really know what they feel for real, so you've just gotta let it flow through you. When I performed my song "Cry" in Philly at the Global Village, so many people were coming up to me crying afterward saying, "You don't know how much I needed that." Music can be healing. It shifts the atmosphere—like, "*dang*, you feel that way too?"

How's the vegan life in Detroit?

My boyfriend is vegan too, and we have a garden. This was my first time experiencing a garden and seeing everything grow, and it was so frickin' beautiful. We grew lettuce, watermelon, cantaloupe, cucumbers, zucchini. His family has a vegan cooking company, Paradise Detroit. A lot of people come to their pop-ups, and they do festivals. They'll be opening a storefront soon. I'm trying to think of other places we go to…nah, I just eat all his mom's food! Detroit is great. A lot of people don't take advantage of the fact that Canada is right across the bridge. I performed up there this summer. That was my first time going across the bridge for something besides camping.

What advice do you give to new vegans or people who are veg-curious?

Know that you're doing something better for your body. If you mess up, just start over. Your family may judge you, but at the end of the day they'll see you're doing something positive, and they'll say, "hold on, this may be something good." I believe any illness can be reversed by the way you eat. Another thing to think about when you're eating meat is the spirit of the animal—what they were going through, the sadness they felt when they got killed. You're putting that spirit inside of you, and it's affecting the way *you* live. When me and my boyfriend were growing the garden, I would go outside and talk to the plants: "I love you. You're beautiful." Everything is energy.

◉ @debradiane313, @leadtheway313, @ParadiseDetroit

© Nicola McLean, *Philippa*, acrylic, 2018.

Life in Technicolor

The first few weeks after I went vegan—still on the reforestation project—offered an unprecedented capacity for joy. Physical labor rewarded by hearty, delicious meals free of suffering and exploitation. New spices, new scents, new flavors. A dance party in the main hut to celebrate another new friend's decade of veganism, tugging bathing suits onto sweaty bodies to go swimming in a mud pond in the moonlight. I was having so many "peak experiences" that the concept was beginning to lose its piquancy. Joy was becoming the new normal.

That's not to say I wasn't happy before. Even during periods when I've felt stuck and frustrated, I have had this sense that I've been getting away with something, that I am possessed of a

luscious secret it hurts no one to keep. When you write fiction, you grant yourself the ability to live your life with as many avatars in as many dimensions as you please. I have been a witch and a ghost and a mystic, a gay time-traveling physicist fleeing the 1950s for the freedom and chaos of the twenty-first century and beyond. Who's to tell me these experiences haven't been "real"? I move through ordinary life like anybody else: lugging my sack of dirty laundry down to the basement, coming home drenched when I forget my umbrella, going out with friends for sushi and cocktails. But I believe in this other kind of reality too—the worlds I build and furnish and live inside for a while before inviting my readers to join me. And it's *this* reality that has allowed me to feel that I am living in technicolor.

And every now and again, if I am very lucky, a reader will tell me that a world I've built has changed them in some modest but significant way. A blogger named Hanna "the Piebrarian" posts original dessert recipes inspired by the novels she reads, and I cried at my desk reading about her experience of *Petty Magic*. "Do you ever look back on the first time you met someone important to you and sort of smile knowingly at your past self? It's so adorably sweet that memory-me has no idea how her life is about to change now that this person has arrived," she wrote. "Similarly, I look back at the Hanna who almost didn't buy *Petty Magic* (because she wasn't sure if she could justify another book purchase) and chucklescoff. In a few short weeks, she will devour this book in one sitting, on an airplane, pausing in the darkened cabin somewhere over the Atlantic while everyone else is sleeping to clutch this book to her chest and thank the universe for sending it to her."[163]

My heroine in *Petty Magic* is Evelyn Harbinger, a 150-year-old witch and retired spy who makes herself young again for nights out on the town. I wanted to create a saucy and supremely confident character so I could revel in her adventures, letting Eve say and do things with the courage and panache I could only dream of having in my next life, and it was deeply gratifying to hear that my story had allowed a perfect stranger to feel as sexy and daring and fun as I did while writing it. But as I glanced over Hanna's recipe for Harbinger ambrosia pie, which calls for copious amounts of butter and eggs, an uneasy feeling revisited itself upon me: that the world I had built wasn't as vast or as generous as I'd wanted to believe. I was a

longtime vegetarian when I wrote that novel, yet I chose to make my festive coven of beldames meat eaters to a one. There's a holiday scene in which a goose escapes the oven and races frantically through the downstairs rooms before the hostess can reapply her nefarious kitchen magic, and she also uses the eyes of a dead fish to spy on her cheating husband. *Why?* Why had I chosen to build this world out of the pre-existing paradigm in which women live for the approval of men (however they may tell themselves they don't) and animals are ours to use? I had encoded themes of predation, revenge, and self-deception inside a rollicking plot packed with top-secret missions, cozy family get-togethers, and exhilarating magical hijinks, but certainly if I could rewrite that novel, I would encode them very differently. I have another definition for self-deception now.

Going vegan brought "real life" and my created private realities into sync. I hadn't been too unhappy before, but the *joie de vivre* I felt at Sadhana Forest was brand-new. It's impossible to articulate this sense of freedom to someone who hasn't experienced it yet, and it certainly does seem ironic that one should feel happier for having witnessed the suffering of innocent creatures. Perhaps I can explain it this way: have you ever been lied to? Certainly, you have. Can you think of an instance when someone close to you lied about something of vital importance? And what if you believed that lie—believed it for *years*—with all your heart? I have been lied to so brazenly by a loved one, and when I was finally granted the truth, I felt a bizarre mix of rage and exhilaration. It is a relief to let the scales fall from one's eyes. To perceive the problem and to do what you can to rectify it: that *is* cause for joy.

Creating out of that happier place has, for me, resulted in work that is much more fully realized than it ever could have been before; because as fond as I am of Evelyn Harbinger and all her mischief and wisecracks, that novel is a record of the person I was growing out of. Each novel I have written since has concerned itself with underlying systems of power—who employs their privilege to abuse others, and why are they able to do so with impunity? How can children (and other vulnerable members of society) gain a sense of agency? I'm also creating vegan characters who articulate their convictions in casual conversation the way other authors' characters

express a preference for cheeseburgers over chili dogs. Especially now that I'm writing middle-grade fiction, I feel a responsibility to represent veganism as a viable lifestyle choice—after all, part of my job is to introduce young readers to alternative ways of looking at the world and the roles they could choose to play in it.

In her essay for Laura Wright's book *The Vegan Studies Project*, Melissa Tedrow has the perfect words to describe the transformation I experienced: "Far more than a dietary or lifestyle choice, or even a form of activism, veganism has been the gateway to full-hearted living that I always wanted but never could access."[164] I thought my fiction writing had given me that gateway, but there is an obvious difference between an expedition into a dimension of your own making and an escape from a jigsaw puzzle of real-life discrepancies pretending as if they add up. There is a sense of divine appointment about the world-building now, a graduation to a place on the other side of uncertainty. I know why the stranger is knocking at the door, I know what she's looking for, and I know that when she asks me to come along I am going to say yes: yes to adventure, yes to color and texture and sound, yes to a sequence of ever-more-impossible things.

Hanna the Piebrarian's Harbinger Pie

Hanna describes her Harbinger pie recipe as "a surprisingly earthy but still aggressively sweet pie with a muddy crust and a rich, smoky custard. Perfect for the witch who enjoys getting down and a little dirty every now and again." Happily, the same is true of this veganized version. Hanna loves a chess custard pie for its versatility—if autumnal spices aren't your favorite, you could try citrus or berries or chocolate instead. Ambrosia cake is supposed to taste like *your* favorite dessert, after all.

Crust:

1 ¼ cups gluten-free flour (I used Bob's 1-to-1)
3 tbsp. Fair Trade cocoa powder
½ cup coconut oil (see notes)
2 tbsp. maple syrup
2 tbsp. plant milk
dash of salt

Filling:

½ cup VeganEgg powder whisked thoroughly in 2 cups ice water (see notes)
½ cup (1 stick) melted vegan butter (I used Earth Balance)
1 cup organic cane sugar
½ cup organic brown sugar
1 tbsp. cornmeal
1 ½ tsp. vanilla extract
1 tbsp. nutmeg
1 ½ tsp. cinnamon
1 ½ tsp. ginger
2 tbsp. whiskey (optional)

Preheat oven to 375 degrees Fahrenheit. To make the crust, whisk dry ingredients and add in wet. Press dough into the bottom and up the sides of the pie plate. Prick the base of the crust with a fork and pre-bake for ten minutes, then allow to cool.

For the filling, begin with VeganEgg mixture in a large mixing bowl and whisk in remaining ingredients. Pour into crust and bake for 45 to 50 minutes until "the center has risen, browned, and will jiggle only slightly when shaken," as Hanna says. Once the pie has cooled, let it chill in the fridge for at least two hours before serving with either store-bought or homemade coconut whipped cream (perhaps laced with whiskey).

Notes:

- Hanna's version features a crust made of Oreos, which are incidentally vegan. If you'd prefer this crust, obtain two cups Oreo crumbs using your food processor (what you do with the filling is your business), mixing in ¼ cup cane sugar and 6 tablespoons melted vegan butter; then follow instructions as given.

- Ordinarily I try to use *ingredients* rather than *products* in a recipe, but in this case, Follow Your Heart's VeganEgg allows for a custardy consistency you simply can't get with other egg replacements. VeganEgg is available in many American supermarkets, or you can order it online.

- Coconut oil is surprisingly high in saturated fat, and given the general decadence of this recipe, it goes without saying that this is a special-occasion kind of dessert. Bake it for a November birthday or a festive winter gathering.

A Conversation with Maya Gottfried

Maya Gottfried is the author of several children's books, including *Our Farm: By the Animals of Farm Sanctuary*. Her book *Vegan Love: Dating and Partnering for the Cruelty-Free Gal, with Fashion, Makeup & Wedding Tips*, illustrated by Dame Darcy, won a 2018 Independent Publisher Book Award (IPPY) in the sexuality and relationships category. Her work has appeared in VegNews, The Huffington Post, Our Hen House, and other publications. Maya lives with her partner and three feline companions in upstate New York.

What's the takeaway when you reflect on the start of your career?

I actually wish I had the naiveté now that I had when I was writing my first children's book. I wrote from the heart, it was very abstract, and it had nothing to do with what publishers were looking for. I wasn't trying to pack myself into the mold of what I was *supposed* to be. There's so much stress these days on your platform and being a brand, and while I understand that times have changed, my personal preference is to be a writer rather than a brand.

YES! Thank you for saying that!

Publishers may need me to be a bit of a brand, and I'm happy to do that work to try to sell my book as much as they need me to—but in my heart of hearts I really want to be David Sedaris, who is *so* not a brand. He is a *writer*. I see so many amazing things going on to make us feel good about the future of books, that people will continue to and increasingly be passionate about great writing and not just writers-who-are-brands. I was saying to a friend of mine who's a musician, I know self-promotion can feel creepy, but try to think of it as connecting with your audience rather than pushing yourself on them.

And if you turn that around and think about the artists you love— you *want* those updates. You buy their work, you heart everything

they post, you share their stuff and show up at their events—you *want* their self-promotion!

If we focus on what we're offering rather than what we're asking for, we're in a good position. Obviously, we want people to buy our books, so there's always an ask, but if the focus is on what you're giving people then it doesn't feel as creepy.

Let's circle back and talk about how you went vegan.

When I was thirty-five (eleven years ago) I fostered a cat, and in an effort to home her, I was friending every animal organization I could find on MySpace! Through a friend, I connected with Farm Sanctuary, and I became kind of obsessed with them: "This place is so dreamy. Where is Watkins Glen? Maybe I can go work for them." Farm Sanctuary obviously educates about factory farming, which involves a lot of egg-laying chickens and dairy, but my first step was going vegetarian. Within a couple months I was on the New York City sidewalks protesting *foie gras* production right next to Gene Baur, the president and cofounder of Farm Sanctuary. I dove into animal rights. It was this bright light in my life; it transformed me in a way that I don't think anything else in my life has. I wanted to write a book about the animals of Farm Sanctuary, who had taught me that every farm animal is an individual with their own personality and history and friends. We get a glimpse of this on an instinctual level when we come into personal contact with an animal, we'll have that moment—even if we're not vegan—of looking into a cow's eyes and seeing that they are *someone*. So, I sat down to sketch out the poems for *Our Farm*, and when I started writing about one particular chicken, it hit me that I couldn't emotionally connect with a chicken who I was hurting on a regular basis through my food choices. In poetry, the emotional connection is crucial. There was this hypocrisy going on, and it was writing that poem that dismantled the separation for me. If I'm using animals in my creative work, and I'm hurting them, that's the definition of exploitation. At that moment I went vegan.

And then, a week before my thirty-sixth birthday, I was diagnosed with colorectal cancer, which was a big shock. Gene Baur had recently published his book *Farm Sanctuary: Changing Hearts and Minds About Animals and Food*. For fun and to keep myself busy (because I had left my job to deal with the cancer), I arranged for him to do a reading at my local community bookstore (where

they sold out of books in five minutes!) That night, Gene mentioned *The China Study*, which is all about how animal foods fuel the fire of certain diseases. I remember sitting and reading that book while waiting to go into chemotherapy treatments at Sloan Kettering. My cancer was stage three, and with any cancer there's the risk of it coming back, even after you're "in the clear." After reading that book, I knew that my vegan diet was my most important line of defense as far as getting healthy and staying healthy even after the conventional treatments ended.

My mom was there when I was diagnosed, and the first thing I said to her was, "It's really important to me to finish this book and have it published." It became the shining light at the end of the tunnel of the cancer treatments. It gave me a mission. It was my third book, but *Our Farm* was the first one that I felt could truly help others and help make the world a better place. I finished the book, and it was published by Knopf.

Everyone I've interviewed hits that note: the wanting to make a contribution, that fiery sense of purpose.

This reminds me of something I heard that's often shared in the Twelve-Steps Community, which is so much about service. I was sharing with a friend that I never really had self-esteem until I started trying to help others, and my friend was like, "Yeah, because self-esteem comes from doing esteemable acts."

I LOVE THAT!

It's when I'm helping someone else that I feel better about myself. That's what fills me up. That's when I feel good. Writing a book that helps the animals also helps the people reading it.

What's your favorite reader story?

This young woman, a tween, came up to me at the Albany VegFest and wanted a picture. She was like, "Oh my gosh, is it really you?" That was surreal. I love walking into a classroom and hearing what kids write. It's fun to write about the animals myself and to

read my books to people, but hearing what children have to write is the best thing in the world.

I wish I had started writing for children sooner, because I feel connected to the future in a way I never did before.

I remember going to a book event at Barnes & Noble with ten or fifteen picture-book authors, and the event was honoring Maurice Sendak, who made a special appearance and was signing books too. The experience of sharing the room with Maurice Sendak as a fellow author—it was the most incredible feeling. That's the hope: that we can be as magical a figure to children as Maurice Sendak was to us.

Let's talk about your pre-vegan work versus the work you're doing now.

When I was twenty-nine, I had the opportunity to write the text to accompany illustrations that would then be pitched as a children's book. The illustrations depicted circus scenes, including animal performances, and I wrote a poem to accompany them using the circus as a metaphor. That book became *Last Night I Dreamed a Circus.* Think about where the culture was with animal performance almost twenty years ago: back then, few of us were aware of the terrible abuse that circus animals suffer, but it's very obvious now. The book has fallen out of print, and I gently let it go into the night. Even though I was grateful for the opportunity to write my first book, I'm also grateful I have the opportunity to move on and only have books out there that reflect my values. Gene Baur has a similar story—he appeared in a McDonald's commercial when he was young, but that didn't prevent him from going on to save many, many farm animals. Even as vegans we're not perfect—a book we write that's totally vegan may not be reflective of other values we develop in the future, and it's always going to be that way. We just have to acknowledge that things have changed and move on from there.

 www.mayabidaya.com

@mayabidaya

© Philip McCulloch-Downs, cover illustration for *The Curious Tale of Otto and Trinity Small*, pencil, 2018.

@vegan_artivist and @mr.cronch

Vegan for the Future

Every artist wants their work to "live on" long after their death, even those whose art is purposely ephemeral. It is only natural to indulge in the occasional daydream of a retrospective exhibition in a prestigious museum or a twenty-third-century English teacher

reading your story aloud to her students, who sit at their desks (*will they still have desks?*) in rapt attention. But it is wiser to focus on creating art worth remembering, wiser still to see yourself and your work as just one contribution along a continuum of human endeavor. We love to create and to receive recognition for it, but we don't give much thought to what life will actually be like for those twenty-third-century schoolchildren, do we? Will they have clean water to drink and to bathe in? Will it be safe for them to venture out of doors?

In *The Willpower Instinct*, psychologist Kelly McGonigal writes that the human brain is inclined to regard the future self as a different person. This disconnect has consequences not just for ourselves (not staying fit or saving for retirement), but for the choices we make that affect the people around us too. Psychologist Hal Ersner-Hershfield found that people with "low future-self continuity" behave less ethically in professional role-play scenarios.[165] They're more likely to pocket found cash instead of looking for the person who lost it, and they're more willing to say things that could damage a colleague's career.

McGonigal doesn't discuss the impact of this phenomenon on future generations, but the ramifications are obvious. Who is going to read your novel or listen to your album if they are too busy trying to avoid the plague, or the latest tsunami, or the wandering, dark cloud the last working newspaper in America has dubbed "the hungry smog monster"? What if they've lost those luxuries of being human?

We can't just paint and write and sing for future generations. We have to eat and buy and save for them too. These days there is a lot of talk about making a complete transition to solar and wind energy to counter the effects of climate change, and while it's true that an individual can do little (if anything) to prevent the continued funding of fossil-fuel energy projects, we tend to overlook what we *do* have control over. Truth is, the vast majority of us make consumer choices that contradict all that we claim to believe in, and most of us will fail to own that folly even after the agricultural runoff comes seeping into the swimming pool, when the pipes run dry and our neighbors start looting the local Whole Foods.

A report on livestock and the environment from the Food and Agriculture Organization of the United Nations reads, "Global demand [for animal foods] is projected to increase by 70 percent to feed a population estimated to reach 9.6 billion by 2050."[166] Instructing livestock farmers in methods for reducing their greenhouse gas emissions is responding to a problem with more of the same, but those with the power to redirect crops grown for food-animal consumption directly into human mouths are unwilling to exercise it because the existing system is infinitely more profitable. Meanwhile, the ubiquitous use of prophylactic antibiotics in livestock feed poses a tremendous public health risk. You've heard of the super-bacteria too resistant for treatment with standard antibiotics? Well, picture a bacterial organism so indestructible it wipes out a sizeable number of those 9.6 billion people. Epidemiologists say the next pandemic is statistically overdue, and while it may not turn out to be *that* bad, no one can know for sure that it won't be.[167] As John Hurt's delightfully raggedy narrator tells us in Jim Henson's *The Storyteller*, "Nature, my dears, is a wise woman who pays us back tit for tat."[168]

Humanity is as resistant to change as the "superbugs" are to antibiotics, yet there is no endpoint in the evolution of this or any other species. Juan Enriquez has presented the concept of *Homo Evolutis*, a version of humanity that can steer its own evolution.[169] The scientific research Enriquez presents is focused on "curing" physical disabilities to the point that they become abilities exceeding that of an average human—a noble undertaking, to be sure, but not as far-sighted as working to "cure" our most selfish and destructive impulses. In his 2009 TED talk, Enriquez cites South African Paralympic gold medalist Oscar Pistorius as a prototypical example of this "upgraded" human species, but Pistorius's subsequent arrest and conviction for the murder of his girlfriend proves my point rather neatly, doesn't it? Enriquez also posits that the new humanity will control the evolution of other species too—which is simply perpetuating the "Darwinian narcissism" (as the philosopher Dale Peterson puts it) that has brought us to this point.

Transhumanism is not the answer. It is our *moral* evolution that is critical to the survival of the species and the planet, as Matthieu Ricard writes in *A Plea for the Animals*:

If in a few million years we have not ruined our planet to the point of having brought about our own extinction, it is not far-fetched to imagine the emergence of *Homo sapientissimus*, who would surpass us in its intellectual faculties, in the richness of its emotions, in possessing a fabulous level of creativity, and amazing artistic sense, and other capabilities whose existence we cannot guess at present. If *Homo sapientissimus* does not simply replace us altogether, will it regard *Homo sapiens* condescendingly?[170]

The rub, of course, is that we have to evolve out of our selfish consumerism in order to buy ourselves that much time. When I look around at how humans are *still* treating those who don't look and sound and act just like they do, at the long lines of cars waiting for the fast-food drive-through window, *Homo sapientissimus* seems like a fairy tale spun by a madman. No one can reasonably argue that this planet wouldn't be better off without us on it. Ray Bradbury puts it best in the final vignette of *The Martian Chronicles*, "that way of life proved itself wrong and strangled itself with its own hands."[171] Artists and intellectuals acknowledge the truth of this, but they usually end up thinking and talking around the problem, throwing up their hands as if they're too caring and sensitive to have played any part in creating this mess.

© Weronika Kolinska, *Octopus*, digital illustration, 2018. @w.kolinska

Bernard Shaw was preoccupied from beginning to end with humanity's responsibility for its own betterment, to the point that his friend H.G. Wells poked fun at his diet and anti-vivisection activism in *The Shape of Things to Come*. Shaw's play *Man and Superman* was inspired by Nietzsche's

concept of the Übermensch, that one specimen of humanity who has taken on "the struggle of Life to become divinely conscious of itself instead of blindly stumbling hither and thither in the line of least resistance," and whose conduct thereby justifies the existence of the entire species.[172] Shaw also wrote in his preface to *Misalliance* that there are two types of imagination: romantic and realistic. Romantic imagination is escapist and solipsistic and riddled with wishful thinking, whereas realistic imagination is clear-eyed and empowering.[173] Shaw believed that even one's most private and personal decisions are inherently political. Colin Wilson writes that in Shaw's eyes, the romantic pessimism of Kafka, Proust, Joyce, and Eliot was a total cop out:

> Kafka's effects of nightmare are produced by piling up dreamlike ambiguities and complications until the mind is hypnotized into a sense of helplessness. Shaw's clarity produces exactly the opposite effect, for it is obviously inspired by a conviction that any problem will yield to a combination of reason, courage and determination…Somehow, whether we like it or not, we have to start believing in the future, and in man's power to transform it.[174]

My favorite examples of realistic imagination are Octavia Butler's Earthseed novels, *Parable of the Sower* and *Parable of the Talents*, which describe a near future (the 2020s, no longer the future by the time you may be reading this) in which human selfishness and brutality continue to their logical ends. Homesteaders try to build a quiet life for themselves and their children and are attacked, stolen from, murdered, or separated from their families forever.

The verses at the start of each chapter serve as admonitions to us, *here*, in the real and present moment. Because if you're reading this, it's not too late to begin a life of enlightened self-interest.

Our evolution has to start now, and as bizarre as it seems, even Big Ag sees the writing on the wall. Corporations like Tyson and Cargill are investing in vegan food companies and cellular agriculture because their CEOs know that animal agriculture is unsustainable. Ultimately, these corporations don't exist to kill animals; their only goal is to make lots and lots of money. But they

won't make money doing honorable work before each individual consumer commits to a more responsible way of life.

In other words, we need to be "ahead of our time"—which is, uncoincidentally, the most double-sided praise an artist can receive. In an open letter urging his fans to consider veganism, Saul Williams writes:

> I have never considered myself ahead of my time simply because a few executives may not have been visionary enough to determine where music or antiquated ideas of race are heading or to realize their role in continually underestimating the intelligence of the listener an d our generation. Rather I have seen those 'powers that be' as behind the times and perpetuators of an old cycle.[175]

Our work as vegan artists is to shed the cold light of truth on the old cycle and those "powers that be," because others are depending on us to usher that system into the history books. We need to live as if our great-great-grandkids' health and safety depend on the choices we make today—*because they do*. With clean water, air, and earth, and with peaceable food in their stomachs, our descendants will be free to enjoy the art we've created, and in turn create their own.

A Conversation with Donald Vincent

Donald Vincent—also known as Mr. Hip—is a poet, rapper, and creative director with an MFA from Emerson College. Mr. Hip's new album, *Vegan Paradise*, was recorded with the help of a grant from the Culture & Animals Foundation, and his YouTube cooking show *That's So Vegan!* presents meals that are easy and affordable. He's also the founder of Le Pamplemuse, a digital multimedia content platform promoting inspired sustainable living. Originally from Washington, DC, he's currently based in Los Angeles, where he teaches creative

writing at UCLA. We chatted over a lunch of vegan mac 'n cheese and seitan riblets at the Boston VegFest, where Donald gave a talk-slash-performance called "You Art What You Eat."

How did you choose the name for your digital content platform?

Pamplemousse is "grapefruit" in French, and we changed the end of the word to "muse" because we want to be a source of inspiration for better lifestyles and better living.

Part of the reason why I became vegan was through organic foods. Organic meat was too expensive, so I just decided to cut it out. When I was a child, I hated grapefruit, but when I was an adult and started grocery shopping for myself, I tried an organic grapefruit one day and fell in love.

What else are you working on right now?

I have a television pilot that's in the third round to see if it'll be produced, and one of the characters is vegan. I was talking to Ellie [Sarty, founder of Compassion Arts] about creating another television pilot where the world is vegan and the meat eaters are treated like vegans are treated now—what society would look like if everyone were plant-based. It's futuristic, the Jetsons as opposed to the Flintstones.

The vegan Jetsons! Love it! What you said about hating and then loving grapefruit reminds me of this chapter I wrote called "Pulling a One-Eighty": training yourself to change your own mind about something.

I like that. I started teaching a high school poetry workshop on the weekends, and I had two kids who were both hip-hop artists. One of the kids, his mom was my coworker. He picked me up from the airport today, and I said, "How's your mom?" And he said, "She's losing a lot of weight. She's starting to eat vegan now, she's on the path, but there are some things she can't give up." And I was like, "To say she can't give something up is to say she can't do something, and she can do anything that she wants to do." So the one-eighty piece resonates.

Let's circle back to your going-vegan story, because I know there's more to it.

Boston Organics is a food delivery service I was using, so I was getting fruits and vegetables I never knew existed. Rutabaga? I was like, "what the hell is this?" But I learned to cook vegan recipes. People were telling me I couldn't do it, "Giving up meat? That's hard!" I officially went vegan in October 2014.

Carolyn Newmark—she was only seventeen at the time, but she managed a poetry-bookstore social media account in New York—always used this little yellow plush chicken in her posts. For Thanksgiving she put the chicken on top of a carton of eggs saying, "Hanging out with my peeps," silly stuff like that. One day the chicken was like, "I want to read at one of your events." So that November we did an event in New York, and she made a video of how chickens are treated in American [factory farms]. Chickens are treated like minorities. That was the day I thought, "Wow, I don't

think I'm ever going to eat meat again." I started doing stuff with the PETA folks here, and I got to meet thirty-year vegans. They'd give me recipes, they showed me how to use a dehydrator. Once I found out how [animal agriculture] affects the climate and everything else, it was like, "There's no reason for me to eat animals."

Did you notice any change in your creative process when you went vegan?

I've always worked two jobs, I've always had school, so my creative process is I have to do it as soon as possible, even if I'm in the middle of a meeting. I have to write down whatever strikes me. Veganism helped me with my insomnia, so when I think about that, yes, it does help my process because it helps me get through my day.

Album art by Jane O'Hara, 2018.

There was a stint where I was releasing song after song after song, and this girl contacted me to say, "I like the new stuff, but are you sure this is your music?" I said, "Yeah. What do you mean?" And she said, "There's no vegan references." Because I usually rap about veganism. I said I didn't want to be "the vegan guy," and she said, "but you *are* the vegan guy." I guess it's being able to have my creative process be my everyday life. I'm more creative at this point than I was prior to. But then it depends on what lens you look at creativity through: is it output? Quantity versus quality? I'd say the quality is better now, but then that might just be a matter of time. And the quantity is better, because I'm writing every day—before I was *thinking* every day, but I wasn't writing every day. A poet told me, "Even when you're not writing, you're writing, because you're living and experiencing." I see the creative process through that lens.

Did you notice any changes in your emotional wellbeing?

I was taking antidepressants, and I didn't like them. Around the time I stopped taking them is when I went vegan. This is TMI, but the doctor told me I'd have delayed ejaculation. I had an uncomfortable experience, and I was like "I can't come, this is not cool, I feel bad for the ladies, I'm not taking these anymore." I was creative even so, but having a clear mind helps.

And I don't like talking about it because not everyone loses weight, but I went from about 218 to 148 in the span of eight months; that was just me biking to work, eating differently, and running every now and then. I always tell people I have more energy, and they say it's the placebo effect, but no, not really. I know the difference when I go to a restaurant with vegan options, and I look around after the meal and everyone's slumped over, exhausted from eating. And I'm like, how do you get exhausted from something that's supposed to give you energy?

Exactly. **And on that note, what's your advice for new vegans on relating to the not-yet-vegan?**

Meet people where they're at. I feel bad for meat eaters with vegans coming down on them. When I started doing demonstrations, the best part was that my feelings were on the sign—for example, *You're not lactose intolerant, you're just not a baby cow*—I'm not saying "you're at fault, you're the reason," I'm just saying "these are my thoughts, let that sink in." That's the approach I take—I don't try to push it on anyone. And I pay attention to people I don't agree with; I tell my students from a writing perspective, if you're writing a position paper, your argument is only as strong as the people who disagree with you. If you're not giving them something to engage with, they're not going to keep on reading, they're not going to care. That's how I feel about vegans pushing veganism.

And what advice do you give to aspiring artists?

Stick to your craft. Richard Blanco, the inaugural poet for President Obama, said that art has gone where no politician has gone before, and that really stuck with me because of how poetry is a counterculture to some extent. Back in the Renaissance, they'd parody the king, make satires, put them on in *front* of the king.

People today need to remember how important art is. Stay honest. How do you write something that other people are going to like, but is also true to yourself? Once you find that balance, it's easier to become a better artist. I used to struggle with trying to write for an audience, but when I started writing for myself, that's when the audience that I was "supposed" to attract would come out.

How do we know we're not being self-indulgent?

We *are*. We're human beings, that's one of our traits, but we artists always give back. You're the most self-indulgent person I've talked to all day, but I'm learning by listening to you being self-indulgent. I don't think there's any art that isn't self-indulgent.

Parting words?

Every time I have a dream about eating chicken, I always wake up in a cold sweat. As long as that happens, I know I'm on the right path.

 ◉ www.hidonaldvincent.com and www.lepamplemuse.com
 ◉ @mr_hip and @lepamplemuse
 ◉ le pamplemuse

TIPS & RESOURCES

This Is Not an "Impossible Dream"

During the writing of this book, I spend four days in Manhattan to receive my master vegan lifestyle coach and educator certification from Main Street Vegan® Academy. Victoria Moran feeds and educates each class of twenty-plus students in her Harlem apartment, and though I know she must be exhausted by all the logistics and cooking and cleanup, each day unfolds in a totally calm and seamless way. That's Victoria's special brand of magic—the centeredness that drew me to her work and message when I first heard her speak at the New York City VegFest back in 2012.

The program wraps up on Sunday evening at six o'clock, but Victoria encourages those of us who don't have a plane or train to catch to kick back and debrief. We speak of our goals for growing our businesses as "professional vegans" and brainstorm even more possibilities for one another. Then William, Victoria's husband, comes home with his accordion in tow, and we ask him if he'll play a few songs for us. "Any requests? I can do show tunes," he says.

"Man of La Mancha," I pipe up. My classmates call out other requests, but William turns the pages of his songbook murmuring, "*Man of La Mancha, Man of La Mancha...*"

Something in me—some*one*—is trembling. *Man of La Mancha* is my father's favorite musical; he took me to the 2002 Broadway revival with Brian Stokes Mitchell and Ernie Sabella two times. But we are estranged. I haven't spoken to him in more than a year.

William plays the opening notes of "The Impossible Dream," and I start to cry. I'm standing in the kitchen, though, so I don't think anybody notices. My heart feels like one of those old-fashioned chocolate fountains, continuously overflowing yet perfectly contained. There is an intense feeling of belonging—right now, right here, with Victoria and William and all our friends—and an unambiguous reassurance that I am on the path I was put here to walk. My father is a quixotic figure in some respects—articulating his ideals yet never managing to live anywhere near to them—and

even as a young woman I understood why he was so captivated by that musical. Sometimes I feel like Don Quixote myself, talking and talking about the cruelty of eating and wearing animals and trying not to wonder if the people around me think I'm as foolish as I so often feel. *Why can't I be a more effective speaker? Why do I let them interrupt me, why don't I call out their illogical arguments? They're not listening and by the time they finally let themselves understand it'll be way too late. My, what a sanctimonious jerk I am!* Some days ethical veganism does feel like an "impossible dream," but I take heart knowing there are more and more humans every day dreaming it with me. At some point there *will* be enough Don Quixotes to pull down the windmill-giants of apathy and conscience-free capitalism. (It's an imperfect analogy, I know: in this case the enemies are not imaginary.)

Perhaps I started out in 2011 with an "all-good" philosophy of veganism, but I don't subscribe to it anymore. A plant-based diet will not render you immortal, and indeed, I have known a couple of vegans who have died of cancer and another longtime vegan who died of heart failure in his late sixties. Your chances of staying healthy are way better on a vegan diet, but they're not perfect. And as much as it pains me to admit it, self-described vegans can also be racist and sexist. I have occasionally met someone of whom veganism can be said to be far and away the best thing about them. We are not angels or saints or shamans in some utopian religion that doesn't exist yet. Most of us don't know how to talk to trees. We're just flawed and fallible humans trying to live as kindly and as unhypocritically as possible.

Recently I was flipping through old journals from my years living in New York, and in between regular entries and notes for my "practice novel" and what would become *Mary Modern*, my debut, there are non sequiturs in looping jumbled script, which is how I can tell I wrote them in the dark. One such fragment reads,

It is as if you reached the unreachable, and you weren't ready for it.

I must have scribbled this down around the time of the *Man of La Mancha* revival, because the last lyric of *The Impossible Dream* is "Yes, and I'll reach the unreachable star." It *is* foolish to envision a

kinder world than the one we see before us. But what is the point of being here, otherwise? Why bother if not to do better?

Victoria has these wonderful lines in her book *The Good Karma Diet* that I wish I could have read as a young girl obsessed with becoming someone else. "I can't cite the specifics of your transformation," she writes. "I only know how transformation works, and it works by acting yourself into feeling differently."[176] A frighteningly simple concept, isn't it? It's a more sincere take on "fake it 'til you make it." But this change isn't so scary when you feel motivated by something bigger than yourself.

There isn't any one perfect way to live your life, no one ideal route to the fullest expression of your creativity. But there *are* clear and straightforward ways to grow into the person you hope in your heart that you are—a transformation that is closer than you think and more profound than you can imagine.

If You Can
Move, You Can Dance[XV]

SOME ADVICE ON GOING AND STAYING VEGAN

Welcome to the best years of your life, my friends—and let me tell you, I'm planning on my personal golden age of radiant good health, productivity, and creative fulfillment to last until the day I die.

But enough with the sweeping pronouncements. I've got plenty of practical advice on transitioning to a vegan lifestyle, along with some frank talk about the challenges you're bound to face—even though going vegan has never been easier with all the delicious and innovative cruelty-free food products on the market today.

I have found only one downside to this lifestyle, and it's not missing dairy; these days cheese and yogurt and milk is only food to me if it's made from almonds, soy, cashews, or coconut. No, the only downside to veganism is having to deal with non-vegans. It is profoundly depressing to encounter people who are so attached to their bacon and steaks and Thanksgiving dark meat, so disconnected from their curious and sensitive inner child, that they will never even for a nanosecond contemplate a vegan diet (at least not in *this* lifetime). I understand deep in my bones why Isaac Bashevis Singer's protagonist in his short story "The Slaughterer"—a holy man socially coerced into becoming the ritual butcher for his community—winds up chucking his knives in the outhouse: "they'll think I'm mad, but I no longer wish to be sane."[177]

It is tiresome too, having to explain my choices on a regular basis, being asked to "make my case" time and time again when everything there is to know about veganism is, as I've said, so easily Googleable.

Pretty much the worst I've ever felt was during my time in Indonesia, when I was traveling with two meat-eating friends. We hooked up with an Italian girl who absolutely *had* to have a fish for her dinner, and the waiter at the seafood restaurant made me feel

XV Adapted from a Zimbabwean proverb: "If you can walk you can dance. If you can talk you can sing."

so uncomfortable ("We serve tempeh with fish or meat. Why won't you eat meat?") that I had to leave.

I walked back to our hotel in tears, wondering why my best friend couldn't have come with me so I wouldn't have to eat alone. *Man, having a conscience really sucks sometimes.*

This lifestyle requires patience and flexibility, but if these have never been virtues of yours, please don't worry: being vegan is actually a way to *become* more patient and much more flexible (though I'm seven years in and clearly still working on it!)

Remember that everything is figure-outable.

Invited to an omni potluck? Bring the tastiest dish in your repertoire (and double the recipe). Same goes for family gatherings: you might want to bring two or even three side dishes, especially if your elderly relatives are flummoxed by the concept of veganism—this way you'll have enough to eat, and your delicious offerings will get your family feeling more receptive toward your way of living.

When in doubt, eat beforehand. Far from ideal, I know, but I live in hope that someday this advice will be obsolete. For now, just remember that "hangry" vegans make ineffective ambassadors!

Be prepared.

I always stop by Trader Joe's a day or two before an international flight to stock up on sesame sticks, wasabi peas, deluxe trail mix, and other tasty protein-rich snacks. That haul adds at least ten pounds to my baggage weight, but this way I will never go hungry. When I traveled to Turkey with my sister and her mother-in-law in the middle of Ramadan (when the locals weren't eating during daylight hours, so restaurants in non-touristy areas weren't open), you can imagine how relieved we were to have something to tide us over. On other occasions, when camping, we've been able to go for a full day without proper meals thanks to my stash of snacks.

While you can buy nuts and fruit at any gas station, you will pay a pretty penny for them, so stock up before you hit the road. Even on an ordinary day, it's smart to keep at least one snack in your bag.

Eat as much as you need to feel full.

Oftentimes people who have flirted with a plant-based diet will say they felt hungry all the time, but that won't happen if you're getting enough calories. Buy yourself the comprehensive edition of

Becoming Vegan by Brenda Davis and Vesanto Melina—it's the most complete and user-friendly vegan nutrition primer out there.

Eat food that makes you happy.

While I love a big nutritious salad with chickpeas and avocado and sesame tahini dressing, I am also admittedly one of those foodies who just *has* to try the vegan lobster roll. And after a long day of writing, sometimes I just pop an Amy's or Daiya-brand pizza in the oven, promising myself I'll eat better tomorrow—and even if I don't, I'm not going to stress about it. I mostly manage to eat fresh fruit and vegetables every day, I make sure I'm eating enough beans, nuts, tempeh, and tofu for protein, and I take a B12 spray supplement (which has a pleasant raspberry flavor). As long as those bases are covered, I feel free to eat whatever I like.

Remember that meat eaters don't have the exclusive on umami.

If you're craving the flavor of your old favorites, focus on cooking with umami-rich plant foods: mushrooms, seaweed, sun-dried tomatoes, olives, toasted nuts and seeds, and anything fermented. Try cooking with nutritional yeast, which offers a delightful cheesy flavor and is packed with B vitamins, protein, and fiber. Make a bacon-esque marinade out of soy sauce, hot sauce, liquid smoke, and maple syrup.

And if—after the two to three weeks your taste buds need to regenerate—you're *still* craving meat or cheese, do a Google image search for "what a heart with atherosclerosis looks like." (I'm sorry, okay? I had to do it.)

Stock your pantry with foods you're excited to try.

I keep a running list of unfamiliar foods and condiments I encounter at restaurants or in other people's cooking—mirin, adobo, pomegranate molasses—and when I get time, I'll buy these ingredients and find recipes to try them in. I'm also not above stashing pricey snack foods (like Hail Merry coconut or chocolate mint tarts, or Louisville Vegan Jerky) as rewards for meeting my writing goals.

It's also a great idea to keep an abundance of fresh fruit and snacks on display in your home—a bowl of pears and bananas, a sealed jar of almonds roasted with salt, thyme, and rosemary—so whenever you feel peckish, the healthy stuff is the stuff you reach for.

Ask for what you need and want.

Remember what happened to me that night in Indonesia? Here's the thing: I could have asked my friend to come with me to find another restaurant, but I didn't. Even if he'd said no (out of deference to our companion), I wouldn't have felt quite so dejected walking back to the hotel. I would have fallen asleep that night knowing I'd done what I could to advocate for myself.

I used to fume in silence, and that is a sad, small way to live one's life.

So now I'm trying not to see or anticipate problems where there aren't any. I usually manage to come across as calm and agreeable as I make a request, and even if a restaurant can't accommodate what I'm asking for, they'll almost always offer an acceptable alternative.

Meal prep for the win!

Batch cooking is way more efficient than preparing a new meal every night. Put on some music, pour yourself a fun beverage, and prepare a few meals you can eat for the rest of the week: a curry or chili or chowder, a lasagna or casserole, a nutrient-dense salad with beans and grains, an array of mezze dishes you can mix and match. A few concentrated hours in the kitchen buys you a week of no-fuss, well-fed art making.

Tweak your "vices."

There's always a healthier and more ethical way to enjoy your favorite treats. Just choose organic Fair Trade coffee with plant milk instead of going to Dunkin Donuts, or quality chocolate instead of the junky stuff produced using child slavery in Africa.

Find your crowd.

Especially if you're the first vegan in your network of friends, you'll want to make it a priority to attend Meetup events and anything else going on in your local veg eateries. And if you live in a place dominated by traditional restaurants and attitudes, it's all the more crucial that you join Facebook groups and other online communities to help you connect with like-minded people. If there's no Meetup group in your area, start one yourself. Odds are high you're not the only vegetarian or veg-curious person in your zip code.

Practice active humility.

Sometimes people will react as if you're judging them the instant you identify yourself as a vegan. How can we communicate with them (on any topic at all) through that invisible defensive wall? If you get prickly in response, you give them the justification they've been groping for, so they can dismiss *all* vegans as rude and intolerant any time the subject comes up. It helps to see people not as not-vegan, but as not-*yet*-vegan. Consider what words might have helped you to ease up and listen in the years before you chose this lifestyle. Without love, without even a good-faith attempt at understanding, what hope can any of us have for the future?

At the Harvard T station one evening, I happened upon a discarded pamphlet entitled "10 Reasons to Become a Mason." I found a great deal of wisdom in reason number 8: "Masonry is a place to spend time with a group of Brothers, who, by acting as good men, can make you want to become a better man. *Not better than others, but better than you would otherwise have been.*"

That's the distinction we'll always want to make.

Endnotes

1 Thich Nhat Hanh, *How to Eat* (Berkeley, CA: Parallax Press, 2014), 56.

2 Carol Adams, *The Sexual Politics of Meat*, 20th Anniversary Edition (New York: Bloomsbury, 2010), 66.

3 Neale Donald Walsch, *Conversations with God: An Uncommon Dialogue, Book 3* (Charlottesville, VA: Hampton Roads, 1998), 297.

4 Ezra Klein, "The Green Pill," The Ezra Klein Show, podcast audio, June 11, 2018, https://player.fm/series/the-ezra-klein-show/the-green-pill.

5 @the_vegan_soldier, Instagram post, September 5, 2016, https://www.instagram.com/p/BJ9jmp2jV6m/.

6 Starr Carrington, "Food Justice and Race in the US," in *Food Justice: A Primer*, ed. Saryta Rodríguez (Sanctuary Publishers, 2018), 182–183.

7 Hassan Malekinejad and Aysa Rezabakhsh, "Hormones in Dairy Foods and Their Impact on Public Health," *Iranian Journal of Public Health*, June 2015, 44(6): 742–758, https://www.ncbi.nlm.nih.gov/pmc/articles/PMC4524299/.

8 T. Colin Campbell and Thomas M. Campbell II, *The China Study, Revised and Expanded Edition: The Most Comprehensive Study of Nutrition Ever Conducted* (Dallas, TX: BenBella Books), 2016, 170.

9 Philip G. Chambers and Temple Grandin, "Guidelines for Humane Handling, Transport and Slaughter of Livestock," report for the Food and Agriculture Organization of the United Nations (Regional Office for Asia and the Pacific), April 2001, http://www.fao.org/docrep/003/x6909e/x6909e04.htm.

10 Andrea Bertoli, "Can a Vegan Diet Fight Depression?" Care2, https://www.care2.com/greenliving/can-a-vegan-diet-fight-depression.html, accessed December 5, 2018.

11 Bernard Shaw, *Major Barbara*, in *Collected Plays with Their Prefaces*, vol. 3 (New York: Dodd, Mead & Company, 1975), 156.

12 Jolynn Van Asten, Revised Veganism and Creativity Questionnaire, September 17, 2018.

13 David Holbrook, *Sylvia Plath: Poetry and Existence* (London: The Athlone Press, 1976), 267.

14 *The Unabridged Journals of Sylvia Plath*, ed. Karen V. Kukil (New York: Knopf, 2000), 502.

15 Ronald Hayman, *The Death and Life of Sylvia Plath* (New York: Carol Publishing Group, 1991), 95–99.

16 *My Favorite Wife*. Directed by Garson Kanin. 1940. Burbank, CA: Warner Home Video, 2004. DVD.

17 Tristram Stuart, *The Bloodless Revolution* (New York: W.W. Norton, 2006), 368.

18 Sylvia Plath, "The Munich Mannequins," in *Ariel* (New York: Faber and Faber, 1965), 82.

19 Anonymous (Henry Brougham), "Ritson on Abstinence from Animal Food," *The Edinburgh Review*, April-July 1803, 131.

20 Karen Ranzi, "Anatomy of a Vegan Business: Service," lecture, Main Street Vegan® Academy Master Class, New York, NY, August 26, 2018.

21 Neal Barnard, "The Incredibly Inedible Egg," The Physicians Committee for Responsible Medicine, November 21, 2014, https://www.pcrm.org/nbBlog/index.php/the-incredibly-inedible-egg.

22 Michael Greger, "Preventing Alzheimer's Disease with Diet," NutritionFacts.org, July 26, 2016, https://nutritionfacts.org/2016/07/26/preventing-alzheimers-disease-diet.

23 Kerry Lemon, Veganism and Creativity Questionnaire, September 14, 2017.

24 Vicki Brett-Gach, Veganism and Creativity Questionnaire,

September 2, 2017.

25 Adama Maweja, "The Fulfillment of the Movement," in *Sistah Vegan: Black Female Vegans Speak on Food, Identity, Health, and Society*, ed. A. Breeze Harper (New York: Lantern Books, 2009), 128.

26 J. P. Guilford, *Intelligence, Creativity, and their Educational Implications* (San Diego: Robert R. Knapp, 1968), 80, 92, 99.

27 Poetreenet, "Saul Williams Vegetarian Vegan Diet Underground Spoken Word Poetry." Filmed 2009. YouTube video, 01:10. Posted March 11, 2012. https://youtu.be/TP0TvA5_hno.

28 Ulrich Kraft, "Unleashing Creativity," in *The Best of the Brain from Scientific American*, ed. Floyd E. Bloom (New York: Dana Press, 2007), 13, 15–16.

29 J.L. Fields, "Matt Ruscigno: Healthy habits and 'skillpower,'" *Easy Vegan*, podcast audio, January 2, 2018, https://soundcloud.com/user-325033841/ep-115-matt-ruscigno-new-healthy-habits-in-the-new-year.

30 Kari Molvar, "One Artist's 'Life-Changing' Morning Drink," January 8, 2018, https://www.nytimes.com/2018/01/08/t-magazine/ana-kras-chai-latte-recipe.html.

31 Sara Sechi, "Be What You Eat," https://www.sarasechiart.com/product/be-what-you-eat-print, accessed October 22, 2018.

32 Preetha Anand, et al., "Cancer is a Preventable Disease that Requires Major Lifestyle Changes," *Pharmaceutical Research* 25(9), September 2008, https://www.ncbi.nlm.nih.gov/pmc/articles/PMC2515569/.

33 Jessa Crispin, *Why I Am Not a Feminist: A Feminist Manifesto* (Brooklyn: Melville House, 2017), 43.

34 Victoria Moran, *The Good Karma Diet* (New York: Penguin Random House, 2015), 10.

35 J.M. Coetzee, foreword to *Second Nature: The Inner Lives of Animals* by Jonathan Balcombe (New York: Palgrave Macmillan, 2010), ix.

36 Marty Davey, "Plant-Based Nutrition 101," presentation at Main Street Vegan Academy, June 19, 2013.

37 Kerry Lemon, *Ibid.*

38 John Hegarty, *Hegarty on Creativity: There Are No Rules* (New York: Thames & Hudson, 2014), 20.

39 Linda Fisher, "Freeing Feathered Spirits," in *Sister Species: Women, Animals and Social Justice*, ed. Lisa Kemmerer (Chicago: University of Illinois Press, 2011), 111.

40 Jenné Claiborne, "6 Genius Cooking Tricks from a Vegan Soul Food Chef," February 14, 2018, https://www.self.com/story/sweet-potato-soul-food-vegan.

41 Guilford, 93.

42 Stanley Chase, Louisville Vegan Jerky, https://www.lvjco.com/about-us, accessed October 1, 2016.

43 David Kesmodel and Owen Fletcher, "Hummus Is Conquering America," *The Wall Street Journal*, April 30, 2013, https://www.wsj.com/articles/SB10001424127887323798104578453174022015956.

44 Paul Jarvis, *Eat Awesome: A regular person's guide to plant-based whole foods* (self-published ebook, 2012), 18.

45 Rynn Berry, *Famous Vegetarians & Their Favorite Recipes: Lives & Lore from Buddha to the Beatles* (New York: Pythagorean Publishers, 2003), 73.

46 Sunaura Taylor, *Beasts of Burden: Animal and Disability Liberation* (New York: The New Press, 2017), 101–103.

47 Brené Brown, *Daring Greatly: How the Courage to Be Vulnerable Transforms the Way We Live, Love, Parent, and Lead* (New York: Gotham Books, 2012), 152.

48 *Ibid.*, 169.

49 Julie Hirschfeld Davis, "Trump Calls Some Unauthorized Immigrants 'Animals' in Rant," *The New York Times*, May 16, 2018, https://www.nytimes.com/2018/05/16/us/politics/trump-undocumented-immigrants-animals.html.

50 Massimo Filippi et al., "The Brain Functional Networks Associated to Human and Animal Suffering Differ among Omnivores, Vegetarians and Vegans," *PLOS ONE* 5(5), May 26, 2010, https://doi.org/10.1371/journal.pone.0010847.

51 Mihaly Csikszentmihalyi, *Flow: The Psychology of Optimal Experience* (New York: HarperCollins, 1990), 69.

52 Ashley Capps, "I Used to See Her in the Field beside My House," in *Mistaking the Sea for Green Fields* (Akron, OH: University of Akron Press, 2006), 41.

53 Malte Hartwieg, Instagram post, August 30, 2018, https://www.instagram.com/p/BnH7mirnJWP/.

54 T.S. Eliot, "Ash Wednesday," in *Collected Poems, 1909–1962* (New York: Harcourt Brace, 1963), 86.

55 Henry Lien, *Peasprout Chen, Future Legend of Skate and Sword* (New York: Henry Holt, 2018), 198.

56 Jill Louise Busby, Instagram post, April 26, 2018, https://www.instagram.com/p/BiCA50YllKm/.

57 Keith Tucker and Kevin Tillman, "Hip-Hop & Food Justice," Resistance Ecology Conference, June 27–29, 2014, https://vimeo.com/99715385.

58 "Going Vegan Has Done 'Wonders' for Mýa," PETA.org, https://www.peta.org/features/mya-from-vegetarian-to-vegan/, accessed September 15, 2018.

59 Jonnelle Davis, "With Ringling Bros. ending, PETA turns its attention to UniverSoul Circus," *Greensboro News & Record,* March 21, 2017, https://www.greensboro.com/news/local_news/with-ringling-bros-ending-peta-turns-its-attention-to-universoul/article_09c365cf-f98a-5dad-b6a3-33e0a46af7a9.html.

60 Trish Bendix, "ANIIML Uses Her Body as a Canvas For 'SLAY!'," *Into,* September 24, 2018, https://www.intomore.com/culture/aniiml-uses-her-body-as-a-canvas-for-slay.

61 Alfredo Meschi, Instagram post, April 3, 2018, https://www.instagram.com/p/BhGLqeaIFQV/.

62 Jasmin Singer, "Compassion Unlocks Identity," filmed May 2017, TEDx video, 8:01.

63 Jill Louise Busby, https://www.jillisblack.com/, accessed September 15, 2018.

64 John Robbins, "2,500 gallons all wet?" Earth Save: Healthy People Healthy Planet, http://www.earthsave.org/environment/water.htm, accessed October 23, 2018.

65 "The Browning of America," *Newsweek*, February 22, 1981, 26.

66 Mat McDermott, "From Lettuce to Beef, What's the Water Footprint of Your Food?" Treehugger, June 11, 2009, https://www.treehugger.com/green-food/from-lettuce-to-beef-whats-the-water-footprint-of-your-food.html.

67 John Robbins, *The Food Revolution: How Your Diet Can Help Save Your Life and Our World*, 10th anniversary edition (San Francisco: Conari Press, 2010), 236.

68 McDermott, *Ibid.*

69 Alex Park and Julia Lurie, "It Takes HOW Much Water to Make Greek Yogurt?!" *Mother Jones*, March 10, 2014, https://www.motherjones.com/environment/2014/03/California-water-suck/.

70 "Food Facts: How Much Water Does It Take to Produce…?" Water Education

Foundation, https://www.watereducation.org/post/food-facts-how-much-water-does-it-take-produce, accessed December 7, 2018.

71 John Robbins, *Diet for a New America: How Your Food Choices Affect Your Health, Happiness and the Future of Life on Earth*, 25th anniversary edition (Novato, CA: H.J. Kramer/New World Library, 2012), 341.

72 Cheryl A. Dieter, et al., "Estimated use of water in the United States in 2015," The US Geological Survey, June 19, 2018, https://pubs.er.usgs.gov/publication/cir1441.

73 "Polluted Runoff: Nonpoint Source (NPS) Pollution," The US Environmental Protection Agency, https://www.epa.gov/nps/nonpoint-source-agriculture, accessed December 11, 2018.

74 "Environmental Racism," The Food Empowerment Project, http://www.foodispower.org/environmental-racism/, accessed December 7, 2018.

75 Leo Horrigan, et al., "How Sustainable Agriculture Can Address the Environmental and Human Health Harms of Industrial Agriculture," *Environmental Health Perspectives*, May 2002, https://www.ncbi.nlm.nih.gov/pmc/articles/PMC1240832/pdf/ehp0110-000445.pdf.

76 C.M. Pringle and Frank J. Triska, "Emergent Biological Patterns and Surface–Subsurface Interactions at Landscape Scales," in *Streams and Ground Waters*, ed. Jeremy B. Jones and Patrick J. Mulholland (Cambridge, MA: Academic Press, 1999), 179.

77 Jon Freedman, "We are Running Out of Water—Now What?" World Resources Institute, May 31, 2012, https://www.wri.org/blog/2012/05/we-are-running-out-water-now-what.

78 "Water Usage & Privatization," The Food Empowerment Project, http://www.foodispower.org/water-usage-privatization/, accessed December 7, 2018.

79 Harper, 25.

80 Dan Hancox, "The unstoppable rise of veganism: how a fringe movement went mainstream," The Guardian, April 1, 2018, https://www.theguardian.com/lifeandstyle/2018/apr/01/vegans-are-coming-millennials-health-climate-change-animal-welfare.

81 Matthieu Ricard, *A Plea for the Animals: The Moral, Philosophical, and Evolutionary Imperative to Treat All Beings with Compassion*, translated by Sherab Chödzin Kohn (Boulder, CO: Shambhala, 2016), 98.

82 Lauren-Elizabeth McGrath, "The Only Honey You'll Ever Need," Ecorazzi, February 8, 2016, http://www.ecorazzi.com/2016/02/08/the-only-honey-youll-ever-need-an-interview-with-honey-labronx-vegan-drag-queen/.

83 Tara Sophia Bahna-James, "The Art of Truth-Telling: Theater as Compassionate Action and Social change," in *Sister Species*, 121.

84 Emma J. Lapsansky-Werner, "At the End, an Abolitionist?" in *Benjamin Franklin: In Search of a Better World*, ed. Page Talbott (New Haven, CT: Yale University Press, 2005), 274.

85 Bahna-James, *Ibid*.

86 Bernard Shaw, *Man and Superman*, in *Collected Plays with Their Prefaces*, vol. 2 (New York: Dodd, Mead & Company, 1975), 679–680.

87 Aph Ko, "How Social Media Serves as a Digital Defibrillator for 'The American Dream,'" in *Aphro-Ism: Essays on Pop Culture, Feminism, and Black Veganism from Two Sisters* (Brooklyn: Lantern Books, 2017), 97.

88 Oksana Tunikova, "The Hidden Link Between Emotional Intelligence and Marketing Manipulation," February 21, 2018, https://medium.com/@tunikova_k/the-hidden-link-between-emotional-intelligence-and-marketing-manipulation-2c19115840ca.

89 Henry David Thoreau, *Walden, or Life in the Woods* (Boston: Houghton Mifflin, 1906), 101.

90 *Ibid.*, 179.
91 *Ibid.*, 237.
92 *Ibid.*, 101.
93 Meta Wagner, *What's Your Creative Type? Harness the Power of Your Artistic Personality* (New York: Seal Press, 2017), 18.
94 Apple Dictionary, s.v. "cognitive dissonance," accessed August 31, 2017.
95 Vegan Rabbit, "I Hope This Post Makes You Uncomfortable," October 28, 2014, https://veganrabbit.com/2014/10/28/cognitive-dissonance-animal-rights-vegan/.
96 David Neiwert, "Picturing Extremism," *Intelligence Report*, Spring 2017, 64.
97 J.K. Rowling, Twitter post, February 1, 2017, 7:56 a.m., http://twitter.com/jk_rowling.
98 Richard Bowie, "Grotesque Image of Nipple on Bacon Goes Viral, Creates Vegans," VegNews, August 11, 2016, https://vegnews.com/2016/8/grotesque-image-of-nipple-on-bacon-goes-viral-creates-vegans.
99 Anne Lamott, *Bird by Bird: Some Instructions on Writing and Life* (New York: Anchor Books, 1994), xxxi.
100 William Crain, "Animal Suffering: Learning Not to Care and Not to Know," *Encounter 22*, Summer 2009, 2.
101 Jennifer Armstrong, "Eating Reading Animals," *The Horn Book*, May 1, 2010, http://www.hbook.com/2010/05/choosing-books/horn-book-magazine/eating-reading-animals/.
102 Saryta Rodríguez, *Veganism in an Oppressive World*, ed. Julia Feliz Brueck (Sanctuary Publishers, 2017), 28.
103 Syl Ko, "Black Lives, Black Life," *Aphro-Ism*, 4.
104 Tucker and Tillman.
105 *Rhyme & Reason*. Directed by Peter Spirer. 1997. https://play.google.com/store/movies/details/Rhyme_Reason?id=0vpoXNCZIqU.
106 "Deejayin," The Temple of Hip-Hop, https://thetempleofhiphop.wordpress.com/the-9-elements/deejayin/, September 13, 2018.
107 "Emceein," The Temple of Hip-Hop, https://thetempleofhiphop.wordpress.com/the-9-elements/emceein/, accessed September 13, 2018.
108 "Street Knowledge," The Temple of Hip-Hop, https://thetempleofhiphop.wordpress.com/the-9-elements/street-knowledge/, accessed September 13, 2018.
109 "Beatboxin," The Temple of Hip-Hop, https://thetempleofhiphop.wordpress.com/beat-boxin/, accessed September 13, 2018.
110 "Street Entrepreneurialism," The Temple of Hip-Hop, https://thetempleofhiphop.wordpress.com/the-9-elements/street-knowledge/, accessed September 13, 2018.
111 Dead Prez, " 'They' Schools," *Let's Get Free*, Loud Records, 2000, compact disc.
112 J'na Jefferson, "Dead Prez's Stic.Man on Why Hip-Hop Can Be Healthy Without Losing Its Swag," *Vibe*, May 9, 2017, https://www.vibe.com/2017/05/stic-dead-prez-health-interview.
113 Chokeules, "The Forty-Year-Old Vegan," *Stay Up*, Hand'Solo Records, 2014, iTunes mp3.
114 *Rhyme & Reason.*
115 "Peace, Love and Overstanding," Marley Natural, https://www.marleynatural.com/blog/overstand-rastafarian-speech, accessed September 13, 2018.
116 "Hip-Hop Declaration of Peace," The Temple of Hip-Hop, https://thetempleofhiphop.wordpress.com/hip-hop-declaration-of-peace/, accessed September 28, 2018.
117 "The Gospel of Hip-Hop: First Instrument," powerHouse Books, http://www.

powerhousebooks.com/books/the-gospel-of-hip-hop-first-instrument/, accessed January 3, 2019.

118 Mary Oliver, *Dream Work* (New York: The Atlantic Monthly Press, 1986), 14.

119 Jordan Kisner, "The Politics of Conspicuous Displays of Self-Care," *The New Yorker*, March 14, 2017, https://www.newyorker.com/culture/culture-desk/the-politics-of-selfcare.

120 Ruth Franklin, "What Mary Oliver's Critics Don't Understand," *The New Yorker*, November 27, 2017, https://www.newyorker.com/magazine/2017/11/27/what-mary-olivers-critics-dont-understand.

121 Mary Oliver, *Upstream: Selected Essays* (New York: Penguin, 2016), 49–50.

122 *Upstream*, 7.

123 Vegan Yarn, "Frequently Asked Questions," https://www.veganyarn.com/pages/faqs, accessed October 15, 2018.

124 Summer Edwards, "7 Sustainable Vegan Textiles You Should Know About," The Minimalist Vegan, July 13, 2016, https://theminimalistvegan.com/sustainable-vegan-textiles/.

125 Jessica Meyer, Veganism and Creativity Questionnaire, April 18, 2018.

126 Martha Sherrill, "Painting Herself into a Corner," *The Washington Post*, March 19, 1994, https://www.washingtonpost.com/archive/lifestyle/1994/03/19/painting-herself-into-a-corner/.

127 Coe, 38.

128 *Sue Coe: Graphic Resistance*, MoMA PS1, Queens, New York, June 3, 2018.

129 Sherrill, *Ibid*.

130 Michael Sims, *The Story of Charlotte's Web: E.B. White's Eccentric Life in Nature and the Birth of an American Classic* (New York: Walker & Company, 2011), 235.

131 *Ibid.*, 4.

132 "A book is a sneeze," Letters of Note, August 2, 2013, http://www.lettersofnote.com/2013/08/a-book-is-sneeze.html.

133 Cheri Ezell-Vandersluis, "From Goat Farmer to Sanctuary Founder," SATYA Magazine, June 2007.

134 *Starman*. Directed by John Carpenter. 1984. https://play.google.com/store/movies/details/Starman_1984?id=hkJnrFfjElc.

135 Jeremy Griffith, *Freedom: The End of the Human Condition* (Sydney: WTM Publishing, 2015), 453.

136 Paquita Maria Sanchez, Goodreads review, June 1, 2014, https://www.goodreads.com/review/show/954653535.

137 Michel Faber, *Under the Skin* (New York: Harcourt, 2000), 183.

138 Jill Adams, interview with Michel Faber, *The Barcelona Review*, March/April 2002, http://www.barcelonareview.com/29/e_mf_int.htm.

139 Dick Gregory, *Dick Gregory's Natural Diet for Folks Who Eat: Cookin' with Mother Nature* (New York: Harper & Row, 1973), 2.

140 Reddit post, July 17, 2017, https://www.reddit.com/r/funny/comments/6nshmt/do_not_leave_children_unattended_at_whole_foods/.

141 Jonathan Balcombe, *Second Nature: The Inner Lives of Animals* (New York: Palgrave Macmillan, 2010), 203.

142 James Flynn, "Why our IQ levels are higher than our grandparents'," filmed February 2013, TED video, 18:38, https://www.ted.com/talks/james_flynn_why_our_iq_levels_are_higher_than_our_grandparents.

143 Ryan Bouchard, Mushroom Hike hosted by the Friends of Ballard Park, May 26, 2018.

144 Anne Casselman, "Strange but True: The Largest Organism on Earth Is a Fungus," *Scientific American*, October 4, 2007, https://www.scientificamerican.com/article/strange-but-true-largest-organism-

is-fungus/.

145 Nicholas Culpeper, *Culpeper's Complete Herbal* (London: Wordsworth Editions, 2007), 93–94.

146 Lisette Kreicher, Instagram post, April 18, 2018, https://www.instagram.com/p/BhthGZDHHfc/.

147 Leda Meredith, *Northeast Foraging: 120 Wild and Flavorful Edibles from Beach Plums to Wineberries* (Portland, OR: Timber Press, 2014), 226.

148 Julie Summers, *Jambusters: The Story of the Women's Institute in the Second World War* (London: Simon & Schuster, 2013), 154–155.

149 Tom Seymour, *Foraging New England: Edible Wild Food and Medicinal Plants from Maine to the Adirondacks To Long Island Sound*, 2nd ed. (Guilford, CT: Globe Pequot Press, 2013), 23.

150 Andrew Perlot, "A High-Energy Diet," Raw Food Health, http://www.raw-food-health.net/High-Energy-Diet.html, accessed August 30, 2018.

151 Kim-Julie Hansen, "What it's Like Being a Black Vegan Woman from Kentucky," April 24, 2016, https://kimjuliehansen.com/portrait-vegan-lacresha-berry/.

152 Richard Appignanesi and Oscar Zarate, *Freud for Beginners* (New York: Pantheon Books, 1979), 95.

153 Madeleine L'Engle, *A Circle of Quiet* (New York: Farrar, Straus & Giroux, 1972), 42.

154 James Hillman and Michael Ventura, *We've Had a Hundred Years of Psychotherapy—And the World's Getting Worse* (New York: HarperSanFrancisco, 1992), 154.

155 *Ibid*, 156.

156 Robert A. Johnson, *Inner Work: Using Dreams & Active Imagination for Personal Growth* (New York: Harper & Row, 1986), 50.

157 R.D. Laing, *The Politics of Experience* (New York: Ballantine Books, 1967), 30.

158 Robert A. Johnson, *Owning Your Own Shadow: Understanding the Dark Side of the Psyche* (New York: HarperCollins, 1991), 27.

159 Michael Ofei, "Vystopia: The Anguish of Being Vegan in a Non-Vegan World," The Minimalist Vegan, May 27, 2018, https://theminimalistvegan.com/vystopia/.

160 Hillman and Ventura, 197.

161 Carrie Arnold, "What the Fish Saw: How Swimming Fish Maintain Orderly Schools," *Scientific American*, December 1, 2013, https://www.scientificamerican.com/article/what-the-fish-saw-how-swimming-fish-maintain-orderly-schools/.

162 Ricard, 19.

163 Hanna Masaryk, "Harbinger Ambrosia Pie," The Piebrary, May 3, 2016, https://thepiebrary.com/2016/05/03/harbinger-ambrosia-pie/.

164 Melissa Tedrow, "Open Heart, Full Plate: How Veganism Healed My Disordered Eating," in Laura Wright, *The Vegan Studies Project: Food, Animals, and Gender in the Age of Terror* (Athens, GA: The University of Georgia Press, 2015), 164.

165 Kelly McGonigal, *The Willpower Instinct: How Self-Control Works, Why It Matters, and What You Can Do to Get More of It* (New York: Penguin Avery, 2012), 179.

166 "Livestock and the environment," the Food and Agriculture Organization of the United Nations, accessed January 4, 2018, http://www.fao.org/livestock-environment/en/.

167 *The Week*, "The next pandemic," August 30, 2014, http://theweek.com/articles/444164/next-pandemic.

168 "The Luck Child," Jim Henson's *The Storyteller*. Directed by Jon Amiel. 1990. Culver City, CA: Columbia TriStar, 2003. DVD.

169 Juan Enriquez, "The next species of human," filmed February 2009,
 TED video, 18:10, https://www.ted.com/talks/juan_enriquez_shares_
 mindboggling_new_science.
170 Ricard, 118.
171 Ray Bradbury, *The Martian Chronicles*, updated and revised edition (New
 York: Avon Books, 1997), 267.
172 Bernard Shaw, *Man and Superman, Collected Plays*, vol. 2, 511.
173 Bernard Shaw, *Misalliance*, in *Collected Plays with Their Prefaces*, vol. 4
 (New York: Dodd, Mead & Company, 1975), 138–140.
174 Colin Wilson, "A Personal View," in *The Genius of Shaw*, ed. Michael Holroyd
 (New York: Holt, Rhinehart and Winston, 1979), 227, 229.
175 "Saul Williams Makes a Heartfelt Argument for Going Vegan," Ecorazzi,
 August 12, 2008, http://www.ecorazzi.com/2008/08/12/saul-williams-
 makes-a-hearfelt-argument-for-going-vegan/ [sic].
176 Moran, 96.
177 Isaac Bashevis Singer, "The Slaughterer," in *The Collected Stories of Isaac
 Bashevis Singer* (New York: Farrar Straus Giroux, 1982), 215.

Further Reading, Resources, and Inspiration

There are many more excellent books and other media out there, but this list will get you started.

Compelling Short Reads

Aph Ko, "5 Reasons Why Animal Rights are a Feminist Issue," *Everyday Feminism* (everydayfeminism.com), December 30, 2014.

Jennifer Armstrong, "Eating Reading Animals," *The Horn Book* (hbook.com), May 1, 2010.

Christopher Sebastian McJetters, "Slavery: It's Still a Thing," Vegan Publishers, (veganpublishers.com), June 11, 2014.

Nutrition and Wellness 101

Virginia Messina's Vegan Nutrition Primers theveganrd.com

Becoming Vegan, Comprehensive Edition by Brenda Davis and Vesanto Melina

Vegan for Her by Virginia Messina and J.L. Fields

The China Study, Revised and Expanded Edition by T. Colin Campbell and Thomas M. Campbell II

Physicians Committee for Responsible Medicine www.pcrm.org

Nutrition Facts www.nutritionfacts.org

Animal-Rights Philosophy

Why We Love Dogs, Eat Pigs, and Wear Cows: An Introduction to Carnism and other books by Dr. Melanie Joy

The Case for Animal Rights by Tom Regan

Intersectional Veganism

Aphro-ism: Essays on Pop Culture, Feminism, and Black Veganism from Two Sisters by Aph Ko and Syl Ko

Sistah Vegan: Black Female Vegans Speak on Food, Identity, Health, and Society, edited by Dr. Amie Breeze Harper

Veganism in an Oppressive World, edited by Julia Feliz Brueck

Veganism of Color: Decentering Whiteness in Human and Nonhuman Liberation, edited by Julia Feliz Brueck

Food Justice: A Primer, edited by Saryta Rodriguez

Beasts of Burden: Animal and Disability Liberation by Sunaura Taylor

My Favorite Food Blogs

Lunchbox Bunch kblog.lunchboxbunch.com

Vegan Richa www.veganricha.com

Minimalist Baker www.minimalistbaker.com

Dianne's Vegan Kitchen www.diannesvegankitchen.com

Podcasts & Films

Animalogy and *Food for Thought* with Colleen Patrick-Goudreau

Brown Vegan with Monique Koch

Mikeypod with Michael Harren

The Chickpeeps with Evanna Lynch, Robbie Jarvis, Momoko Hill, and Tylor Starr

Easy Vegan with J.L. Fields

Main Street Vegan with Victoria Moran

The VGN Podcast with Christopher Sebastian McJetters, Tyler Tolson, and Tom Lane

The Bearded Vegans with Paul and Andy

Sagittarian Matters with Nicole Georges

A Prayer for Compassion, directed by Thomas Wade Jackson

The Ghosts in Our Machine, directed by Liz Marshall

Cookbooks *(in addition to those mentioned in the text)*

Artisan Vegan Cheese and *The Homemade Vegan Pantry* by Miyoko Schinner

Eat Vegan on $4 a Day and other books by Ellen Jaffe Jones

Vegan on the Cheap and other books by Robin Robertson

The Joy of Vegan Baking and anything else by Colleen Patrick-Goudreau

The Main Street Vegan Academy Cookbook by Victoria Moran and J.L. Fields (I have two recipes in this one!)

Vegan Cupcakes Take Over the World, *Vegan Pie in the Sky*, and anything else by Isa Chandra Moskowitz and Terry Hope Romero

Spirituality and History

Main Street Vegan, *The Good Karma Diet*, and anything else by Victoria Moran

Yoga and Vegetarianism by Sharon Gannon

The World Peace Diet by Dr. Will Tuttle

Food for the Gods, Famous Vegetarians, and other books by Rynn Berry

Nonprofit Organizations

Food Empowerment Project www.foodispower.org

Our Hen House www.ourhenhouse.org

Farm Sanctuary www.farmsanctuary.org

The Humane League www.thehumaneleague.org

Chilis on Wheels www.chilisonwheels.org

Black VegFest www.blackvegfest.org

Mercy for Animals www.mercyforanimals.org

Vegan Arts Collectives

Art of Compassion www.artofcompassionproject.com

Compassion Arts www.compassionarts.org

Arts and Literature

The Sexual Politics of Meat and anything else by Carol Adams

Dead Meat, *The Animals' Vegan Manifesto*, and anything else by Sue Coe

Always Too Much and Never Enough by Jasmin Singer (memoir)

Fetch and anything else by Nicole Georges (graphic memoir)

Fearless Drawing by Kerry Lemon

The Literary Ladies' Guide to the Writing Life by Nava Atlas

Mistaking the Sea for Green Fields by Ashley Capps (poetry)

Vegan Xicana and other zines by Suzy González

Modern Tarot by Michelle Tea

Fiction by Vegans *(though not necessarily vegan themed)*

Popco, *The End of Mr. Y*, and anything else by Scarlett Thomas

The *Peasprout Chen* novels by Henry Lien

Elizabeth Costello by J.M. Coetzee

Heartbreaker, *Northwood*, and anything else by Maryse Meijer

The Curious Tale of Otto and Trinity Small by Philip McCulloch-Downs

The Girl Who Handcuffed Houdini by Cynthia von Buhler

Acknowledgments

I feel deeply grateful to everyone whose talent and insight grace these pages: Nava, Berry, Heidi, Debra Diane, Janyce, Maya, Yitzy, Colin, Cynthia, Henry, Melanie, Nicola, Tanya, Josephine, Alec, Donald, Kerry, Jane, Philip, Marina, Meneka, Immy, Jerry, and Weronika; Sue Coe and Dan Piraro (with thanks to Faye Duftler and Christy Higgins for their assistance), plus all the vegans (and not-yet-vegans) whose ideas I draw upon. (Same goes for all the inspiration that didn't make it in.) Kathy, Neil, Mieke, Jenny: thank you for giving me such juicy "sticking points" to respond to. Christopher Sebastian McJetters, Julia Feliz Brueck, Aph Ko, Syl Ko, Dr. A. Breeze Harper, Saryta Rodríguez, Rama Ganesan, Keith Tucker, Kevin Tillman, Omowale Adewale, Starr Carrington, and Dick Gregory (RIP): thank you for all you've taught me about intersectional veganism.

Thank you from the bottom of my bleeding heart to Jamey Ellis for "converting" me to this kinder way of life, to Aviram, Yorit, and all my friends at Sadhana Forest for creating such a warm and loving place to learn and grow in, and to Sophie Dubus and Candice Martin for being such lovely travel companions in Munnar (when I couldn't stop talking about vegan baking!) Lauren Gazzola and Victoria Moran, knowing you has made this book worlds better than it ever could have been otherwise. Rynn Berry (RIP), Carmella Lanni and Carlo Giardina, Rain Truth, Dianne Wenz, J.L. Fields, Karen Ranzi, Stephanie Redcross-West, Marcia Kalisch (RIP), and all my other wonderful teachers and friends from Main Street Vegan® Academy; and to Leigh Sanders and everyone at the Art of Compassion project. Joelle Renstrom and James Miller, Keith Godbout, and Marika McCoola, thank you for all the research links and moral support. Love and thanks to Jacqueline Manni, Chantal Schreiber, Lillian Barker, Annie McGough, Jaclyn Wood, and Keith (again) for showing up for the e-course preview version of this book, and to Una Marzorati, Vivien Straume, Vicki Brett-Gach, Dianne Schnieders, Jolynn Van Asten, and Jessica Meyer for taking the time to fill out my veganism and creativity questionnaire.

Big thanks to more vegan friends, old (as in longstanding!) and new: Dan Comerford, Kelly Turley, William Melton, Michael Harren, Jason Atkins, Christopher Allison, Rick Williams, Rachel Toews,

Casandra Royce, Joe Tochka, Chrissy Toti, Stephanie Kirkpatrick, Vinicius Martins, Rachel Atcheson, Karen Krinsky and Chris Belanger, Fiona McQuade, Bristol Maryott, Cameron Gray, Cheri and Jim at Maple Farm Sanctuary, and Kathy, Lara, and John at Unity Farm Sanctuary.

I'm so grateful to Jennifer Flores, Seanan McDonnell, Hanna Masaryk, Mike Dolan Fliss, Matthew Turner, Emily Madapusi-Pera, McCormick Templeman, Kendall Kulper Toniatti, Mackenzi Lee, Erin Callahan, Anne Weil, Amy Lou Stein, Michael Rasmussen, Dixie Buck, Elizabeth Duvivier, Meg Fussell, Giavanni Washington, Teri Simonds, Gail Lowry and Paul Brotchie, Anne Wichmann, and Tim DeSutter. More shout-outs to my friends at the Writers' Room of Boston (especially Debka Colson, Mary Bonina, Kate Gilbert, Mike Sinert, and Alexander Danner) and to Amanda, Juli Anna, Mary, Morgan, and everyone at the Providence Athenaeum, where I wrote most of this book. Kate Garrick, you're a treasure. Thank you to Cathy Jaque, Barney Karpfinger, Martin Rowe, and to Brenda Knight, Yaddyra Peralta, Robin Miller, Jermaine Lau, and the rest of the Mango team for all their work on this project.

Steven Saranga, you make this sweet life even sweeter (for contrary to rumor, vegan boyfriends are *not* as rare as unicorns). Big love to Mumsy, Bill, Kate, Elliot, and all of my family for loving and supporting me no matter what.

Photo credit: Anne Weil

About the Author

Camille DeAngelis is the author of several novels, a travel guide to Ireland, and *Life Without Envy: Ego Management for Creative People*. Her young adult novel *Bones & All* won an Alex Award from the American Library Association in 2016. Camille is a certified vegan lifestyle coach and educator through Main Street Vegan® Academy, and she lives in New England. Visit her online at www.cometparty.com.

Mango Publishing, established in 2014, publishes an eclectic list of books by diverse authors—both new and established voices—on topics ranging from business, personal growth, women's empowerment, LGBTQ studies, health, and spirituality to history, popular culture, time management, decluttering, lifestyle, mental wellness, aging, and sustainable living. We were recently named 2019's #1 fastest growing independent publisher by *Publishers Weekly*. Our success is driven by our main goal, which is to publish high quality books that will entertain readers as well as make a positive difference in their lives.

Our readers are our most important resource; we value your input, suggestions, and ideas. We'd love to hear from you—after all, we are publishing books for you!

Please stay in touch with us and follow us at:

Facebook: Mango Publishing

Twitter: @MangoPublishing

Instagram: @MangoPublishing

LinkedIn: Mango Publishing

Pinterest: Mango Publishing

Sign up for our newsletter at www.mango.bz and receive a free book!

Join us on Mango's journey to reinvent publishing, one book at a time.